In *JUMP•CUT*, the follow-up to the authors' acclaimed *Make the Cut*, leading film/TV editors and industry veterans Lori Jane Coleman ACE and Diana Friedberg ACE offer editing techniques, insider tips and unwritten rules that contribute to making a great production. They provide seasoned and aspiring editors with the tools needed to jump•start the next stage of their editing careers, or to break into this challenging industry. Using a mix of practical techniques and career-focused advice, *JUMP•CUT* covers best practices for editing dramatic motion pictures, episodic television, documentaries and reality TV, taking into account music, sound effects and dialog. The book is rounded out by interviews with many leading Hollywood editors, including Alan Heim ACE, Michael Tronick ACE and Mary Jo Markey ACE, who share their years of experience and unique paths through the industry.

Lori Jane Coleman ACE was born in New York City and is a third generation filmmaker. She has been a film editor in Hollywood for forty-three years in features, movies of the week, mini-series and episodic television. A recipient of two ACE Eddie Awards and one Emmy nomination, she has lectured at multiple universities in America and been the Director of the American Cinema Editors Internship Program for twenty years. She has two daughters, Deirdre and Allison. Lori Jane and her fiancé, Scott, live in Incline Village, Lake Tahoe. Coleman was the recipient of the prestigious American Cinema Editors Heritage Award for 2017.

Diana Friedberg ACE is a multiple award-winning editor and producer. In 1967 she began her career in South Africa and moved to Hollywood with her family in the 1980s. With a MFA from USC in film production, she has edited and produced features, episodic television, animated series and non-fiction productions for companies as diverse as Disney, National Geographic, Stephen J. Cannell and Leonard Nimoy Productions. During the span of her five-decade career, she has worked on many groundbreaking documentaries for television and other markets. Friedberg was the recipient of the prestigious American Cinema Editors Heritage Award for 2017.

JUMP•CUT

How to Jump•Start Your Career as a Film Editor

\ˈjəmp-ˌkət\ noun

A sudden often jarring cut from one shot or scene to another without intervening devices (as fade-outs); *broadly*: a transition device in film editing that represents a momentary omission in a continuous shot, creating an effect of discontinuity or acceleration that moves the character or story forward.

Lori Jane Coleman ACE
Diana Friedberg ACE

Routledge
Taylor & Francis Group

NEW YORK AND LONDON

First published 2017
by Routledge
711 Third Avenue, New York, NY 10017

and by Routledge
2 Park Square, Milton Park, Abingdon, Oxon OX14 4RN

Routledge is an imprint of the Taylor & Francis Group, an informa business

© 2017 Taylor & Francis

The right of Lori Jane Coleman and Diana Friedberg to be identified
as authors of this work has been asserted by them in accordance with
sections 77 and 78 of the Copyright, Designs and Patents Act 1988.

Library of Congress Cataloging-in-Publication Data
Names: Coleman, Lori Jane, author. | Friedberg, Diana, author.
Title: Jump cut : how to jumpstart your career as a film editor / Lori Jane
Coleman, ACE & Diana Friedberg, ACE.
Description: New York : Routledge, 2017. | Includes bibliographical
references and index.
Identifiers: LCCN 2016020512 (print) | LCCN 2016032116 (ebook) |
ISBN 9781138691339 (hardback) | ISBN 9781315535418 (e-book) |
ISBN 9781138691353 (pbk.) | ISBN 9781315535418 (e-Book)
Subjects: LCSH: Motion pictures--Editing.
Classification: LCC TR899 .C6455 2017 (print) | LCC TR899 (ebook) |
DDC 778.5/35--dc23
LC record available at https://lccn.loc.gov/2016020512

ISBN: 978-1-138-69133-9 (hbk)
ISBN: 978-1-138-69135-3 (pbk)
ISBN: 978-1-315-53541-8 (ebk)

Typeset in Times New Roman and Optima
by Florence Production Ltd, Stoodleigh, Devon

Dedications

This book is dedicated to my two extraordinary daughters, Deirdre and Allison. I love you to the moon and back.

To my fiancé, Scott Gordon, I thank you for bearing with me and riding out the storms. You are who I look forward to, from now until the end of my days.

For all my interns. Over the past twenty years, you have never ceased to amaze me. You have inspired me to share with you everything I am able to, and I adore each and every one of you.

This book is dedicated to Charles Vincent Coleman (1947–2000), in loving memory.

Lori Jane Coleman
Incline Village, Lake Tahoe, 2016

I dedicate this book to all the producers and directors who, over the decades, have entrusted me with their material and guided my creativity.

I thank my family for their constant support, love and understanding. Lionel, since we first met on a sandy dune on my first feature film as a director you have been at my side. It has been an exciting road with many twists and turns, each one a life changing adventure. Thanks for sharing the challenges and the rewards. To my son David, thanks for your support and love. Your kindness and generosity are appreciated more than I can express. To my daughter-in-law Allison, we welcome you to the family. To my daughter Amanda and son-in-law Robby, my grandchildren Asher and Everett, you fill me with so much joy and happiness. Words cannot express my love for my beautiful family.

This book is also dedicated to all who have a dream to become a film editor. You truly can jump•start your career and become the best.

Diana Friedberg
Los Angeles, 2016

Contents

PART 3 GUIDELINES FOR EDITING NON-FICTION 113

Chapter 6 Editing Scripted Documentaries 115

Chapter 7 Editing Non-Scripted Documentaries 153

Contents

Foreword

During our tenure as Directors of the American Cinema Editor's Internship Program from 1994 to 2014, we set out to train incoming college graduates to become skilled assistant film editors. We placed them in editing rooms that spanned features, television, post production facilities and reality shows during the four-week course. Numerous students sought the internship, and since we only accepted two interns a year into the program, we felt compelled to try to help everyone else as well. We created a lecture series in which we presented all the same material the chosen interns would learn and to which all of the applicants were invited. This gave every hopeful applicant a unique chance to hear stories and bits of advice from editors and assistants. It was an invaluable opportunity for the graduates to network with film industry colleagues as well as meet some of their heroes at close range.

The response was overwhelming. We heard from hundreds of students, both domestic and international, who wished they were able to make the long journey to Hollywood, but unfortunately were not in a financial position to make that happen. To reach as many aspiring editors as we could, we recorded and transcribed the lecture series, and then published what became our first book, *Make the Cut, A Guide to Being an Assistant Editor in Film and Television*. In it, we set out to encapsulate the inner machinations of an editing room and prepare the aspiring assistant for the tasks at hand. A few of our main topics were etiquette, work ethics, technological savvy and personality traits that lead to a successful immersion into the world of editing. We presented the editorial process from dailies to online, from scripted to reality, from your first day on the job to wrapping up the movie. It became the local handbook for many assistant editors, and has been adapted in several film schools as required reading.

Now that our faithful readers and students have become successful assistant editors, we would like to share our sequel, *JUMP•CUT, How to Jump•Start Your Career as a Film Editor*. This book starts where the last one left off, and if you arrived in Hollywood with your heart set on moving into the editor's chair, it just might be the guidebook that will help get you there.

We sincerely hope so.

Acknowledgments

Huge shout out to all my assistants who have indulged me with their patience and kindness. Cheryl Chandler, Joe McJimsey, Daniel Valverde, Jan Northrop, Sharon Silverman, Mark Hartzell, J.P. Bernardo, Chris Miglio, Jen Krouse, Greg Dean, Katie Schaefer, Brandi Bradburn, Dan Holland, Daniel Simmons, Hunter Via, Meridith Sommers, Lauren Pendergrass, Melissa Brown-McCoy, Rosanne Tan, Carsten Kurpanek, Marissa Mueller (by proxy), Kelly Stuyvesant, Lissette Rodriguez, Ray McCoy, Drew Johnson, Dana Gasparine, Nancy Hurley and Hillary Wills. Thank you for bearing with me, and teaching me so very much. If I have missed someone's name, please know I meant you too.

To my mentors, you have lighted my way. Thank you for your wisdom. Sincere appreciation goes to Mike Berman, Gene Ranney, Jimmy Honore, Gani Pastor, Jack Davies, Chris Holmes, Corky Ehlers, Danny Cahn, Sr., Danny Greene, Lou Lombardo, Bud Isaacs, Tony Gibbs and Graeme Clifford. You opened your hearts and editing rooms, and your teachings are a gift. A special place in my heart is reserved for Louie—his work opened my eyes, and I wish he were here to talk to.

My head is filled with the extraordinary teachings of my director, Mick Jackson. Over the course of twelve years, you taught me a new way of looking at dailies. I thank you for sharing your wisdom—each day brought a new pearl.

I loved working with you Michael Pressman. Your stories and dailies were always a treat. You helped temper my way.

I was honored to work with writer/director David Hollander on several projects. We cut outside the lines and you allowed the film to breathe. You are a wonderful, kind man. Thank you for waiting for me on *Personal Effects*. It is a personal favorite, and contains one of my favorite scenes I have ever edited.

For four years I had the pleasure of editing for producer/director Stephen Kay on *Covert Affairs*. It was a fun ride, and you helped me push the envelope. I have a tape of you inside my head.

To my editing colleagues, it has been a pleasure working alongside each and every one of you. I thank you for your notes and friendship. To all the interns, thank you for volunteering for everything. I love watching you all grow and learn.

LJC 2016

I would like to acknowledge all my colleagues in the film industry in South Africa with whom I had the privilege of working for nearly twenty years. Mentors Ashley Lazarus and Jackie le Cordeur afforded me opportunities of learning the editing business and organized my apprenticeship at Pinewood Studios in London.

I will always be indebted to you for paving the way and introducing me to the world of film.

Moving to Hollywood with our family provided many challenges. We will always be indebted to Michael Campus who made it possible for us to make America our home.

I was honored to cut for many wonderful producers and companies. Each and every one was a learning experience that enriched my life. Journey Entertainment, FilmRoos, Stephen J. Cannell/New World Productions/Stu Segall Productions, Bunim Murray, MPH Entertainment, Leonard Nimoy Productions, National Geographic and Disney Educational Productions afforded me extensive opportunities to cut many forms of entertainment on film and tape.

Most importantly I wish to acknowledge my husband Lionel Friedberg who has shared my passion for films, film history and film music since we first met. He has been a constant inspiration, guide and a profound source of wisdom and knowledge. Together we have made over a hundred films for television and cinema. You have enriched my life and career beyond imagining. It is my fervent hope that we continue to share our love of filmmaking for many years yet to come.

To all the interns and assistant editors who have passed through the internship program at American Cinema Editors, I thank you for sharing your enthusiasm and friendship. It has been a great privilege to share my experiences with you and know that you will all be cutting your own shows. I look forward with great pride to reading your credits on the screen.

DF 2016

So You're an Assistant Editor, Now What?

Deep Assessment

Opportunities don't happen, you create them.
 Chris Grosser

*Just when the caterpillar thought the world was ending, she
turned into a butterfly.*
 English Proverb

In our first book, *Make the Cut*, we shared guidelines about how to become
an extraordinary assistant film editor. We discussed the unwritten rules of
etiquette and protocol in the cutting room, the process of dailies to online,
negative cut or digital intermediate (DI) and the inherent paperwork involved
with organizing and managing the editing room. We intimated some of the
more fortuitous personality traits. We said that if you wanted to be an editor,
you had to be an outstanding assistant editor first. We are confident that, by
following our guidelines, you have become a polished assistant editor—
enough to shine.

Many of you have gone to film school and specialized in editing. Perhaps
some of you have found your passion for editing after graduation, or by happy
accident. Regardless of your road traveled, we have all arrived at that same
state of mind—we love to edit—we are passionate about it. It is therefore a
common occurrence that after assisting for a while, your desire to edit again
grows stronger and more urgent. That need to create art, tell a story, build
the sound design, is intoxicating and it is not quite realized by performing
the assistant editor's work.

There are career assistant editors who do not feel this same need to become an editor and take on the vast responsibilities consummate with that role. Instead, they perform their tasks with skill and grace, and turn assistant editing into its own art form. They are the heart and soul of the editing room. One of the most phenomenal career feature assistants I know, Carole Kenneally, assists Conrad Buff ACE (*Training Day*, *True Lies*, *Titanic*). She started with Conrad in 1995 as his VFX editor and then became his first assistant in 2000 on *Thirteen Days* and has been his first assistant since then. Editors appreciate loyalty and enjoy the ease with which they start each project due to their long-term working relationship with their first assistants. Carole is an invaluable asset for his editing team, and travels wherever Conrad accepts a gig throughout the world.

However, for many assistant editors, after the initial joy of getting a paid assistant editor job in the real world has lost some of its glow, the day arrives when you start to feel frustrated that you haven't moved up as quickly as you had hoped. You soon realize that there are no guarantees that you will move up. You begin to look for a roadmap that does not exist, and ask:

- When do I move up to editor?
- How do I get out of reality television and into scripted?
- How do I get into features?
- Where do I start?

The frustrations you feel are pervasive. They shatter your ability to function with enthusiasm and are perceived as a bad attitude. This only works against you when you throw your name in the hat for an editing gig. I implore you, do not lose faith. You will find a way to take the editor's chair somehow, someday. After all, this is what you love doing twelve hours a day.

> *Never give up on something that you can't go a day without thinking about.*
>
> **Sir Winston Churchill**

Every editor I know has stood at this very same crossroad with countless future career paths in front of them that had yet to unfold. Their stories, some of which are told throughout these pages and in the final chapter, will show that their journeys, though divergent, were all successful in their own way. Common threads that led to their respective career achievements, such as work ethic, commitment to excellence, talent, personalities and, most importantly, their passion for storytelling, can be found. Whichever path you take will be the right one for you.

*In any moment of decision, the best thing you can do is the
right thing.*

The next best thing you can do is the wrong thing.

The worst thing you can do is nothing.
 Theodore Roosevelt

In this chapter, we have some guidelines to offer that address the aforementioned questions and will help you navigate your personal roadmap. We suggest you start with an evaluation of where you are in your career currently. Assess where you would like to be eventually, and what tools you need to get there.

1.1 CHOOSE YOUR VENUE WISELY

Happiness is not something readymade.

It comes from your own actions.
 Dalai Lama

- Where are you now (current position/field—union/non-union)?
- Where do you want to be? Do you want to change fields?
- Do you want to cut features? Television? Documentaries? Reality?

If you are working in Hollywood, I hope you have joined the Motion Picture Editors Guild (MPEG) after your first or second year of assisting on non-union shows. Go to their website (www.editorsguild.com) to find out about the rules and requirements for joining the union. If you reside in other countries, or cities in America, there are less stringent rules about joining unions, but if they do exist, it is a good idea to become a member. It will provide a base for networking.

In general, you have to schmooze; network with your colleagues and your favorite editors and assistants. Write letters to the people you would like to work with. Send them to the MPEG, or American Cinema Editors (ACE). Ask to have your letters forwarded.

Find the social gatherings of post personnel, ask to be Facebook friends and/or LinkedIn associates. Ask the assistant and perhaps the editor for a meet and greet and buy them coffee. Find the blogs where other film assistants discuss tech questions and post job offerings. Contact co-producers, associate producers and

heads of post production at the studios. Networking is the mainstay of finding work in every city around the world, especially in Hollywood. Word of mouth is sometimes the only way to get in the door for the interview. This methodology works when you are an assistant or an editor looking for your next gig.

You have worked hard to gather your 100 days, to be eligible for the union roster. Perhaps you accomplished this by working in reality or on independent features. Think about your field of choice—reality, scripted television, cable, documentaries, commercials, features or music videos. I urge you to determine this carefully because the amount of time you spend in each venue entrenches you further in that venue. Your resume, experience and network of colleagues will expand there, and though there is crossover into other venues, it often entails starting over with an entry-level job. For example, if you are the lead assistant on a reality show, you might have to go back to being the apprentice on a feature. If you are the editor on a reality show, and want a gig on a scripted show, you might have to go back to being an assistant until they recognize your talents as an editor.

People are pigeonholed easily in the film industry, and as long as you are aware that each time you spend a year in one venue, you are a year further away from the next venue you might want to try. Feature folks do not often hire television assistants or editors, and television producers do not often hire feature assistants or editors. There are a handful of editors and assistants who are able to make the crossover, but not too many and not too often. Television people feel feature people are too slow. Feature people feel television people are hacks. It is easier to crossover as an assistant, than as an editor. The main point is that choosing your venue from the start will put you on the right path, networking immediately. The process will restart when you crossover.

After your name is on the roster, and you are eligible for union work, you have choices:

- Should I stay in reality and move up to editor?
- Should I branch out to features (independent or union)?
- Should I try to get into scripted television?

This is a monumental decision, and one that might cost you precious time on your road to where you eventually want to sit—the editor's chair. Some of you know that you want to work on big studio blockbuster features, from

sci-fi to action, dramatic epics or comic book films heavy on visual effects (VFX) or maybe animated films. These movies take many months, sometimes years to complete. More often than not, there are long hours and weekend work. The pay scale is usually high—over scale, and with overtime, the salaries are excellent. Many times you are required to go on location for long periods of time. There is often a large staff, complete with first and second assistants, multiple film editors, VFX editor, apprentice and/or a post production assistant (PPA). They will be your family for a long time. The ascent to editor, if you make it, takes many years, and requires patience and a quiet tenacity within the confines of your editing room.

Some of you are attracted to independent features (indies) or documentaries. The stories that are told are often humanistic, unique and thought provoking. Oftentimes, they are directed by upwardly mobile filmmakers, with whom you have the opportunity to grow, succeed and contribute. They are usually underfunded, on a short schedule, and might not have a distributor, so they will seek entry into film festivals. If you are lucky, they will receive attention and/or recognition at the festival, and it can catapult your career quickly. But this is not a given. Many editors in indies work on dozens of films, without hitting that one jackpot. Also, you will need your own editing station and will work out of your home often. The pay is less than scale, without union protection from non-payment of funds, working holidays or weekends, or misconduct. You are often your own assistant. Moving up to editor in this venue is relatively quick, but along the way there will be a lot of freebies, long hours and, sometimes, bad scripts.

Perhaps you are attracted to television. The pace is faster in TV, the pay is scale and the assistant has to multi-task incessantly. Sometimes you have to assist more than one editor and you will have to acquire the skills necessary to handle many people asking you to do things simultaneously. Jobs last from two or three months (a pilot), to six months (a 13 episode show) to ten months (a 22 episode show). You can develop a relationship with the co-producer in charge of editorial, who will also task you with many requests. You will learn to balance how to please the co-producer and your editor. Though moving up to editor is never guaranteed, there is a great chance that you will have opportunities to win the editor's chair within three to five years. You need three main ingredients:

- Talent
- An editor and producer who support you getting a break
- A show that stays on the air for multiple seasons

While you are still an assistant film editor, try to make a well-informed decision about your venue of choice. Evaluate the income you hope to make and what your financial goals are; assess how willing you are to go on location—now and in the future when you may have a family. Decide upon the kind of pace you enjoy in the different cutting venues—whether you like working seven days a week or prefer a five-day week with only occasional weekend commitments; how willing you are to work many late nights; how important the quality of the script and project is; and if you envision an Emmy or an Oscar on your mantel. Make educated decisions and then navigate your way forward.

> You need a nest egg to make changes in your career. Create a savings account dedicated to living costs for when you are on hiatus for three to six months. This safety net will help you make decisions based on where your creative heart lies, instead of financial necessity.

If you want to cut features, I highly recommend aiming for that venue immediately. Look for a job on independent features and network with union feature assistants. If you are in the editor's guild, you can accept feature PPA jobs when there is an editor or assistant with whom you want to work. It will be a good place to learn and advance to apprentice or second assistant editor.

If you want to edit scripted television, and have been assisting in reality, then you are well trained for a large part of what a scripted assistant does. The amount of organization, attention to detail and multi-tasking skills that you acquire in reality is a great preparatory education that can be applied to the scripted world of television. Many folks fall in love with reality television and enjoy advancing to lead editor. However, if you still want to edit scripted, then make the crossover while still an assistant. It is hard to be hired as the editor with a new set of producers with only reality shows on your resume. You might have to prove yourself again by going back to assistant.

If you want to cut reality or docs, unscripted television is a great background. You can stay put and make sure you climb the reality ladder—from night assistant to lead reality editor.

After working as an assistant film editor for a few years, it should be clear whether you want to end up as a feature, television, documentary, commercial or reality editor. You have seen the various lifestyles, the different salaries and the activity level differences. Think long and hard about what kind of stories you want to tell and what sort of creative freedoms you need. Think about how long you are willing to wait to move up to editor without getting disenchanted.

1.2 ASSESS YOUR CURRENT STATUS

- How long have you been an assistant editor?
- Will you be moved up the next time a slot opens on your show?
- What is your current state of mind about your career?

In *Make the Cut*, we suggested that you have a 1-year, 3-year and a 5-year plan. Now it is time to reevaluate how well you have done on this path, and begin to think about your 10-year plan. Here is one suggested road map:

- 1-year plan—Complete 100 roster days and join the union.
- 3-year plan—Working in the venue of your choice (TV/features/docs). Cutting every day.
- 5-year plan—Assisting the editors you most admire. Cutting every day.
- 10-year plan—Editing your first feature/TV show/doc or commercial.

It is important to take the time to plan where you work, and with whom, in these time spans.

> *If you set your goals ridiculously high and it's a failure, you will fail above everyone else's success.*
>
> **James Cameron**

These are your go get 'em years, so your energies should be focused on navigating your career. Work hard and long—get up early and stay late. Work for free. Volunteer everywhere. Since there is a chance that your break might not be forthcoming in the venue of your choice, it will be up to you to find a path that will lead to the editing seat you want.

> *I'm a greater believer in luck, and I find the harder I work the more I have of it.*
>
> **Thomas Jefferson**

These plans are a guideline, with the time frame and accomplishment bar raised as high as your imagination will allow. Perhaps you are already cutting on the side—indies, shorts, docs or webisodes. Maybe your editor has asked you to cut in sound effects (SFX), temp music (MX), visual effects (VFX). You might even be editing scenes for your editor. Do all of this and your time frame for moving up to editor will be much faster. If you are not doing these things, ask yourself why not, and change your daily productivity now.

Wherever you are in your career path, take a deep breath and give yourself a pat on the back. Then reevaluate where you are headed and whether you are on the right path. If things have gone awry, then examine your situation and define what circumstances affected your decisions that led you astray. If you can identify career choices that have gone wrong, then you will be able to find your way back to your original goals. Maybe the post staff or editors in your life are unsupportive, your living arrangements are too expensive or fraught with tension, or there are personality flaws of your own that need some work. Fix these dilemmas as soon as you can. Remember to choose your projects with your personal career strategy in mind. Each commitment to a new show can take from three months to two years or more. Ask yourself, "Will this project get me closer to my goals?"

If, after several years of being an assistant editor, you have not succeeded in achieving your goals, then something is wrong. Either you have had the worst luck in the projects you have chosen, or something you have done is affecting your career and reputation. Perhaps it is personality issues, or work ethics. Maybe it's a combination of things. This is the time to ask yourself how you could improve and then figure out the best way to jump back onto a successful path. Be perfectly clear and impartial about what elements need to be changed.

> *Success does not consist in never making mistakes but in never making the same one a second time.*
> *George Bernard Shaw*

Too many times I have watched assistants struggle with their lack of luck and upward mobility. I can tell you that 99 percent of the time it is because of their personality (they are too combative, maladjusted, verbose or needy, and have excuses for everything) or slack work habits (they arrive late, are disorganized, non-proactive and make mistakes). Be honest with yourself, and up your game.

1.3 STEP AWAY FROM THE INTERNET

- How much time do you spend logging onto the internet?

There is a time vampire lurking in our lives—the internet. I think if you were to honestly add up the amount of minutes you spend on Facebook, emails and texting, you would find that the sum exceeds an hour or two. Yes, you are expected to check for work related emails, but that is not the true problem. To avoid these internet time drains, set up a new email address dedicated to work emails. Today's social networks have become a part of our lives and it is difficult to step away from being connected—even though you are at work. But you must. Those one or two precious hours dedicated to staying connected detract from the time you could be cutting or watching your editor cut. It leaves a bad impression when an editor/director/producer walks into your room and you are on the internet. It is a rare assistant who can do all their assistant work as well as juggle their electronic lives. Put aside a part of your lunch hour, or take a break once or twice a day, or wait until after hours to catch up on personal social networks.

> *Oh would some power the gift give us, to see ourselves as others see us!*
>
> **Robert Burns**

If you have chosen television as your venue, then your plan is to be moved up eventually by your editor or producer. If you are assisting on a successful television show, and a slot opens up, be prepared to ask for the opportunity to fill that seat. If the powers that be do not know you want to edit, your name will not make the list of possible editors for that vacant chair.

If there is a first assistant, or a more experienced assistant on the show with you, it is possible that the post production staff and producers will move them up first. You might be next, but you will only know this if you set the stage properly. Let the associate producer, co-producer, your editor, the other editors and the executive producers know that you are aiming for the editor's chair and that you are qualified. Toot your own horn—tell them about the indie you cut during hiatus, let them know you are working on a film that is getting ready for a festival. Share your editing successes that you have achieved outside their project so that they know you are capable of more than assisting. You must raise their confidence in you.

There are several opportunities during the course of the television season that go above and beyond your assistant job that you must volunteer for. They are:

- Recaps
- Gag reel
- The show's webisodes
- The opening credits
- Music alts
- SFX
- VFX

If your editor lets the producers know that you have done these tasks, and done them well, then you will be on the producer's radar. It might lead to a comfortable relationship with the producer so that he sees you as something other than an assistant editor. It is an opportunity to sit with the producers as they give notes on your work. It prepares you to conduct the environs of your editing room with grace. Hopefully, it accelerates the path to being moved up.

If your editor, or anyone else on the show, is not helping you compete for the next open slot, then you need to take a hard look at whether you are on the best show for your career. It might be time to make a hard decision— when to leave this show and your editor, and find greener pastures. You need to accomplish being on the right show, with the full support of your editor and co-producer, within your first five years.

> *All our dreams can come true—if we have the courage to pursue them.*
>
> **Walt Disney**

If you are working on features with one or two of your favorite editors, your upward ascent usually takes longer than in television. Feature directors hire the editors and must attain studio approval for their choices. Even if you have edited several independent features, shorts or documentaries, the studios are wary of putting their multi-million dollar project into the hands of a novice. They like track records and box office names. Unless you have worked for the director on a previous project, your name is not often on the short list for a big project. Sometimes the director fights for you, but can lose that battle more often than not. Happily, there are occasions when they fight hard and win.

You start from the bottom rung on a feature—apprentice or PPA—and you work your way up to second assistant. This can take a year or two. Hopefully one day you will be asked to be the first assistant. Again, this might take a year or more. Then you can begin the ascent to additional editor if you have proved your worth. These moves can take an inordinate amount of time, so be prepared for the long haul.

In features, it is imperative to have the full support of your editor to make any moves towards editing. You will make all the same moves as a television assistant, and once your editor has faith in you, he might recommend you for various projects that he cannot sign on to. It is also good to be on the director's radar so that they know you can edit well and that you are capable of taking on one of their smaller projects.

Sometimes you become so valuable as the tech assistant, or the VFX editor, that you find yourself off your chosen career path of picture editing. Do not settle. Keep your eye on the carrot, and remember that sometimes you have to make that hard decision—how to find your way back to your selected goal and possibly leave your editor. This is harder in features, because you have already devoted two or three years to this crew. Changing teams will possibly set you back another two or three years. What can help in these situations is a candid discussion with your editor, in which you share your dreams and hopes about editing. Always take a chance, and let people know of your aspirations.

> *Change is a continuous process. You cannot assess it with the static yardstick of a limited time frame. When a seed is sown into the ground, you cannot immediately see the plant. You have to be patient. With time, it grows into a large tree. And then the flowers bloom, and only then can the fruits be plucked.*
>
> *Mamata Banerjee*

Ask yourself how you are feeling about your career. Step back from the daily grind and give yourself a good talking to. Assess your emotions, your sense of self. Are you happy, short-tempered, numb, frustrated, excited, desperate? You deserve to feel that awe-inspired, full throttle passion for the art of storytelling every day. If this is lost, it can, and will, be regained when you examine how you have been blown off course, and what you need to do to correct it.

1.4 CHOOSE YOUR EDITOR

- Which editors do you want to work with?
- Who are their assistants?

As we discussed in *Make the Cut*, you should select your five favorite editors and determine who their assistants are. Follow their career paths and determine what projects they worked on together, for how long and whether their assistant moved up on a given film. See who they hired more than once. Follow the career moves of their assistants and how they navigated to the position you would dearly love. Check out this site: www.imdb.com. Look up who their producers were, the writers, the co-producers and all of the assistant film editors and figure out all the repeat combinations from previous shows. IMDb is a veritable road map that you need to explore. It will provide good information that you can include when you write to them and ask to meet with them over coffee. This applies to all venues, from television to features.

You must have a plan as to where and with whom you want to work, and how long you are willing to wait to cut. Your career arc is affected by the

> When choosing these editors, make sure they are the kind of editor who will support your desire to move up. Find out the pecking order of the staff—if there are other assistants on the show who are also hoping to move up. You will be the last in a long line, so the show must have a very long shelf life for you to move up. Weigh the advantages of working with a brilliant editor, against the amount of time or possibility that you will be allowed to co-edit.

choices you make each and every time you start a gig.

- Do they give you credit for your work?
- Do they encourage you to edit?

If your editor encourages you to edit, and if he lets the director or producers know that it was you who cut the scene that was well received, then you are in a good place. If he does not give you credit, if he is not happy with your cutting or the sound effects work you did, then the chances of him supporting your upward mobility is slim. All your ducks need to be aligned for the

moment that opportunity knocks. Most commonly, it will take your editor's recommendation, the co-producer's nod, as well as the executive producer's willingness to place you in the next vacant editor's seat. After all these ducks are in a row, you still have to get studio approval.

It is essential that you choose your editors, co-producers and executive

> Here is where luck enters your world. In television, being moved up may happen when your editor is given a shot at directing an episode. If they have faith in you, you might be asked to temporarily fill their seat. Or, if one of the editors decides to leave the show early or not return in season two, and you have proved yourself during season one, then there is an organic opportunity to move up. However, if you are working on a high-profile show, with great ratings and critical acclaim, the editors tend to stay put. Plus, the stakes are higher when moving an assistant editor up, and it is therefore a less common occurrence. Conversely, if you are on a show that gets cancelled, your chance to move up might be delayed another year or two until you are on a successful show.

producers wisely. They all have track records and reputations that will inform you as to whether they are open to your career aspirations. Remember to do your homework and research all of the staff involved in your next show.

1.5 TOOLS

- What editing platforms are you familiar with?
- Do you stay current with the latest software and technological developments?

The assistant film editor has become the proverbial technological center pole in the editing suites. Without your expertise and organization, the post process would fall apart. You are responsible for an uncanny amount of knowledge of all tech advances. You are a source of information for both the editor and the post producers. You need to know Avid, Final Cut Pro and Adobe Premier. You will be asked to create temp VFX such as composites and split screens in After Effects and Photoshop. You must be able to do multi-layered tracking and stabilization. This is true in both television and features and can be a skill set that sets you apart and above the competition for a project. Become versatile with your tools. Google updates about system upgrades and embrace this technology. It might make

the difference between you getting that job on the film you are aching to be a part of or being passed over. You must now be computer savvy to succeed in editorial.

1.6 FINANCES

You can only become truly accomplished at something you love. Don't make money your goal. Instead, pursue the things you love doing, and then do them so well that people can't take their eyes off you.

Maya Angelou

By definition, saving—for anything—requires us to not get things now so that we can get bigger ones later.

Jean Chatzky

Unfortunately, most of you will ignore this section. But I strongly suggest that you pay attention—you will thank me one day.

- Have you saved money?
- Have you paid off your student debt?
- Do you have a Roth IRA? Other investments?

Having financial constrictions makes it hard to turn down work and often you will have to take a job that brings you no closer to your career goals. In *Make the Cut*, we suggested guidelines for budgeting income so that you would have the most control over your career path. Basically, you need to eliminate the most expensive debt first—credit cards. Then pay off your student loans and car financing as quickly as you can while maintaining your lifestyle. Your rent should not be more than one or two week's salary. Remember to amortize this figure, and allow for an equal amount of weeks on hiatus. Add up all your utility bills and necessities and know what your monthly expenses are; include rent, electricity, water, gas, cable, internet, cell phones, credit cards and student loans, Individual Retirement Account (IRA) contributions, car insurance, health insurance, average gasoline amount, lunch money, food for home, toiletries and medicines. Subtract this number from your amortized monthly salary. If there is any money left at the end of the month you must save half of it. You will need it for emergencies like doctor bills, flights home, increased rent, new tires, new brakes, DMV registration. You will want it for birthday presents, holiday gifts and weddings. You need to treat yourself to the theater and concerts. But most

of all, you will need savings so that you do not take just any job that comes along. Save whatever money you can to make it through hiatus and find the right job for your career.

You must save for your present self, and your future self. At retirement, MPEG distributes your monthly pension according to the amount of years you have contributed to the fund, as well as an Individual Account Plan (IAP) that has a tidy sum. The United States government will release to you your Social Security benefits. These two incomes combine to help you through your later years, but will not cover the rising cost of medical care, home mortgage, transportation and food. Some of you will own a residence so that you do not have to worry about the cost of a mortgage without a paycheck coming in. Some of you might say, "I never want to retire," which is understandable because we are passionate about cutting. However, there might come a day when you are incapacitated physically, or mentally exhausted. Sadly, age chauvinism enters into the equation, and you no longer have control over the decision to work. You must have some other form of income on a monthly basis to make it through your golden years.

Investments come in all forms, a Roth IRA, mutual funds, stocks and bonds, limited partnerships, land investments and annuities to name a few. All of these options are better than having your money sitting in a bank. Find a financial advisor, an investment firm or do some research and consider an Electronically Traded Fund (ETF). Arrive at a plan for your financial future in your twenties or as soon as possible. Enjoy the magic of compound interest, institute it now and you will be a millionaire in your sixties. You must always put aside a percentage of your income for a rainy day.

1.7 SUMMARY

I think the person who takes a job in order to live—that is to
say, for the money—has turned himself into a slave.
Joseph Campbell

Editing is what you love doing for hours on end. To be hired as an editor takes work and so much thought. If you have an insatiable curiosity about new technology, and you have networked with all your favorite editors, assistants and multiple post producers—and if you are purportedly the next in line for a bump up and have the editing skills—then you are poised and ready to jump out of your current seat and move up to editor.

You just need a break.

The quickest way to move up to editor is to do all of the above, and train yourself to be the best editor you can be. This means studying the way your editor cuts a scene, how he elevates it—or hurts it—and then how the scene is altered by the director, producers, studio and network. It means you must study the way all of your favorite editors cut a scene, then reverse engineer their work and then emulate them. It means experimenting with your footage for hours on end. Then compare your version of the scene to the final cut, and see how close, or far, you were from the mark.

It takes time, tenacity and a true passion for discovering the multi-layered talents that an editor possesses—and it takes commitment. When your paid job is assisting, making the time to edit is challenging. Editing takes energy and a high level of concentration—you need to get lost in the scene and be in the zone. You probably feel overworked and overwhelmed as it is, and there is just so much time in the day. After all, you would like to have a life outside of the work place.

But you must make time.

From six to nine in the morning, before anyone comes in, or from nine to midnight, after everyone has left.

You should be cutting every day.

> *Don't say you don't have enough time. You have exactly the same number of hours per day that were given to Helen Keller, Pasteur, Michelangelo, Mother Teresa, Leonardo da Vinci, Thomas Jefferson, and Albert Einstein.*
> **H. Jackson Brown, Jr.**

Reevaluate your circumstances constantly, and ask yourself:

- Have I cut enough scenes this week?
- Have I emulated my editor a little better?
- Have I received less notes and applied what I learned from the last scene's notes?
- Have I learned any new rules?
- What is the next challenging sort of scene that I should cut?

Always think about what you could be doing to further your career and gain more editing knowledge. Watch many sorts of movies, many times—with and without the sound on. Study them for the editors' technique with sound design, transitions, how they start and end scenes. Examine how the editor accomplished making each scene work so well.

> *Many of life's failures are people who did not realize how close they were to success when they gave up.*
> **Thomas A. Edison**

Have a plan, stay your course and keep the faith.

Cut. Cut. Cut.

> *There are two mistakes one can make along the road to truth*
> *. . . not going all the way, and not starting.*
>
> **Buddha**

The timeline for moving up to editor is hard to define because it is so individual. What follows in this chapter is a breakdown of a suggested path to moving up, while making sure you take care of the job you were hired to do. Remember, your first commitment is to be the best assistant editor, and editing a scene or doing sound work happens only after you have accomplished the tasks the editor and post staff ask of you.

> *I can't imagine a person becoming a success who doesn't*
> *give this game of life everything he's got.*
>
> **Walter Cronkite**

One of my favorite stories about navigating one's career comes from Bonnie Koehler ACE (*Star Wars: The Empire Strikes Back, Grumpy Old Men, In Plain Sight*). As a young Stanford graduate, she came to a realization that filmmaking was her passion, and she set about it with a raw energy that set her career on fire. This is an excerpt from the panel discussion for the ACE Internship Lecture Series:

In college, I was interested in all things visual. I liked writing, painting, sculpture, drawing, photography, dance, architecture and I wasn't sure how I was going to combine all of those things into a career. All of my friends at Stanford were going to go to graduate school or inherit millions of dollars. But I was going to do neither. I knew I needed a plan but I kept putting it off. I just pictured wonderful things for myself, but I didn't know what the action steps would be for those wonderful things. And then one day I saw

a poster on a kiosk of the Summer Film Institute, and the poster was this sexy black and white photograph. This guy had a camera on his shoulder and he was shooting documentaries, and I thought, "Oh yeah! That's so cool! Carrying a camera." And I was watching a lot of documentaries; Fredrick Wiseman was big in those days, black and white documentaries in the '70s. I just thought: "That's it. Filmmaking—that's it!"

So I graduated and jumped right into a summer film program at Stanford where I made some films. It was so amazing to me to put those things together. I just cut it all up and kept recutting and putting music to it. I used a song from Van Morrison, I mean why not? I just loved Van Morrison music, and so I cut the whole thing to Van Morrison music. It was just so much fun. And I put this film together and I thought, "Now I have something I can show Francis Coppola. Because he's probably going to really want to see what I've made here." In 1972 you could go through the yellow pages and find American Zoetrope in the phone book and drive to and go up the stairs and Francis was right there. So I brought him my film and I showed it to him and I actually got a screening with Francis and funny thing—this is a true story—Van Morrison was downstairs—in the automat. He heard the film, and came upstairs like "Ehhh, who's using my song, man?" I showed him the film and he said, "Yeah . . . you can have it, you can have it, it's ok." It was so wonderful! But then it was really a few years before things really started to gel with me because Francis did not, surprisingly, hire me. But I thanked him very much. But this was the place to be. American Zoetrope in San Francisco in 1972 was THE place to be.

The job I did get very quickly was at a commercial house cutting a lot of 16mm commercials and industrials. You'd actually make a film for the phone company training their employees. But I threw myself into those because I would also record the voice with the narrator and I'd cut the sound effects and the music from the music library. So I spent two years doing that, and then that company got an opportunity to do a 35mm film and I was going to edit it. And we needed a place that had 35mm equipment, and American Zoetrope rented editing rooms and they actually rented the cutting room next to Francis's office. So I thought, that's the one I want. So I rented that room, and I cut my little children's feature on that and assisted myself, in that room. Across the hall was Doug Stewart, a fabulous Hollywood editor cutting a movie for Phillip Kaufman, and he had his door open and his Moviola was just bang, bang, bang and I thought, "Oh, THAT is cool." Then down the hall, a really narrow hallway, Richard Chew and Walter Murch were cutting The Conversation *for Francis. And there was a commercial division. So there was all this cool stuff and John Korty was there. All the filmmakers in the Bay area were there at the copy machine. So I was cutting my film and assisting myself and I was doing sort of a sloppy job of assisting myself, I later learned. I met Richard Chew's real assistant from New York and that's when I learned that assistant editing was just not*

semi-editing. It was a whole group of skills that you need to put together to make the workflow happen. At that time film was incredibly physical. I started learning what Julie was doing assisting Richard and Walter and I thought "WOW, that, that's a whole craft unto itself." And I made a nice leap. Richard Chew was hired to cut One Flew Over the Cuckoo's Nest, *a movie that was going to be made but it ended up being delayed a couple of years. And after I met Richard, he hired me to assist him on a couple of other things, including* Star Wars.

I left Star Wars, *replacing myself with somebody else to cut a children's feature. So I gained more experience cutting 35mm on the KEM. But then I came back to the Lucas' for* Empire Strikes Back. *I moved to Los Angeles and I thought I could jump into film editing but there were some union issues even though I had joined with* Cuckoo's Nest— *there was the eight year waiting rule and I hadn't gotten my name on the right list. So I defaulted back to sound and I am glad I did. I did a lot of sound design and a lot of the directors I work with now in television say to me the best editors have always been sound and dialog editors.*

A jump came again when John Korty, a director from the Bay area, called me up and he was doing a Hallmark Hall of Fame film and he wanted me to edit it. He had been a little out of touch with me and didn't realize I'd been doing so much sound and thought I had been editing the whole time. And I thought, "Oh am I rusty? No I'm going take this." So I jumped on the Hallmark job and I cut that, very successfully. And that led to Steve Bochco hiring me for L.A. Law *and got me on to the TV track. Television offers a little more stable life and I got into television and loved it.*

What I love about Bonnie's story is her initiative, clever solutions, rolling with the punches, and the infectious passion she exhibits for her art. Her transitions in career were as navigated as life allows, and she kept her eye on the ball. A successful journey with its share of bumps and curves, but a great ride after long hours and hard work, and some fun along the way.

2.1 COMMUNICATE YOUR DESIRE TO EDIT

Let your editor, co-producer and executive producers know that you are a cutting assistant when you interview. Tell them that you hope to contribute to the editing workflow as often as possible. Let them know that your goal is to be an editor. If they do not know this, you might wait around for a long time and watch other assistants be offered the opportunity for which you had hoped. Of course, you still have to prove that you are a responsible assistant and that nothing will fall through the cracks while you are helping the editor cut. Some editors let their assistants cut an entire act. This is a great platform

from which you can evolve your relationship with the producers and let them see that you are a capable editor as well as an assistant. It is also a great training ground for honing the skills of listening, understanding the spirit of the note and how to make changes for both the editor and the producers.

When people talk, listen completely. Most people never listen.
Ernest Hemingway

When you cut a scene for your editor, he will invariably have notes. Take these in your stride. I cannot tell you how annoying it is to sit with an assistant editor who argues with you about the changes or makes excuses. Even if the note is a bad idea, you must let them view the changes that they ask you to make. If you strongly dislike how these changes are working, create an alt scene, save it in the bin so that you can offer up this new solution constructively.

This is the main reason that I suggest you work for someone whose work you admire. They will give you many notes, and if you disagree with them stylistically, it will make the process arduous.

Oftentimes, you can interpret their request and make a change that satisfies the spirit of the note, without compromising your editorial tastes. After cutting for your editor for a while, you will eventually get no notes. You will apply all the previous notes from various scenes and be able to emulate your editor's sensibilities. Once you can mirror a given editor's style, you can then intuit what the director or producer would like as well, and incorporate that into your editing palette for the next scenes.

If you find yourself in a position where the editor does not offer you scenes to cut, you must find some time to cut on your own. This might be tricky, but is still a great training ground for you. Cut a scene and compare it to what your editor did. Learn how he fixed problems, and incorporate this into your bag of tricks. Eventually, you will have to ask your editor to take a look at what you cut so that you might have some feedback. If this does not produce a positive reaction or a willingness on your editor's part to give you a scene from time to time, then you must reevaluate whether you are in the right place for your future goals. Even if there are wonderful writers, producers or directors on the show with whom you hope to work, you must weigh this against your relationship with your editor. Perhaps it is worth the investment of your time to stay. However, without the support of your editor and post staff, your upward mobility is not secure. Either way, put your resume in order and be prepared to look for a job with better career opportunities.

You know, sometimes all you need is twenty seconds of insane
courage. And I promise you something great will come of it.
Benjamin Mee

2.2 DIG IN

- Do you come to work early to cut?
- Do you stay late to cut?

The workload for an assistant editor is hectic and demanding. It amazes me how one person can juggle multiple shows, keep their editor happy and deal with the erratic social behavior of colleagues, all the while maintaining your equanimity. There is little doubt in my mind that at the end of a ten- or twelve-hour shift, your energy levels are low, your passion for editing wanes and your brain feels a bit fried. The last thing you want to do is dig in to cutting a scene that requires immense amounts of energy and creativity.

You have friends, a partner, family, movies to watch, books to read, bills to pay, chores to do, parties to attend—a life beyond work. Your time is like a pie, to be divided amongst all of these. However, you must add editing to this list, and carve out enough time to do it. Come in early, before anyone arrives, when your energy is high and no one is giving you something to do. Or stay late, on one or two given evenings. Remember, this is your bliss, your career and your future. Bank on you.

2.3 CONTRIBUTE TO THE EDITING WORKLOAD

- How much VFX/SFX/MX editing do you do for your editor?
- Have you cut the reprise, the opening credits, gag reel, scenes or acts?
- Have you asked to be the editor for any webisodes the show produces?

Assuming that your editor is open to you cutting for him, a good place to start is with sound effects (SFX), visual effects (VFX) and music (MX) editing.

Offer to sweeten the sound effects that have already been added to a scene. Make sure you are working in a copy of the current cut so that you do not inadvertently delete anything. When you have tidied up all the offstage cues, fluctuating dialog levels, added the background (BG) walla, sweetened the

various SFX and implemented some sound design of your own, mix it all so that the dialog is easily heard and your SFX is not shouting, "Look at me."

Ask for notes. Do not assume that it is perfect the way you have cut it; this is your opportunity to learn, grow and find the key to pleasing your editor's instincts when it comes to sound design. Then make the changes exactly as suggested. Incorporate these notes into the next scene you cut. This will show your editor that you were listening, and that you get it. If you do not like the changes, cut an alt version and ask for your editor to take a look.

Most assistant editors are responsible for the temp VFX. In both features and television, you need to be able to composite shots, create split screens in various forms, ramp visual speeds, stabilize shots and temporarily remove objects or even people from a shot. Become adept in Adobe After Effects and Photoshop.

It is always best to have the VFX completed before the editor's cut output so that there are no blue or green screens left in the film. Your editor and director will appreciate this. Become familiar with all the buttons in your VFX palette and motion effects menu, before you need to use them. VFX take a long time to create and render, and the last thing you want to suffer through, when there is a deadline, is figuring out how to run the machine.

If your editor has great faith in you, he will give you the opportunity to score or possibly track a scene with a needle drop. If you are good at this, your value goes up tremendously. You need to know when to start a cue, how it builds, where it shifts and when to end it (see Chapter 4.18).

Choosing the piece of score is subjective and time consuming. Though many editors use their favorite scores from films and previous projects, I think it is best to stay within the confines of your present composer's pieces, or from his library. This way, the selected temp cue is within their wheelhouse. In television, if you are in season two, and the producers were happy with the score from season one, then you would by definition be temping with cues that have already been approved. When you temp with an inimitable John Williams cue, your composer might never achieve the same effect. It puts him in a tough spot. Sometimes, it behooves you to temp with a perfect cue composed by a different musician, so that the composer has an idea of how

you want him to stretch. Some composers even like when you go outside their library, but I would recommend first having a discussion with them about this.

When adding a needle drop, the music supervisor is a safe go to, but try to step outside this box from time to time and offer up one or two of your own personal favorites, especially if they are indie and affordable.

> When there are several needle drops that the music supervisor has sent to you to try with a scene, the assistant should create a duplicate copy of the scene and cut all of the musical choices into this alt mx timeline. Make sure there is a good intro and that the lyrics start at a special moment. These lyrics must not fight the dialog. Make sure that the end of the scene has a musical signature, and that the transition into the following scene includes a resonating beat of the song. Again, make sure you mix the song so that it does not interfere with the dialog or SFX levels that the editor has cut in. If there is no dialog, then you can rock out.

When you shine at your VFX work, and sweeten scenes with great sound design, and even add a needle drop or a touch of score, you have lightened your editor's workload and he will come to rely on your help and suggestions. You also become more familiar with his tastes and style of giving notes. It will add to the amount of confidence he has in you and your abilities. It will inspire him to share more of his editing responsibilities and knowledge. It also prepares you for when you take the editing chair. Make an effort to help complete your editor's scenes with SFX, VFX and MX, with his permission. Try to do this at the end of every day.

Another way to contribute to lightening the workload for your editor is to learn how to cut a recap. There is a reprise at the start of most television shows and it will most likely be assigned to the assistant editor to cut. It is usually thirty seconds to a minute long—which sounds simple, but it is not. There is an art to a good reprise, which we will explore in Chapter 5. You will be working with the associate producer who will give you notes before presenting it to the executive producers. Take these notes, learn how to improve your cut and then apply them to your next reprise; it is essential to your upward mobility. Remember that the associate producer and executive producers are the folks who will say yay or nay to you getting a chance to move up to editor. If the process is frustrating, the communication strained and there is little improvement from the first reprise to your last, you will most likely be overlooked when a seat becomes available.

This will be the most important way to impress your producers, so do your homework. Look at all the previous recaps that have aired to get an idea of the style inherent to your show. Watch the previous episodes, make a list of the story points that are essential to include and start pulling material as soon as possible. Start working on the reprise at the start of dailies, so that you have the time to hone it without the pressure of deadlines.

Placing the opening credits is another way for you to prove yourself to your editor. Volunteer to do this and then take his notes carefully, again applying what you have learned from his sensibilities for the next time. The art of placing the opening credits is to carefully assess where the credit will interfere the least with the story and dialog, and not detract from the first and last frames of the edit point.

Most assistants who have been around a while have had to cut the gag reel for the wrap party. It is time consuming, and often gets pushed to the last minute. But you will be the team hero when you are done, and that will last in everyone's mind for at least a short while. Executive producers will appreciate your sense of humor, and how you made everyone on the show, cast and crew, laugh and share a sentimental moment. Watch other gag reels, and ask other assistants how they organized their past attempts. Create a gag bin and start pulling funny bits from dailies each day.

Cutting a scene is of course the most fun. Make sure you choose a scene that speaks to you, so that your passion for the scene comes through. Some scenes you need to practice are:

- Two-man scene
- Love scene
- Fight
- Three-man scene
- Restaurant scene
- Interior car scene
- Telephone conversation
- Four- or five-man scene
- An argument
- Chase
- Montage
- Courtroom scene

- Surgery scene
- Boardroom
- Scene with monitors and graphics

Practice cutting these scenes in the above suggested order. The degree of difficulty increases as you work your way down the list. When you have cut most of these types of scenes and can navigate your way through tough dailies, then you will build up the speed you need to stay up to camera when you move up to editor.

Always have a good reason for the cuts you make because you have to be able to defend each splice. Remember the reason you chose that performance, or that size coverage or whether the dialog was per the script. When you are satisfied with the scene and how it plays, add the BGs, the SFX and decide where a cue might come in, and place it. Make sure you know what the previous scene is and whether there is music that will be scored at the end of it. This might affect what piece of score you have at the start of your scene. Do the same thing for the end of your scene. Please add head leader of a second of black before your scene, and fade the incoming MX up so that the start is not abrupt. Add black to the end as well, and continue the MX into it so that you can fade out. If the editor has already cut the previous or following scene, duplicate that scene and join them to your cut. Make a great transition into and out of your scene. When the scene has all of these bells and whistles, it is ready to show to your editor—for notes. This is the most valuable time with your editor, so make sure you get a sense of how he would have cut it. You should apply all that you have learned about his style from the last scene when you cut your next scene. Eventually, you will hear those wonderful words, "Great—no notes." I had only one assistant, Meridith Sommers, who ever heard those words from me. Meridith works with 1000% effort when cutting a scene. Her work is polished, the kinks worked out and the scene flows. Her dedication to getting the most out of the scene came with determination, paying attention and plain old hard work. She also knows when to ask for help. After working together for three years, and constantly cutting scenes for me, the day finally came on *In Plain Sight* when I had not one note for her. It was perfect. Now I knew I could recommend her as an editor.

Sometimes, my assistants do such a great job on a scene, that we arrive at a hybrid of my version and his, with me stealing the best of his work and incorporating it into the final cut film. I always make a point of letting the

director or producers know where the credit lies. Hopefully, when you are in the editor's seat, you will do the same for your assistant.

> It was a great pleasure to have Carsten Kurpanek assist me on *Make It or Break It* and *Covert Affairs*. He cut a montage of a funny scene with Piper Perabo (*Coyote Ugly, The Prestige, Looper*) interviewing 'walk-ins' to the CIA. It was so beautifully done and well crafted. It had a great needle drop that drove the scene better than mine. Though the montage ended up going through many iterations, I was able to use the music he had temped it with, and it remained in the version that aired.

Perhaps one day, when you have proven you can temp in SFX, MX, place opening credits, cut a flawless recap and put together scenes with little or no notes, your editor might take a chance on you and give you an entire act to cut. This will put you on the executives' radar, and they will see how well you edit and handle the responsibility of the post schedule, all while juggling your assistant duties too.

Once you are known as a cutting assistant, and the executive producers or writers enjoy being in your company, they might ask you to edit the webisodes that are sometimes made concurrently with the production. This is an honor, a tremendous amount of work and a sure sign that the producers have faith in you. Chances are excellent that when an editing seat opens up, you will be on their short list. This methodology worked on *Covert Affairs* for our assistant, A.J. Calomay, and he began a fruitful relationship with Chris Gorham (*Ugly Betty, Popular, Covert Affairs*) who directed the webisodes. In seasons four and five, he was moved up to editor for individual episodes on the show. If we had gone to season six, I firmly believe he would have been moved up to permanent editor in the third slot.

2.4 RECOGNIZE A SAFE ENVIRONMENT

- Is your editor willing to share credit as a co-editor?
- Is the co-producer willing to move you up and pay you while you cut?
- Did they hire an outside editor or move someone else up before you?

If you have cut an act for your editor, you need to discuss sharing editor credit. If he feels you have contributed to the show enough to receive co-editor credit, perhaps he can get the producers to allow it. This would entail the producers giving you an editor's salary while you are cutting. It is a hurdle, but can be

navigated occasionally. When it works, you will have a credit on your resume, which will help when you leave the show or the show ends.

Once you have spent a season or two with a show, proven your worth and continue to be enthusiastic about moving up, ask yourself how you can make this happen. Here are some of the circumstances that need to be in place. First, an editor has to leave a chair open. Sometimes this happens when they get a shot at directing, vacating the seat for one episode. This is the best circumstance, because your editor will most likely recommend you for the job. He will feel safe knowing his assistant is cutting the show the way he likes it. He also knows that he will meet with little resistance to his notes in the editing room. Sometimes the departure of an editor is based on health reasons, an offer to do another film or personality conflicts with the producers. These are awkward reasons, but they still leave an empty seat. You must be completely prepared when opportunity knocks. It is showtime. And trust me, there are only a few times in a career when a window of opportunity opens. You must go for it—and nail it.

> There are times when taking your editor's seat is impolitic, and could cause a rift in your relationship. In 1996, my friend Ray Lovejoy (*The Shining, Aliens, 2001: A Space Odyssey*) asked me to be an additional editor on the film he was cutting, *2 Days in the Valley*. The atmosphere in the cutting rooms was tense, and I could not quite figure out why. All I knew was that I was happy for the opportunity to help Ray finish the film. After a couple of weeks, the co-producer asked me to focus on cutting scenes with the music team—an odd request which I ran by Ray. Ray told me that they were replacing him and he would understand if I said yes. Out of loyalty to Ray I did not stay. Clearly, he felt betrayed by the producers and I was not comfortable getting a break based on his having to leave the film.

The point is that if you prepare constantly by cutting every day, network with as many people as possible and do multiple projects on the side, then you will be ready when an opportunity presents itself. In a panel interview with John Refoua ACE (*CSI: Miami, Dark Angel, Avatar*), these basic tenets of career navigation are exemplified.

When I first moved to LA I didn't know anybody, I got started late. I was twenty-seven years old before I figured out I wanted to be an editor. I took a class at UCLA extension and I went there every weekend while working at my retail job. I learned that the way you get bumped up is completely different for everyone. I saved whatever money I had and I went to the instructor and I said, "Hey, I'll work for free, whatever it is you want,

because I don't know anybody in this business." A month later he said, "Well there's a no-salary job, nine to five." So I did it. Free—for three months. I had depleted nearly all my savings and I figured, "I'm not getting any job offers, so I guess I'll go back to what I was doing." I set a deadline for myself and it was, "This Monday I'm going to call up my old job and say, will you take me back?" Then, that Friday, amazingly enough, my instructor called somebody and said, "Hey, you know John's been working for three months. He seems to know what he is doing, so give him a break." They hired me on a non-union TV show and I started there and I just kept working. It's a business you really have to have a passion for and your passion will wane at times, of course. But you know the fire is there. You need to be patient and have the passion.

I guess the big Avatar *break came from knowing James Cameron. I met him on* Dark Angel. *On* Dark Angel, *I remember the last episode of the second season, which turned out to be the last episode of the whole series, he decided to direct it and shot for sixteen days and we had to deliver fourteen days after that to meet the air date. We were up till late, as he likes to work many hours and doesn't sleep. I don't think he goes to the bathroom! We would be up late at night, and he would say, "I want to do this myself, I want to do that myself," so I would take the initiative and take a scene and cut something out of it. I was one of the editors and we would split it up into two pieces and there were a couple of scenes he said he wanted to mess with, which is his prerogative, he can do whatever he wants, and I was still able to present to him and take initiative and say, "I know you're going to do this yourself, but here's something I did, take a look at it." At three in the morning I could have gone home, but I said, "Here he is, just sitting in there so let me just do something that I can show him." Turned out he liked it, and he brought me onto the next project and then* Avatar. *So you never know where things lead, as long as you keep applying yourself.*

Breaks come in many forms, and working on a successful television series (one that lasts more than a season or two) is a great launching position for upward mobility. If, however, the newly vacated seat on your series goes to an outside editor, or someone on staff who you believe was not next in line, you will have to reevaluate your status on your current job.

If you find yourself overlooked on a continuing basis, chances are, when the next seat opens up, you might get passed over again. Something is wrong. It is best to face this head on—have a discussion with your editor, the associate producer and perhaps the executives. Perhaps there has been some misunderstanding that needs to be cleared up, or personality conflicts or there is dissatisfaction with perform-ance. Listen carefully. There will be soft padding around what they say, and you must interpret the spirit of the notes. The hyperbole is meant to save your feelings.

Take their notes to heart. Identify and improve what you can. Also, it might be time to look around for a new, safer environment. Do not allow inertia or fear of change determine your career trajectory.

2.5 THINK OUTSIDE THE BOX

Do you cut independent projects in your spare time and during hiatus?

Along with cutting scenes for your editor, it is a good idea to take an editing position on an independent film. These are often no-pay, lo-pay or deferred payment jobs, so very little money, if any. What it offers you is a widening circle of contacts who will one day be successful and take you with them. It is also another editing credit on your resume that might convince your current producers of your worth. It is great training to take on the responsibility of being the sole editor. It will help prepare you for cutting scenes that are sometimes less than perfectly directed.

Once in a while, an opportunity will present itself early in your career that affords you the chance to work with a new director who one day might be very successful. There is no way to know which director will catapult your career to the heights you dream of. Risks need to be taken. A perfect example of setting your sights, working for free or deferred-pay and having the talent to back up your progress, is the story of Stephen Mirrione ACE (*Traffic*, *Ocean's Eleven*, *The Revenant*) and how he got his start in the business.

*I knew when I was in college that I wanted to be an editor and I wanted to be a feature editor and it gave me a huge advantage over the other students. Most of the people I went to school with in the small film program in Santa Cruz really didn't know for sure what they wanted to do. All they knew is that they wanted to live in San Francisco and not Los Angeles because LA was awful. That was probably my biggest advantage knowing that I needed to immediately move to Los Angeles. So I moved down to Los Angeles and started hanging out at USC and UCLA to try to make contact with graduate students at both of those schools and to volunteer to work on their films in any capacity in editorial. That is how I met [Director] Doug Liman (*Bourne Identity, Jumper, The Edge of Tomorrow).
He had a flyer up and his film happened to be one of the only student films being shot on 35mm at the time. He had a cutting room at Disney and so I spent that first summer getting to know Doug and working as an assistant on his thesis film until his editor, who had just recently come out from New York, decided that she was done and that she needed to move*

onto something else. Doug wanted to keep working so I took over and we worked nights usually for the rest of the summer. At the same time I was trying to pursue getting assistant editing jobs so I could get my days and get into the union. I was really focused on doing everything and taking a specific path to becoming an editor. I got very lucky because that summer Doug was hired to direct his first feature called Getting In—*a really bad movie with Andrew McCarthy and Kristy Swanson and they were silly enough to hire me. We struggled through that and got to the end and thought, "We've done it, we're film makers." Then we discovered, "Oh wait, no one wants this movie." It took about a year to understand the rollercoaster of trying to get distribution. Every other week you'd hear stories about how it's about to be bought, and then it's not. During that time I tried to focus back on assisting but then another feature fell into my lap and I did that. The same thing happened with that—the film could not find distribution.*

After a few years of that I started to really feel like I'm not going in the path that I want to be going in. I'm editing, I'm getting great experience, it's a lot of fun, but I'm not making the kind of long term serious legitimate contacts that I need to sustain a career. It was right at that juncture that Doug came to me and said, "I wanna do this movie called Swingers *with Jon Favreau. We've got money left over from the first movie; work for $300 a week, and let's do it." At the time I was also being offered a post-super job on MTV's* The Real World, *the San Francisco season. For me, that would suddenly be financial responsibility—to be able to really have enough money to pay rent and all those things that I was barely able to do up to this point. Something inside of me said, "You know I'm young—this is my last real chance at this, and I've got to take the opportunity." So I did* Swingers *instead, and thank goodness I did.*

We finished that movie but it didn't get into Sundance. We all thought, "We did another one that's not going to go anywhere." Right around that time I started getting back out there to try to get assistant editing jobs and Doug told me, "Oh no, people are really interested." We had this screening after Sundance, and distributors came and started showing interest. I told Doug, "I've heard it all before, I've been through this, don't call me and tell me about all of this until you have a signed check, I can't deal with this." Two weeks later he called me and said that Miramax bought the movie. We made it for $250k and they bought it for $5 million dollars. Everybody's life that worked on that movie changed from that point forward.

There were a lot of opportunities that were leading to dead-ends, but I was super focused. It was my only priority and the only thing in my life that was important to me. I knew that it was going to take a 100% of myself to get where I wanted to be and as quickly as I wanted to be there and I didn't give up on that.

Stephen's career navigation, tunnel vision and immense talent led to an incredible, academy award winning, successful career that continues to flourish.

2.6 LEARN HOW TO LEAVE

This is a freelance world, and we work our way out of a job each time a show comes to its conclusion. However, we are sometimes compelled to leave before a show has ended. There are many good reasons to leave a show: an editing opportunity, a gig in a preferred venue or a chance to work with someone you admire. For whatever reason, there are some graceful ways to do it that cause less waves for those who remain.

> I would not recommend making a habit of leaving shows too often—this reputation will follow you. There will come a time when the producers will not hire you for fear that you will leave when the next better offer comes along.

Leave for a career opportunity

One of the best reasons for leaving a job is an offer that will advance your career. It is a no-brainer for you and what your objectives are. However, it can get sticky with some folks, and they might hold it against you. They feel deserted and 'less than' which makes them behave poorly. All you can do is give them enough advance warning. Always be honest about your aspirations (earlier rather than later) and offer to come back and help out on weekends or after hours if they are in a bind. Always be grateful for the help they have given you and let them know that you appreciate them.

Leave to make a venue change

If it is your goal to leave reality for scripted, or television for features or indies for documentaries, and the opportunity presents itself, you should go. Remember to give enough notice. Never leave your employers in a bind. They were kind enough to hire you when you needed those hours for your union roster days, or a paycheck during lean times. It is standard for leaving any job, or terminating a position, to give a two-week notice. Editor's Guild rules demand that your producer give you at least one-week notice in writing. Essentially, it is best to give as much notice as possible to alleviate their stress in finding a replacement for you. This is a good opportunity to help assuage your producers' discomfort by offering to replace yourself and/or train the new person. Even if that means coming in early or staying late on your own time. They will remember how much you tried to make their jobs easier, and will be willing to work with you again.

Leave for a worthy mentor

If you feel you are not advancing in a timely fashion, perhaps it is time to find someone to work with for whom you have a deeper admiration. Someone who will be a mentor, help you learn more about editing and support your cutting aspirations. If you find this person (an editor, director, co-producer), it is worth the difficulties of leaving that will surely arise. No boss likes to be left. This will be a harder discussion to have than if you were leaving for the above-described reasons. But you must have the fortitude to evaluate your current situation, your lifelong goals, and take action. This is a weighty decision, so before you jump ship, be as sure as possible that you make an informed decision about with whom you cast your lot.

2.7 SUMMARY

Networking is the mainstay of finding work in Hollywood. In general, you have to schmooze; meet with your colleagues, your favorite editors and assistants; write letters to the people with whom you would like to work in care of the MPEG or the ACE office; find the social gatherings of post personnel; ask to be Facebook friends and/or LinkedIn associates; find the blogs where other assistants discuss tech questions and post jobs offerings; and contact co-producers, associate producers and heads of post production at the studios. Word of mouth is often the best way to get in the door for the interview.

If you have to make a change and find a new editor or post production team, be wise in your choices. Ask the right questions at the interview before making a year or two-year commitment to a show or crew who will not support your hopes to move up to editor.

If you have made all the right choices about venue, and honed your assisting skills to perfection, now is the time to log sufficient time cutting. If you do not cut every day and build up your speed, you will not be prepared enough when opportunity knocks. Remember that when you finally do have an offer to cut a show, there is a time schedule that must be met and this can be challenging to even the most seasoned editors. You must practice editing in advance of your window of opportunity, so that when your moment of truth arrives you will be well prepared.

So . . . Cut. Cut. Cut.

Discover the Rules

Theory

If you hear a voice within you say, "You cannot paint," then
by all means paint, and that voice will be silenced.
 Vincent Van Gogh

Now that you have your career path going, there are editing guidelines that
will help you learn your craft. Too often, we are told that there are no rules,
but through years of experience, we have found that there are patterns that
can be codified as a starting point.

Many editors say they cut from instinct and are guided by natural cadences,
emotional catharses and the dailies that are before them. This may be true
for some. But I believe that these instincts come from unwritten rules that
have not been voiced yet, and that these rules can be quantified and defined.
If you know the rules, your ability to start editing a scene and find one of
the best paths within that scene will be easier. After you finish cutting a scene,
you might play it back and for some reason the scene does not work. You
can recognize a few bumpy places—perhaps make some trims, or add
moments for a beat or two; maybe extra cutaways for reactions are needed
or the pacing needs to be picked up as the scene progresses; but there is still
something not quite right. This is when you return to the 'basics' and follow
the myriad of rules we suggest in the next chapters.

At the time I started work as an assistant editor, I had no idea that I would
fall in love with the craft of editing. I just wanted to learn how to be a good
assistant. But I was lucky. I assisted editors who encouraged me to cut, and
I began to pay closer attention to the films I loved and the editors who cut

them. I started to figure out how these individuals were able to create such artful stories through the juxtaposition of visuals and sound.

I got into the Editor's Guild in 1974, and by 1977, I was assisting Lou Lombardo ACE (*The Wild Bunch, McCabe & Mrs. Miller, Moonstruck*) on *Up in Smoke*. I was thrilled to have the opportunity to work with him—he was an inspirational editor, uniquely creative and a very cool guy. He was one of my five favorite editors. Louie let me cut as much as I had time for, and one day he heard me struggling with the timing of an off-screen voice (Tommy Chong) trying to get the attention of Cheech (Richard Marin). Louie said, "Darlin', just start Tommy's line 8 frames before Cheech starts to turn his head." I expressed doubt. Sure enough, when I placed the offstage dialog 8 frames before the first frame of Cheech turning to look, it worked perfectly! Of course I spent an hour or two trying it at 6 frames, 7, 9, 10 and 11. Remember, film and track was still 35mm in the '70s, and had to be spliced. Sure enough the 8-frame rule worked the best. By the end of the day, I expressed gratitude to him for this great rule. Louie just smiled and shook his head.

Later, when I had been editing for a while, I began to play with the 8-frame rule. When I shortened the reaction time to maybe 7 frames or even 6, it changed the message about the emotional state of the actor. For example, in a scene from *Covert Affairs*, 'Annie,' played by Piper Perabo, searches for a murderer in an abandoned warehouse. She hears an offstage noise, and turns, startled, to see where it came from. Shaving her reaction time by a few frames sharpened the edge and informed the audience of her heightened fear and adrenaline. Conversely, if you lengthen a reaction time to longer than 8 frames, the message might be that the character is aloof, or attitudinal, possibly slow-witted. It is amazing how one twenty-fourth of a second can make the character appear smarter or tenser, changing the entire feeling of that moment.

This special moment with Lou was an epiphany for me. How many more rules were there? Could it be that there is a roadmap of sorts? And why hadn't anyone ever mentioned these rules before? Up until that day, I had learned how to cut by observation. I learned so much by watching over the shoulders of Dann Cahn ACE (*Make Room for Daddy, I Love Lucy, The Real McCoys*) as he cut *Police Woman*, and observed Graeme Clifford (*Don't Look Now, The Rocky Horror Picture Show, The Man Who Fell to Earth*) as he edited *The Postman Always Rings Twice*. I watched countless films, reverse engineered the various cutting patterns, gleaned technique from what worked best in their cut scenes. But no one had ever given me such a concrete, verbal guideline. I wanted more.

Over the next forty years, there were some notable rules that a few editors shared. Jonathan Pontell (editor/producer) shared his one-eye rule and John Heath (editor/director) shared a 2-frame rule. I have stolen some great rules and theories, and made some up as I went along. These rules are suggested starting points. Just the basics that help keep a scene clear and smooth. They will help you work out the problem scenes that come your way. Once you know these rules, feel free to throw them out the window and create your own.

On and off for a dozen years, I had the great honor to cut for the brilliant Emmy award winning director Mick Jackson (*The L.A. Story, The Bodyguard, The Memory Keeper's Daughter*). His ideas, concise timing and visceral sensibilities have become a voice in my head, guiding me. Applying what he taught me, to every new film, and with many other directors has become a virtual support system in my career.

A teacher affects eternity; he can never tell where his influence stops.

Henry Adams

These guidelines eventually generated a list of dozens of rules that have saved me countless hours in the cutting room. They help sculpt a story out of even the most challenging film. Like architecture, they serve as a keystone—to each movie, each scene, each moment.

The first step towards editing a film is to understand intimately what your script is about. Do some homework. Just like in assisting, there is work to be done before the first day of dailies.

Break down the shooting script—read it two or three times, take notes and become so familiar with the story that when your director, writer or producer talks to you about the script, you know exactly what they are referring to. As an assistant, you broke down the script for sound effects, stock shots and needle drops. As the editor, you have a different break down process that will help you edit your incoming dailies with greater ease.

The breakdown will give you a deeper and intimate understanding of the characters. It will make clear what the writer intended as far as the story's themes, and bits of symbolism and metaphor. It also helps to identify the 'A,' 'B' and 'C' story within your movie. There are very few editors who do this; however, I have found that it helps to have as much information

as possible about the movie you are about to help craft. It saves you count-less hours of recutting scenes to change the tone. It helps when you need to remove ten minutes from your show, because you will most likely lift the 'C' or 'D' story.

I like to cut the film in my head during my first sit down with the script. This way, I feel as if I have seen it already, and whatever the director and the cast bring to the table is icing. There are talented editors in features and television who prepare very differently than I do. Thelma Schoonmaker ACE once said that she would read the script one time and then put it aside, allowing her to react to the footage as it came in. Of course, she was receiving dailies from Martin Scorcese. We know his dailies are gorgeous and add an unparalleled creative dimension to the script; plus which there are weeks and months of editing in the feature schedule to create the best version before handing it over to the studio. However, in television, the schedule is like a runaway train and there is little time to shape and mold, tear apart and rework; the tone of each scene must be close to the expected mark from the start. It helps to fully know in advance every plot twist, character arc and parallel theme to be able to successfully edit hours of film in one day.

Here are some basic guidelines on how to break down the script.

3.1 SCRIPT BREAKDOWNS

I read the script and let the story wash over me. I then break down the script for character, themes, metaphor, lifts, and heights and valleys. All these individual parts that make up the whole story will affect the way I cut a scene. I try to imagine everyone's faces, expressions, how they feel about what is being said, or, equally important, what is not said. I see their proximity to each other, their moods and hidden agendas. I like to feel as if I were in the room with my characters, and I am their protective, best friend. I see the movie unfold visually, and hear the sounds of their environment. This process of envisioning the film will make it easier when you receive the dailies. Essentially, you have already watched it. You will know who you want to cut to for certain lines, the beats that will be important to infuse and the gist of the scene. Of course when the film is shot you might be wonderfully surprised by how the director has elevated the dailies with eye candy, brilliant coverage, marvelous performances and a style that embellishes the story even more than your envisioned scene. You might also be sorely disappointed, and this is where your preparation and editing skills can service the show.

After my first read-through, I do a character breakdown, story breakdown, thematic breakdown and list of possible lifts in the shooting script.

The character breakdown lets you follow one character throughout the movie. It is a list of all the acts and scene numbers that this character appears in. It has a brief scene description. I also make a side note about their emotional state of mind during the scene, and even attribute a numeric value based on the emotional level of the character at that point in the script. This number indicates the degree of their passion, anger or humor from one to ten. When you know the emotional level at which you last saw your character, it will help you identify the performances that best match the scene you are about to cut.

In our fictitious film, *Mandy and David*, Mandy Black is a journalist who is dealing with an emotionally devoid husband. One day at work she receives an anonymous note threatening her life. She reports her situation to the police who assign Detective David White to the case. David is currently working on a serial murder case. He also has a challenging home life with a terminally ill wife. Mandy survives an attack one night and the perpetrator leaves enough evidence for Mandy to ID him. This leads to David solving the serial case as they are one and the same person.

As you can see in the character breakdown (Figure 3.1), Mandy's emotional state fluctuates. When we receive the dailies for a scene shot out of scene number order, I will use my breakdown as a reference and a guide for the tempering of that performance.

Another character we will breakdown is David White, the detective (Figure 3.2).

When you finish the character breakdown for all of the main players, you will be able to see whether they are the 'A,' 'B,' 'C' or even 'D' story by the amount of screen time, the amount of scenes they are in. If you are on a feature where there are no act breakdowns, you will be able to tell just by the amount of screen time. Count the pages of dialog for each character and you will know whether they are the 'A' story or the 'D' story.

After the character breakdowns are done, you will have enough information to start a story breakdown (Figure 3.3). In the story breakdown you look at the arc of individual characters in the movie.

CHARACTER BREAKDOWN

CHARACTER NAME: *Mandy Black (Journalist)*

SCENE#	SCENE DESCRIPTION	Emotional Value #
ACT 01		
03	Mandy makes cupcakes	1
08	Mandy arrives at work—finds anonymous note	3
13	Mandy receives warning phone call	4
ACT 02		
16	Mandy meets Detective White at diner	2
19	Mandy tells co-worker about her predicament	3
21	Mandy and husband go out—she does not tell him	4
ACT 03		
24	Mandy walks dog and is mugged	8
30	Mandy at police station	7
38	Mandy tells husband	6
ACT 04		
41	Mandy back to work	5
42	Mandy in conference room with the Boss	3
ACT 05		
43	Mandy goes over mug shots	3
48	Mandy identifies attacker	7

FIGURE 3.1

CHARACTER BREAKDOWN

CHARACTER NAME: *David White (Detective)*

SCENE#	SCENE DESCRIPTION	Emotional Value #
ACT 01		
04	David leaves home says goodbye to Claire, ill wife	4
05	David arrives at work—work is piling up	2
10	David called into field for a murder	4
ACT 02		
12	David consults doctor about his wife	5
14	David tells Claire that she needs to seek counseling	4
20	David leaves work … doesn't go home	3
ACT 03		
22	David arrives home. Claire pretends to sleep	4
30	David meets Mandy at police station	3
36	David out in field … another murder	6
ACT 04		
40	David back to work—compares files of 2 murders	7
ACT 05		
43	David and Mandy go over mug shots	4
48	David watches Mandy identify attacker	6

FIGURE 3.2

STORY BREAKDOWN

CHARACTER NAME: *Mandy*

Mandy gets anonymous note.

Mandy is mugged.

Life at home is non-communicative and disrupted.

Mandy meets Detective David White. Identifies the attacker.

Detective White knows the attacker.

FIGURE 3.3

Now we are able to do a story breakdown for David (Figure 3.4).

STORY BREAKDOWN

CHARACTER NAME: *David*

David is concerned for Claire, his ill wife.

David is working on two possible serial murders.

David consults physician about his wife.

Life at home is non-communicative and disrupted.

David meets Mandy who identifies the attacker.

Detective White knows the attacker—similar to murderer's *modus operandi*.

FIGURE 3.4

Once you have identified the pared down storylines of all the other characters in your story breakdown, it becomes evident what parallel threads the writer has created in the film. This is helpful because it sums up the characters' story arcs in a nutshell and makes it easier to compare and contrast.

The thematic breakdown follows (Figure 3.5), with the insights from the story breakdowns. The juxtaposition of the parallel tales produces an understanding of the symbolism and metaphor that the writer has interwoven.

THEMATIC BREAKDOWN

Both Mandy and David are having issues in their home life.

Both Mandy and David know the assailant.

FIGURE 3.5

In a full breakdown, there would be half a dozen or more characters to assess. Finding commonalities in your characters and story can be obvious at times but rather obscure in some cases. If you are able to find the interwoven threads, you will tell an even more complete story with your visuals and sound design.

> Before the first day of principal photography, a tone meeting is set up. This is where the writer/producer goes through the script with the director scene by scene, and the editor is invited to listen (more than contribute). The writers will answer questions from the director about the tone of each scene, various pitfalls to avoid and the level of emotion that they hope to see. The director might address location or character problems that he would like to infuse or lift. The notes from this meeting can also be denoted on your breakdown of the script along with your previously assigned numeric value. With these notes as guidelines, the editor can hopefully tell what the director will likely deliver, and what the writers are attempting to get on screen. If a scene arrives with an entirely different tone than the writers had hoped for, then the editor will be able to tone the scene accordingly and keep everyone's preferences carefully in balance during that first editor's pass.

The larger implication of these intertwined themes is that it informs the editor about what music to choose, or perhaps when to use dissolves. When the editor wants to help 'marry' two characters who have a common story thread, using the same thematic temp score helps blend their journeys. I am more inclined to let a music cue continue longer from one scene into the next to help mirror two characters. When choosing stock footage to bridge

two scenes that are about life passages (birth, death, new beginnings) I might choose stock that is symbolic of these rites—waterways, bridges, canals. A dissolve between the images of these parallel characters conjoins them even further. When breaking down the script, I make a list of stock shots that will possibly be needed at the head of a scene, as well as score or needle drops that I might use. When cutting a pilot or movie, I always consult the director about his take on the musical soundscape that they would like to use.

When I read the script, I like to make notes on the page about which dialog I would pre-lap from the next scene and which bits of the scene I would like to condense. If you know in advance that you will pre-lap the first line of dialog from Scene 13 over the end of Scene 12, or over a stock shot you will add, it will affect your opening shot for Scene 13. This will preempt recutting the opening of the scene when the movie is assembled. If you know that your script is long, and that you will be over the format footage, it is helpful to notate the lines of dialog that can be lifted or shortened without hurting the story.

The final list I make, the Lift Breakdown, is a list of scenes (or partial scenes) I feel can be omitted from shooting, and/or lifted after they have been shot. Once in a while this list will be of value to your director and producers during shooting. After principal photography has been completed, this list of lifts might help when it comes time to suggest how to take out time when your film runs too long. I keep this list of lifts to myself unless asked. It is fun to see how right or wrong you are after the picture is locked.

When you have completed your homework on the script, you will be much more prepared for your tone meeting, your first discussions with the director about the film, as well as your first day of dailies. When the dailies stray from the original concepts of the script because of direction, performance or happenstance, your acute awareness of the story that was meant to be told will add to the ease with which you make it through. This preparation can be the groundwork for your approach to the film. There is much more creative leeway with script interpretation on a feature.

From this paperwork skeleton, the foundation of every scene, sequence and movie will be built. As in architecture, there are rules for a sturdy construction. To achieve a balanced visual tension, you must understand when to use the master, how to layer the visuals and how to infuse a full soundscape.

As the editor, it is your job to sculpt each moment of every scene to its greatest potential, engage your audience and move the story along.

3.2 ARCHITECTURE—THE MASTER AS THE SUPPORT BEAM

When you sit down to cut your first scene, view the master to see how the director blocked the scene. The master will normally cover the scene from top to bottom. It lets us see what every performer is feeling about what is happening, and where everyone is in relation to the other characters. Without the wide coverage, we lose sight of the characters' geographic relationships. This is essential for the scene to play. If the director's coverage or the actors' performances leave a hole in the scene, the editor will then have the master to fall back on. Most importantly, the master is the essential support beam in your construct that should be accessed judiciously throughout a scene. Even if all the tighter coverage is brilliant, and every moment has been captured on film, the overall effect of not using the master in the scene is that your audience will feel claustrophobic.

In television, since the screen is smaller than in a theater, the master is oftentimes too wide to see the range of emotions on an actor's face, and the producers or studio shy away from it for fear of disengaging the audience. It has come to be regarded as the conservative way to tell the story. However, in features, the use of the master, and allowing the scene to play wide, is much more accepted.

The three best times to use the master are:

- For geography—when a character enters/exits or changes position from one side of the room to the other.
- For emotional content—when the story calls for underlining the emotional state of despair or solitude.
- For safety—when you need to reorient the audience and remind them of who is in the room and where they are in relation to the other characters. It is important to avoid using the part of a master that has no movement in it—something or someone should always be moving or wiping the frame.

There are of course other uses of the master. In musicals, the master is essential to show the footwork of the dancers. In sports sequences, the

geographical location of the ball and its proximity to scoring is essential, and in action sequences, the master lets the audience know where the pursuer and the pursued are in relation to each other during the chase.

The master is a way of letting the audience feel safe in a scene—once they know who, what, when and where they are, it makes the viewer comfortable and they will be ready to receive more input from the story. The audience will be able to pay closer attention to the dialog once they are oriented. If your audience is confused about geography in the scene, they will disengage. It will take them out of the movie, and ultimately make them miss dialog, getting them further away from the story you are trying to tell.

Now that you have viewed your master, you have a firm grasp on how the scene will play—who enters, who leaves, who sits, when intimate dialog starts. The one question that I am asked often by young editors is, "Where should I start, how do you know what to cut to first?" There is no singular correct answer to that, but what we hope to do is give you some guidelines on how to make that first cut easier.

> I like to orient the audience quickly, and will cut to the master or wider shot within three or four cuts of the start of a scene. Take a look at some of your favorite films, and count how many cuts the editor used in each scene before cutting to the master. It is amazing how many scenes could have been so much better if the director had provided a good master or if the editor had used it to help orient the audience periodically during a long scene.

3.3 EYE CANDY

The second item to look for in dailies is eye candy. Though hard to define, eye candy is usually aesthetically pleasing visuals that are attention compelling. Wipes—an actor crossing in front of the lens, a car-by—long lens coverage, time-lapse, a woman's robe falling to the ground, slo-mo, a hand touching another hand, explosions, crashes, eyes opening to look at you, and so many other icons can be defined as eye candy. They are as mesmerizing as a crackling fire, or crashing ocean waves. When you identify the eye candy, you will know which images to insert in the proper story place. They become one more piece placed in your chessboard of a scene.

When I find the eye candy in a scene when scrubbing through dailies, I know the director will want those shots in the scene, as do I. Remember, the director and the director of photography (DP) worked very hard, spent a lot of time and money to capture these magical shots. I will even cut around performances to make a bit of eye candy remain in a scene.

3.4 THE DIRECTOR'S BREADCRUMBS

The third component you look for in dailies are the breadcrumbs that the director has left for you. There might be a shot that the director designed to open and to close a scene. It is perhaps a master that enters the character into a room that turns into his over-the-shoulder coverage; or maybe it is the close up tea kettle coming to a boil on the stove; it is the crane shot that starts over an exterior ocean and travels inside the window to the house on the beach; it is the dolly shot that starts in black behind your character and widens to reveal her walking down a hospital corridor. The closing shots are harder to design and to find. A slamming door, two people shaking hands, a high angle shot of a figure alone in a silent room, a close up of a face turning towards an offstage sound; these are all interesting ending shots and good devices to help move the story forward and project us into the next scene.

Sometimes there is no shot designed, and you are on your own with the story and the homework you have done with the script. Perhaps you can pre-lap the incoming dialog or the sound effects of the following scene, or add an establishing shot. Perhaps it is a piece of score that binds the ending of a scene to the incoming shot. When you break down the script, you can make notes as to whether you will be in close up or wide at the beginning and endings, and know that if you are ending the previous scene on a wide desolate frame, that you will want to use a dynamic change in size and angle for the next scene.

As you watch dailies, note the performance evolutions from the first printed take to the last printed take. Know that the director worked very hard for the change in nuance that was accomplished in the final take. For my first pass, I usually start with the last printed take. You can always go back and cull the previous printed takes for a performance that might be better for a certain line or action. But for the sake of speed, and to create the architecture of your scene, you can begin cutting with these final printed takes or the preferred takes that are notated by the script supervisor on the facing page of your lined script. Make sure, before you put this scene to bed, that you

have viewed all the dailies and that you have not missed a vital moment that was captured way back in take one or two.

Sometimes the blocking of the scene changes by the final printed take, and if the director has elected to print the previous masters that reflect his original blocking, it might only be to match some of the tighter coverage. You will have to make a choice as to which blocking solves most of your performance hurdles, and go with it.

One easy breadcrumb that the director leaves for you is shots that take hours to film. Crane shots, dolly shots, any coverage where they laid tracks down, rack focus, camera moves—all of these took extra time to film. They should not be ignored. If the director shoots a zillion takes of an insert or close coverage, he is obviously trying to get a specific thing. Identify what that is and use it. If there is a pick-up shot in dailies, then note where in the scene the director started this pick up, and surmise that he probably wants to use the pick-up performance for that line.

If the director has covered the scene with over shoulders as well as side angles, it is your job to find the most organic usage of this coverage. Even if you feel the side angles are less emotional, or the close ups are not well framed, or the 50–50 performance is too broad, or the wide is devoid of feeling, you must still use all of the coverage from the various setups. Find a way to make them work best—identify the throwaway lines, and be in the less emotional coverage for that. When you have a relationship with the director after more than one film together, you will be able to dispense with using the coverage you do not care for, but until then, the director will generally want to see everything he has shot.

In 2003, I edited an episode of *The Guardian* called *Hazel Park* that was directed by Emilio Estevez. His dailies were beautiful, strong and had raw energy. I made sure to use every shot he sent me, only to find out during editor's cut that he did not want the 'B' camera to be used at all during a particular scene. Though rare, some directors do not want to use the 'B' coverage of each setup—that might be something the producers or DPs have foisted upon them. It helps to communicate with the director about their usage of extra cameras in advance of the shoot.

Listen carefully to the sound track in between takes. The director's private input to the actor can sometimes be heard in the recording, so pay special

attention to what he says after "Cut." A director will often start talking to the actor about nuance or shifts in attitude that will help guide you in the cutting room and make you aware of how to sculpt the performance.

If there is stray or random coverage of extras or specific background activity, try to figure out where the director wants to use it, and/or call the set, and ask for input; it might only be for transitional use or as cutaways in a specifically designed fashion. But if it is shot, there was a reason, and not understanding what the coverage is for is no excuse for not using it or seeking guidance.

Once you have looked at dailies, have found the eye candy and decided where the master could be best used, as well as discovered the director's breadcrumbs, there are some theoretical rules that we want you to be aware of before you begin editing your film. Know where the eyes of your audience are at all times, marry the sound with your picture organically, understand what each character is going through during each scene, clean up the production and cast errors, and have a reason for every single splice. All of this is a vital part of your job.

3.5 CUSTODY OF THE EYES

Editors take the audience on a journey—an emotional roller coaster told in part by its visual landscape as well as auditory soundscape. You essentially have custody of the audience's eyes and ears and mind. The writers, the directors and cast and crew have provided this story and its visuals for you. But what you do with these images and story, these building blocks of clay, is entirely up to you. You must know where your audience's eyes are looking at all times, or as close to guessing that fact as is possible.

The British call a splice a join. It is what we do; we join one image to the next as invisibly and smoothly as we can. To do this, we need to take into account where we left the audience's eye in the last image, and how to match that placement in the next image. For example, if the first image on the screen is a car passing by going left to right, we will most likely cut on the frame where the car leaves the screen. The next image should be of something that demands the audience's eye to be on the right side of the screen where we left it. If we edit with that in mind for each and every splice throughout the film, we will have provided a smooth journey for the audience's eyes.

Take a look at some high-end commercials—most car advertisements are wonderful examples; turn the sound off so that you are not distracted by it. You will see that one image gracefully transitions to the next with the least amount of movement of your eyes. Even though they rely on the use of many dissolves in commercials, the director and editor have designed the shots so that things virtually morph in front of your eyes and the images edit gracefully together. Always ask yourself, "Where have I left my audience's eyes?" before making the next join. When choosing a stock shot or montage material, it is absolutely up to you, the editor, to marry these images well—with what has come before and what will follow, and allow the audience's eyes to have a smooth experience.

If you take care to make this eye journey pleasant, the cumulative effect will be that the audience will not be tired of viewing, or be disturbed by an indefinable irritation. However, if you are attempting to put the audience on the edge of their seats, and create agitation, then the opposite strategy works, and you can allow the eyes to be taxed with erratic movement.

3.6 TEN O'CLOCK RULE

In photography, one of the simplest rules of composition is the Rule of Thirds, which has its origins in a classical Greek concept of the Golden Ratio. If you divide your frame into thirds vertically and horizontally, you have nine boxes, like a hashtag or tic-tac-toe board. Where these lines intersect is a good placement for points of interest. For example, in a tight close up of a person's face, the eyes are traditionally framed where the top horizontal line trisects the vertical lines on the left and right. If you were to draw a round-faced clock and superimpose it over this graphic, then you would see that where the top horizontal line meets the left vertical line is at ten o'clock. When you join two pieces of film together, I believe the default position that your eye tends to go to when watching a movie is this ten o'clock position. I believe this is due to the audience's interest in the characters in the film; we seek the actors' eyes first, and slowly allow our eyes to travel the rest of the frame clockwise.

One might ask about our friends in the world who read right to left instead of left to right, and if this rule applies to them. I watched some of my Israeli friends' eyes, as they were viewing my test scene, and to my surprise, they followed this ten o'clock rule as well.

Of course, if you are cutting images that project the audience's eyes to different parts of the frame, e.g. a train running right to left, a rocket up into the sky, then the eye will follow the item of interest, making the ten o'clock rule secondary.

Once you have decided where the eyes are looking within a frame, you have to estimate the amount of time it takes the eye to fully capture the information of these frames, and time the duration of your shot accordingly. Be aware that the timing is affected by the size of the screen, and that a few frames more are needed for the eye to travel on a large theater screen as opposed to a smaller home television monitor.

I learned this lesson the hard way. My first project for writer/producer David E. Kelley (*Chicago Hope, Ally McBeal, Boston Legal*) was cutting the pilot of *Picket Fences*. Jonathan Pontell (*L.A. Law, Ally McBeal, The Practice*) was the co-editor and associate producer on the project, and he introduced me to David who asked me to sit second chair. I was thrilled to get back to work after a six-year hiatus when I stayed home to raise my two young daughters. I had never cut an episodic television show before, only movies made for television, mini-series and features. There was a learning curve for translating the timing and cadences of two very different venues. Essentially, I had to pace up the dialog, minimize the long heart-felt looks that characters shared and lessen the use of the master. When we locked the show, I still felt there were one or two scenes with cuts that were too abbreviated, even for television. When the network decided to screen the final air master at the Television Academy, it never occurred to me that the translation of a small television monitor to a large screen would have such an impact on the cuts, especially the ones that I felt were already too short. After the screening I was a bit mortified, and promised myself that I would always know in advance the size of the venue in which my film would be screened before locking a picture.

3.7 LAYERING

There is a competition in our brain between auditory and visual perception, and the editor must make the choice as to what the audience will see and/or hear first, second, third and so on. For example, we might start silently in black. A beat later, we might introduce the sound of a distant train and as we hear it getting closer, we might cut to picture—the train races by, under which we hear the clackety-clack of the railroad ties, wind buffeting us and then we introduce the high pitched wail of the train horn. Underneath this screech we begin to hear a human shriek, which segues us to the next scene

of a newborn child wailing in his mother's arms. Each picture and each sound has been added in layered timing. We have asked our audience to look at this, now listen to that and now hear this new sound underneath it, so that we might cut to a new visual. We have created a symphony of sounds, each one placed strategically to lead the audience forward through the story. There might be only a fraction of a second separating these layers, but the timing you choose must consider that it takes the brain a moment to digest every new bit of information. We invite the audience to come hither with each added sound and picture frame. This layering will add to the grace of your film, and move the story along elegantly.

> Once in a while, we do not layer sound. As my director, Mick Jackson, would say, for impactful cuts, "throw the kitchen sink" at the screen. In our film, *The Memory Keeper's Daughter*, Dr. David Henry played by Dermot Mulroney (*My Best Friend's Wedding, The Grey, About Schmidt*) is informed by telephone that his son has been arrested. When he hangs up, we smash cut to the prison guard and Dermot quickly walking down a jail corridor. We hear jail sounds, the phones ringing, the clatter of doors sliding shut, boot heels, police station chatter and anything else we could think of on the cut. The impact was energizing and forceful and accomplished the emotional change Mick was looking for.

Sound also gives a new value to silence. The lack of sound can add to the pulse of your symphony and the rhythm of your storytelling.

Remember that pre-lapping dialog is also a form of layering, and serves the dual purpose of pulling the audience forward to the next scene. After you cut to the sync picture, you can start the background sounds, as opposed to during the pre-lap.

3.8 JUGGLE THE CHARACTERS IN THE ROOM

In a simple two-man scene, our attention and cuts are on one person or the other, but when you add more characters into the mix, the editor is faced with choosing when to cut away from the on-camera dialog and incorporate into the scene the other characters in the room. The audience needs to know what everyone onstage is feeling and thinking. Like a juggler, it is the editor's responsibility to make sure that all the balls are in the air throughout the scene. The hardest part in deciding when to use these cutaways is figuring out which dialog can be heard even though the cut is on someone else in the room. Once we know what dialog can be sacrificed to a reaction shot, we

have an opportunity to define with one cut or two, what other folks in the room are feeling. These feelings are their unwritten dialog in the story, and offer a key element to the scene.

3.9 CYCLES OF MOTION, DIRTY FRAMES AND EMPTY FRAMES

When choosing where to cut on physical action, it is smoothest to allow the cycle of motion to be completed. An arm extends to point camera left, a punch is thrown, a pair of eyes is averted, etc. For the sake of pace, you can start a cut with the motion already begun, but if you cut away before the motion is near completion, it will feel abortive. Following this axiom, the editor still needs to cut away before a person starts to blink, or a head starts to turn, or any motion begins. If you allow a frame or two of this new cycle of motion to remain at the end of your cut, then you have what I refer to as a dirty frame. This extra frame or two causes the audience's eye to be attracted to an interrupted moment. Of equal dismay is allowing a character or object to exit the frame and then staying on this now empty frame. This allows the audience to become bored or start thinking about something other than the story you are telling.

> Remember, you not only want custody of your audience's eyes, but of their thoughts and feelings. If we do stay on an empty frame, devoid of people, it is important to keep the story going with dialog, sound or MX. There will be occasions, though rare, where the empty frame, and the silence, is actually helping to tell the story. There are dramatic reasons for staying on an empty frame. Just like cutting to a wide master at the end of a scene, it can emphasize the isolation/weariness/impotence/futility of a situation or a character. Do not overuse this technique, for it will lose its effect.

3.10 ACTOR GROOMING

Many performers have bad habits. They lick or smack their lips, play with their hair, blink incessantly, close their eyes before and during the beginning of their lines, breathe loudly in between lines and a myriad of other tics that need to be cleaned up by the editor. The cumulative effect of these repeated nuances will leave the audience annoyed or distracted. It will help the actor's performance to remove them. They will appear focused on their character and unaware of themselves as actors. Try to clean up all performances, so that what nuance remains speaks only to the story.

3.11 HEADLESS HANDS

When you cut to hands, you need to know to whom they are attached. For example, when an actor is in a procedural scene, setting the bomb, examining forensic material or combing through drawers, you have to let the audience know, before or after this close coverage, who is involved in this moment. We care so much more when we know who the player is. As we discussed earlier, the master helps keep your audience oriented and safe in a scene. Headless hands will work against this feeling.

When cutting a procedural scene, e.g. crime scene laboratory footage or a jump cut montage of an actor searching an apartment, it is important to keep this in mind. You must always refer back to the character's face during any procedural as an anchor for the audience. It helps to humanize the scene as well, which contributes to the audience's investment in the scene.

3.12 OWN EVERY CUT

When you have completed your cut of the film and hand it over to the director, be confident that every single decision you have made about the exact frames you have chosen to splice has a reason. You must be able to answer the inevitable questions, "Why this close up?; Why open in that shot?; Why is this line off camera?" You must have a viable answer to defend your thought process. It might be hard to recall all the intricate problems you encountered while editing the sequence; you will surely remember that you were handcuffed in your choices due to a combination of missed coverage, performance issues, camera bumps or wrong dialog. You must be able to articulate the problems, but without complaining, and also be willing to change your cuts graciously according to the spirit of the director's notes.

It gets trickier later when you sit with the producers in the editing room and they ask similar questions, and now you have cuts in there that were not your original cutting pattern. Without pointing a finger, let them know that you have an alternative (alt) version of the moment in question and will be happy to infuse it. Always protect your director's back.

In the end though, it is your name on the screen as the film editor, and if there are moments, cuts, transitions or performance choices that you feel strongly about and want to change, you must speak up. Once. And then let it go. Sometimes, the more you dig your heels in, the more the final decision is made in opposition rather than creative acumen.

I like to make a joke of the changes that I disagree with—to keep it light hearted. If I feel really strongly about changes that hurt the story and therefore the movie, I will joke and say, "Well, there goes my Emmy," or "Please don't make me leave it this way, it is a misdemeanor edit!" If the cut is particularly odious, I will say, "This is a felony edit . . . and it will put me in editor jail." Hopefully, they laugh, and let you change the cut. If not, the atmosphere in the room is still one of levity and you can move onward.

3.13 POLISH YOUR CUT

When the time comes to review your cut, ask yourself:

- Have I been true to the script?
- Have I incorporated every moment for each character's story?
- Have I made the most of the comedy and the tears?
- Have I used all the eye candy?
- Have I captured the best performances?
- Have I added the necessary stock shots?
- Have I added the superimposed chyrons, subtitles, credits?
- Have I added the sound effects, the walla, the backgrounds?
- Have I removed all the director's cues?
- Have I cleaned up the offstage camera noises, floor creaks?
- Have I added the source music and EQ'ed it?
- Have I scored the appropriate moments?
- Have I adjusted all of the levels of the dialog, SFX and MX?

> *You never get a second chance to make a good first impression.*
>
> **Will Rogers**

When I assisted Lou Lombardo ACE on *Up in Smoke*, I was excited about the opportunity to cut for an editor who was so accomplished. The first scene I worked on was going well, though Cheech and Chong had little regard for continuity, and I was quite proud that I had fixed some awkward bits. Louie asked if I were ready to show it. I said, "Sure," and fired up the Moviola. Louie stood over my shoulder, watching the scene on that little ancient screen, and around thirty seconds in, he reached out and hit the hand brake. He said, "What was that sound?" and I replied, "It's a director's cue." Louie let go of the brake, looked at me, paused, and said, "Don't waste my time. Clean up the sound and I'll look at it later." I was mortified. I had disappointed my hero. To this day, I will never show a scene before its time.

Take this to heart, and make sure that you polish each scene you cut before you allow anyone to watch it. It is fatal to lose your director or producer's attention to a stray noise, forgotten insert or an unsolved editing problem in the coverage or performance.

Since the inception of digital editing, the expectations for an editor's first cut have risen to include sound effects and music. Many producers, even directors, have come to expect the temp MX tracks and SFX to be perfectly laid out, and their ability to extrapolate what the film would be like without these embellishments is limited. Too often, your producers will be displeased because of the lack of sound design. The 'wrong' song or the unsweetened action scenes make them dislike the sequence, even though the story and visuals are well told.

There are many editors who do not add sound effects or music into their first cuts. Perhaps they leave the SFX to their assistants, or wait to track their scenes after they have all been assembled into a first cut. My methodology is, get the picture right, the dialog track at a cadence that is crisp and refined and then, before I put that scene to bed, cut the SFX in so that it is part of my orchestral palette. The editor has the ultimate responsibility, and opportunity, of choosing when and how to elevate the story with their soundscape. Each new sound is married specifically and organically to the dialog and the visuals.

I like to add the score or a needle drop if the scene calls for it when I am completely satisfied with the cut. This way, I know the scene is in good enough shape to play dry. Look at your original breakdown of the script and note where you felt the score should start, or if the scene needs a lyric in a needle drop, or if the previous scene would have the score that would transition into the start of this scene. Perhaps the end of the scene needs to have a cue to underline the momentum, and that will segue into the following scene. Place these cues into your first cut of this scene, and all you have to do when you attach the preceding or following scene when it is shot and received, is extend your music. It might not be the right cue in the end when you watch the movie as a whole, but your spotting is correct, and the tenor of your choices will be in the ballpark.

The film editor is the one person on the show who weaves the imagery, dialog, sound effects, titles and chyrons, and music into one tapestry. Some directors,

especially in features, share this responsibility. The timing and placement of these threads that create a piece of artwork come together in the editing room, and are overseen by you. After the movie leaves your room, the sound and picture are separated and placed into expert, but compartmentalized hands and you are the only person who knows the original composition intimately. The director has a clue, but nobody knows the tracks like you.

This chapter's guidelines are some very basic rules of how to approach constructing your sequences. You have to keep them in mind as you wade through dailies, and allow them to be a good place to begin. If followed, these rules should help keep your audience engaged. It should preempt the need for directors, producers and studio executives to unravel the architecture of each scene. There might be line lifts, or swapping out performances, or shuffling scenes around, but the basic foundation of your structure will be stable and therefore unassailable.

In the next chapter, we will get down to some nitty-gritty rules and guidelines that will help speed the process of your first cut.

Practical Uses

Learn the rules like a pro, so you can break them like an artist.

Pablo Picasso

In the last chapter we gave an overview of structure, doing a paper cut of your script, finding and using the best images to make your audience safe and engaged, layering imagery, cycles of motion and the responsibility of having custody of the eyes of your audience. Now we need to focus deeper, into the interior scene, the "how to" part of editing.

We have discussed one practical rule, the 8-frame rule, and how to manipulate the emotional content of the storyline. There are more. Many have been handed down to us from editor mentors, colleagues, directors and producers. We must also add to our lists of rules through our own experiences, and by examining the editing styles of our predecessors and contemporaries. We simply have to reverse engineer their editing patterns, and voilà. We can emulate what we love best.

Most editors cut instinctively, utilizing these unspoken guidelines; our aim in this part of the book is to translate these unwritten rules into words. In essence, to codify what has previously been unexpressed.

Think of yourself as a fly on the wall, watching the story unfold; or perhaps an invisible, omnipotent observer, listening to the players' words, gleaning what is in their hearts. Ask yourself, who are you watching, on which lines? Who are you interested in seeing? When do you glance over to see a reaction? Which character does this scene belong to? Your editing pattern and cutaways can be as simple as the answers to these questions.

4.1 CADENCE—DIALOG AS YOUR MELODY

After we find our opening shot, and then make sure the audience is safe in the scene with the use of our master, we begin to introduce the dialog of the scene. Sometimes it is the reverse; we pre-lap the dialog of the scene, and then find our opening shot or master to let us know where everyone is in relation to everyone else. Either way, as soon as we have begun our dialog, we have created the first measure of our song. It has a cadence—the actor's meter sets a pace, and the editor must decide if it needs to be sped up or stretched out. The dialog will be your melody—it is your constant, and sets the pace of the entire scene. It can pick up in tempo, it can have an interval of silence—a rest. But each new phrase will continue inexorably to the end of the scene. The pictures will be woven around these lyrics. Once you have your dialog click track honed, then the additional SFX you add will become integral parts of your proverbial song. They become the additional instruments you add to pepper the dialog and complete the soundscape.

When you have your first cut of the scene, the timing will already be impeccable because your sound track has been incisively trimmed. Your structure will be sound because you have carefully infused your master, or wide enough coverage that allows you to see where everyone is in relation to each other, into your cut periodically. All you have to do to finesse the scene will be to choose which takes you might want to trade out, which cutaways you need to infuse, and which beats might have been missed, and need to be elongated, or possibly removed. Getting the dialog cadence right on your first pass will help make the rest of the work that needs to be done that much easier.

4.2 2, 4, 6, 8, 10, 12 FRAME RULE

- The 2-frame rule—this rule was pointed out to me by my colleague John Heath (*Warehouse 13, Picket Fences, St. Elsewhere*) while we were cutting *Picket Fences*. The theory behind this rule is that it is best to cut on motion. For example, you are on your actor's face in close up and you want to cut to the three-shot as he looks up to see someone enter the room. Allow the performer to turn their head two frames in the close up, and then cut to the three-shot with two frames missing from the start of that action. If the speed with which the actor moves his head is the same in all coverage, this will be a smooth cut. This rule also works if you allow the actor to turn their head for three frames

in the close up; just trim three frames off of the 'B' side of the cut. And four and four, and so on. It gets harder to match, and therefore less seamless, the more frames you allow on the 'A' side.

However, if the actor is inconsistent with the speed of his head turn, you will need to make adjustments on either the 'A' or 'B' side of the cut, adding more to the side of the cut in which the actor turned their head faster.

- The 4-frame rule—this rule was taught to me by James Galloway ACE (*Kane and Abel, A Death in California, Lou Grant*). Count four frames before cutting after a question is asked. This is a good place to start, but the scene will dictate whether you need to shave off a frame for cadence, or possibly add one frame because of a cycle of motion. Remember, do not let your actor start to blink at the end of a cut. Allow no dirty frames.

Just like the 8-frame rule, you can play with the timing of these four frames and manipulate the emotional tension and intent of the cut. For example, when the editor starts the response to the question sooner, even creating an overlap, the intensity shifts. When you add a longer pause on the 'B' side of the question, you invite the audience to wonder about whether the person is telling the truth, or are they taking the time to make up a story. This will necessitate shaving some frames off of the 'A' side of the cut.

Another example of the manipulation of the timing of questions is in the courtroom setting. When a witness has finished their statement, if you have the lawyer quickly pose the next question, the tension rises. After another question is asked, and the momentum is accelerating, there is no time to wait for four frames until you cut to the person on the stand. Each silent frame is given to the witness. We watch them choose to lie, or not. Each frame we add to the head of the 'B' side affects how we evaluate their answer.

- The 6-frame rule—this is half a beat. For those of you with a faster heartbeat, it is the 5-frame rule. It is used when you need to add a bit of a moment but not make a meal of it.
- The 8-frame rule—this is the offstage start of a sound that can be placed 8 frames before the on-screen character turns their head to look. It is where you start your pre-lap.
- The 12-frame rule—this is a beat—for some editors with a faster heartbeat, call it the 10-frame rule.

The theory I have about the 12-frame rule becoming the '10-frame rule' change is twofold. On film, we were careful not to choose the wrong frame because the evidence of our decisions was loud and visible. Better to be too long and have to trim. The other reason is that the world has moved on, and the accepted rhythms and cadences of films (thank you Sesame Street and MTV) are shorter. Two frames shorter in fact.

4.3 AIR ON THE 'A' AND 'B' SIDE OF THE CUT

It is boring to have air on the 'A' side of the cut as well as the 'B.' Choose who you want to give the moment to, perhaps whose scene it is, and give the extra frames to their side of the cut. If you are having a hard time deciding, think about being that invisible person in the room, and who you would be looking at. Remember, it is your job to keep the story moving forward with each splice and that includes the amount of frames you give to the head or tail of each cut.

4.4 PROJECTILE RULE—CAUSE AND EFFECT

As explained to me by Lou Lombardo ACE, the projectile rule is—if you are on the character as he throws the football downfield, and you let the ball exit the frame and then count two empty frames before cutting, then the 'B' side of the cut will be two empty frames before the ball enters. Three-three, four-four, etc. The further the distance, the greater the number of frames. This rule is a great place to start; however, I am not a fan of empty frames, so I keep the timing, but add more of the frames to the 'B' side.

Cause and effect cuts should always go together. For example, if you cut to a person throwing a ball, the next cut would be to a person catching the ball. Fire a gun, see what the bullet hits. If an actor shoots someone a dirty look, cut to the recipient of that look.

4.5 MATCH/SHMATCH

Continuity is wonderful. When actors match their physical action throughout their coverage—using the same hand to pick up their coffee cup or wave goodbye—it is marvelous. That is one less handcuff the editor has in the cutting room to make the scene seamless. However, there will be times when trying to match will be impossible. The discontinuity becomes what you must

use in the scene so that you can preserve the far better performance of a given actor.

If the scene is working, the dialog is good and the pace of the story is right, chances are the audience will not catch that the actor's coat is now unbuttoned, or that they kicked the soccer ball with their right foot on the 'A' side of the cut and then follow through with their left foot on the 'B' side. Match shmatch. Performance and storytelling supersede a match cut any day. Unless of course, the mismatch is so odious that it throws you out of the scene. For example, the actor says their line in the master while entering the room, but then says the line after sitting down in the coverage. No great fixes for that, but if you have to choose which one to use, stay in the first bit of coverage until you can gracefully cut into the closer coverage.

In 1977, I got my first break to edit a movie for television. I was assisting Bud Isaacs ACE (*Brian's Song, The Alfred Hitchcock Hour, Raid on Entebbe*) on *Thou Shalt Not Commit Adultery*, directed by Delbert Mann (*Marty, That Touch of Mink, Separate Tables*). During the first couple of weeks of dailies, Bud let me cut scenes for him and was pleased. Soon though, he found out that he needed immediate heart surgery, but he was confident enough in me to recommend that Del give me a shot at editing the movie. Del agreed to look at my work and I was asked to edit a reel (approximately ten minutes of cut footage) by the next day. I was thrilled. And overwhelmed with how much this night's performance would mean to my career. I called Lou Lombardo during my dinner break and asked him to please come watch what I had cut and to give me notes. He said, "Darlin', you will do fine. Stop worrying." This was not the response I wanted; so much was in the balance with this great opportunity. I asked if he had any last minute advice. Louie said, "Yes. When you punch in to the close up from the master, you have to match." I said, "Thanks. But, well, anything else?" He said, "One more thing. When you cut out from the close up to the master, you don't have to match." That was all. Damn if it isn't true. And I got the job.

I still prefer matching, but I have learned to use tricks to get around it when necessary. Some hints for circumnavigating matching hell:

- Cut on motion at the start of a cut.
- Recompose the image you cut to with a blow up to create enough of a size change.
- Use sound to distract the audience.
- Cut wide to the master as a last defense. This will help make the audience's eye get lost in the cut and not see the mismatch.

4.6 OVERMATCHING IN THE MASTER

When you cut out to the master within a scene, you try to match a person's action from the two-shot or close up on the 'A' side—sitting, standing, turning their head—the rule of thumb is to overmatch the action on the 'B' side. This means that you repeat two or three frames of the same action from the wide to the close. The reason this works is that the eye gets lost in the frame. If you are editing a feature for the larger screen, overmatch an extra frame or two. This harps back to the '10 o'clock rule.' If in the following shot, you mean to direct the audience's eye to something that happens at '5 or 6 o'clock' on the screen, you might even add a third frame for more time. If you do not overmatch, the action might be lost in the cut, leaving the audience with a missed moment.

> Cutting to the master is not the only time you overmatch. For instance, when editing a fight sequence, sometimes that extra frame makes a punch land harder. With explosions, the repeated eye candy in different angles is so fun to see. But you must be careful not to get caught overdoing it. Even in dialog scenes, there are moments that call for a frame or two of overmatching to feel the moment at its fullest. Experiment with that extra frame or two. Knowing when to make these choices comes from experience. There will come a time that you reach a higher level of editing and it becomes your own art form.

4.7 SPORTS—FOLLOW THE BALL

When you cut a sports sequence, a good rule of thumb is to 'follow the ball.' The forward thrust of the story is intertwined with the ball's progress. The editor must orient the audience frequently to see the ball going from right to left, and left to right. Once you establish which team is going which way, the audience will come to expect that continuity, and will feel safe in the scene. In a courtroom setting, you 'follow the eyes' of the participants. When character 'A' looks at character 'B,' cut from 'A' to 'B.' In a chase scene, you 'follow the cars'—being careful to have the pursued car going the same direction as the chase car. It is essential for the editor to orient the audience with a shot that includes both cars. Following the proverbial ball is your center pole.

4.8 DANCING—SEE THE FEET

A note that one of the producers on *Divine Madness*, Howard Jeffrey (*West Side Story, Turning Point, Divine Madness*), gave me was that it is essential to always see the footwork of the dancers. This often meant cutting to the master, the only shot that incorporated the feet. Since the master can disengage the audience, the editor must try to utilize the master judiciously, saving it for the extra special bits where the feet 'fly.'

4.9 MONTAGE—JUXTAPOSE IMAGES

A montage is a series of shots with jump cuts or dissolves, and is useful to condense time, to add comic relief or heighten emotional moments. It is often underscored with music, or sound effects, or lack of added sounds for a dramatic effect.

We have talked about joining images, and how gracefully we can connect them when the editor knows where the audience's eyes are in the frame. It is essential for the editor to also place one image on top of another in a careful juxtaposition when creating dissolves or montages. For example when the actor is on the left side of the frame, dissolving through to something on the right side of the frame will look planned and elegant—it fills the frame evenly. The idea is to edit seamlessly from one image to the next, with as clean a transition as possible, honoring both the 'A' and 'B' sides of the dissolve.

When choosing a stock shot to precede a scene, make sure the stock shot will follow the previous scene artistically as well as lead the audience into the first shot of the new sequence with either cuts or dissolves. Determine where you left the audience's eyes, choose a stock shot that is pretty, informative and will juxtapose well with the outgoing and incoming scene.

During a telephone call scene, the editor must try to make the conversation intimate, almost as if the actors were in the same room. It will orient the audience to have each character facing each other. Often, these phone conversations are shot on different days and if either the script supervisor or director has overlooked the screen direction, then the editor is left with two characters facing the same way or looking opposite ways. One trick solution that works on occasion is to flop the film. If the camera is tracking around the actor, look for places to cut that will put the characters facing each other if only for a cutaway (see Chapter 5.9).

4.10 COME BACK TO A CHARACTER IN THE SAME POSITION

When you cut away from an actor for a reaction shot or responsive dialog, and then cut back to the first actor, it is less disorienting to find them in the same position they were in before you cut away. This applies especially to telephone conversations. If they are standing, cut back to them standing, before they sit down. If they are in the doorway, cut back to them in the doorway before they cross the room. If you change their position off screen during the cutaway, it will bump on the return cut. There will be times when this is impossible. Then the editor should explore other coverage or the master to obfuscate this discontinuity.

This same rule applies to the emotional changes of a character. A mood change, facial change, as well as a physical change must not happen off screen. The audience will feel robbed of the transitional beat and the emotional content of the moment. You will lose an opportunity to see into the character's thought process that helps propel the story.

Sometimes it is best to stay with a performance from one given take—so that both physical and emotional arcs remain continuous and organic in performance. Be careful when you do interchange takes. Make sure that the camera size remained the same. If the new take is framed differently, resize the image to match the previously used take.

The editor strives to cut in all the beats, moments and nuance of the performance and script—including the unwritten dialog beats that are the undercurrent of the scene. However, one of the first changes the producers or studio might ask for is to take out the air in the scene. There will be various ways within the scene to accomplish this note. Though I am not a fan of post-lapping dialog, it is a better fix than finding the actor in a different position. It allows the dialog to continue which will pace up the scene, and still captures the change of position. I suggest you trim up the scene elsewhere, before you sacrifice the 'same position' rule.

4.11 THE EYES HAVE IT

We naturally seek the eyes of our actors to help inform us what they are thinking and feeling. When character 'A' seeks eye contact with character 'B' in the room, the editor can use that look to motivate the cut from 'A' to 'B.' Just like the 'projectile rule' and the 'cause and effect rule,' when character

'A' looks (cause) at 'B,' we cut (effect) to them. This causal relationship will get you 'around the room' in your cutting pattern. For example, in a courtroom scene, as the witness testifies, we cut to a reaction of character 'A,' nodding her head and then looking over to the jury, where juror 'B' is nodding his head too. Each look gets us to the next cut gracefully, and we end on the juror agreeing with 'A.' We have told the audience who is agreeing with whom, who might be winning this case and the veracity of the witness. Their looks have made the cutting pattern simple and clean. These looks between characters get you 'around the room' in dialog scenes, parties, sports events, conference rooms, dinner tables and countless more. It is how you lead the audience to know, feel and understand the subtext of a scene.

> The cumulative effect of eye contact in a movie has a great effect on how much your audience is engaged with the characters. If you cut away at the end of a line before your character has made eye contact with whom they are speaking, it will chisel away at their relationship. It is this relationship that you are trying to sculpt. The same holds true on the 'B' side of the cut; start with a frame or two of eye contact. When it comes time to trim up scenes, you will be able to judiciously sacrifice these frames here and there throughout the movie. In my first cut, I infuse every bit of eye contact possible.

4.12 NEVER LEAVE ANYONE HANGING TO DRY

When you choose the takes to use in a scene, always protect the actors' performances. You must also protect the director, the DP and the script. For example, if one take has a boom shadow across an actor's face, look for another so that you do not leave the DP hanging to dry. If none exists, then the editor needs to red flag it for VFX to remove the shadow. If VFX is not an option, then the editor should adjust the cutting pattern so that the part of the take used does not include the shadow. As the editor, your choice of performance and which takes to use for reaction cutaways is paramount to the success of the story being told. If the performance is strong and believable, but there are matching issues with the counter coverage, the editor must sacrifice matching for the best performance. The same theory holds true for dialog—if there are written lines that do not ring true, either at script level or once it has been shot, the editor should at least try to defend taking out this dialog, risking the ire of the writer/producer. If the actors have strayed from the written dialog during the scene, the editor should look for the takes where the correct dialog is spoken. If there are no takes with the correct dialog,

consider cutting away from the actor so that you might loop the correct line in post. If there are bumps in the camera move, wardrobe mishaps, hair or makeup mistakes, or sound issues, always look for another take that will not leave any crewmember hanging to dry.

> The editor should take care to protect everyone involved in the film. From cast and crew to assistant editor and post production staff. Members of the film crew will pass through your editing suite, and the criticisms or gossip that are shared in your cutting room need not be repeated. What happens in editorial stays in editorial.

4.13 ONE-EYE RULE

Jonathan Pontell (*The Practice, Ally McBeal, Nashville*) shared the one-eye rule with me on *Picket Fences*. It helps so much, and supports the theory that the audience is really watching the performers' eyes. As the actor exits frame, and one of his eyes is no longer visible, cut to your next shot. The audience loses interest when they can no longer see at least one eye, so our attention as the viewer reverts back to the now-empty frame. You want to avoid this, and keep the attention of the audience moving forward with the story. This rule is a great place to start when deciding where to cut away, but the speed of the exit or possible head turn will determine if you need to add a frame or two. If there is an eye blink as they exit frame, then cut before or after the blink is completed.

> This rule also applies to any object leaving frame, like a car. Pretend that the front wheel or the driver is your 'one eye.' Remember—avoid the empty frames.

4.14 METER—PAUSES, COMMAS AND PARENTHETICAL PHRASES

Meter is defined as a measured rhythm in verse. There is a rhythmic flow in film that is set forth by the actors' performances and their dialog. Language, music and film share this common bond. Once the editor sets the pace of the dialog by altering slow or fast deliveries of lines and changing the meter of the scene, there will be a natural cadence to the sequence.

When there is a natural pause, or a comma in the dialog or a parenthetical phrase, this is a good place to cut. For example, Shakespeare wrote, "Some

are born great, some achieve greatness, and some have greatness thrust upon them." Each of these phrases, separated by a comma, would be a natural place to cut. There is a measured rhythm in the sentence that allows the audience to be ready for the next bit of sound. This is a guideline, and overuse will make your cutting patterns predictable and mechanical which will diminish the desired effect. Changing the syntax of your cuts, by changing their duration, will help keep your editing fresh.

> Bum, Ba, Da, Bum Bum ... Bum Bum. Think 'shave and a haircut.' We are all waiting for the next phrase—'two bits'—to come in a rhythmic fashion. The speed with which you say the first part determines the length of time before our ear is ready to hear the second part. Go ahead, say the phrases, play with the length of each phrase and hear the differences.

As we've discussed, the dialog is the first thing you consider before you make your initial picture cut in the scene. The cadence of the dialog sets the tone of the scene. It is the essential ingredient in what will become the sound architecture. The editor is not compelled to keep the rhythms of the actor; you must feel empowered to pace up performances, pull up dialog or stretch it like taffy and create the beats and moments that the script calls for. It is what I refer to as the 'click track' or metronome of the scene. The dialog is the first 'musical instrument' of your orchestrated scene; it comes in measures—with a cadence, divided into beats. It has a life of its own. The syntax of the first phrase prepares us to expect the next phrase to come in similar cadence—you know it is coming and you feel 'safe.'

Before the editor hands the film over to the director and the producers, he sets the pace of the movie, decides which angles to use, what size the shot should be and which actor to be on for which lines. We massage the emotional heights of the audience's experience with a chosen shot and the performance they hear. The auditory experience is of equal, if not greater, importance to the visual tale. It is the editor's job to marry these worlds, picture and sound, so that they fit together in an intricate tapestry.

4.15 PRE-LAPPING AND POST-LAPPING SOUND

In Chapter 3.7 we discussed layering sound and pre-lapping as a form of pulling your audience forward. When we hear the offstage voice, and see our actor look towards that voice, and then cut to that voice, we have gently

asked the audience to follow—organically guiding them to the next bit of story. We are using the '8-frame rule' (see Chapter 4.2), the 'projectile rule— cause and effect' (see Chapter 4.4) and the layering rule (see Chapter 3.7). If the editor does not pre-lap the incoming dialog (or sound effect or music), the audience will feel pushed rather than pulled. This can be an advantage if you mean to impact the audience with some force. Cutting on the first frame of dialog is crisp, adds tension and will make the audience pay attention closely. Pre-lapping is a device that can be overused, but when in doubt, err on the side of the pre-lap instead of post-lap.

Post-lapping sound must be used judiciously, because the audience will feel like they have 'missed' something if you cut away too soon. It does help to take out the air in a scene, but at what cost? The editor can often succeed with post-lapping if the dialog is predictable. For example, if an actor sings 'happy birthday,' by the time you get to the final phrase of 'happy birthday to you,' the audience is ready to look at the reaction of the birthday girl before the phrase has ended. Any predictable phrase is fair game for an earlier cut to a reaction without fear of shortchanging the audience.

> Take the time to watch a conversation between two friends. When you look away from the person talking to catch a glimpse of a response, this is where you will cut. We often know what the person is going to say in ordinary conversation, and our tendency is to overlap or even interrupt the person speaking. That is exactly how you should cut it in the film.

I like to pre-lap my dialog as I edit so I use the Steve Cohen ACE (Editor/ Author of *Avid Agility*) editing tip to make this a simple procedure (option/ overwrite with three point editing). Follow this method to the end of your scene, and if you are diligent about the pacing of the dialog, you will find that when there are changes made by directors and producers, they will come in the form of dialog lifts, performance alts or the size of the shot—not the pace of the scene.

Cutting your dialog in syncopated time is interesting too. This could be a cut of long duration followed by a couple of much shorter cuts. It's a disturbance of the regular flow of rhythm that adds interest to the pacing of the scene. It is a storytelling choice that is as musical as the pattern described previously. You have changed the beat but it is predictable and safe in its own way. It keeps the hopefully captive audience engaged and on the edge of their seat.

Either way, it is most important to choose which style serves the story best. It changes from scene to scene, based upon the emotional construct of the film.

Whichever style of editing you use, and whatever the pace of any given scene, treat your audience to a layering of each sound, from dialog to music, so that the soundscape is enmeshed in an orchestrated concert—always tumbling forward. You will have created a symphonic support structure for your movie.

4.16 BAND-AIDS®—CONSONANTS, SPEECH BLENDS, SFX AND MX

When problems arise with dailies, the editor can resort to using sound as a Band-aid®. One of the many reasons that pre-lapping dialog works is because any sound that starts on the 'A' side of a cut and continues onto the 'B' side helps mitigate the discomfort to the eye when we splice from one image to another. Use consonants and speech blends that are called digraphs (i.e. ch ('chip'), sh ('shut'), ph ('phone'), th ('theater'), ng ('sing')). Use sound effects and music as a Band-aid® to obfuscate mismatches, hard 180° cuts that cross the line and transitions to a new scene. These digraphs and consonants work because they are more than one frame. Notice that the letters 's' or 'f' are easy to use when splicing together two separate takes. It is because they take more than 2 or 3 frames in a recording. When you use the first frame of the 's' on the 'A' side of the cut, and then make the transition to the 'B' side using the second frame of the 's' from the other take, they will go together seamlessly.

> Cut dialog on pauses, phrases, parenthetical asides or where you would place a comma—these are natural places to cut away. The audience is ready and prepared to see a new visual. They are almost braced for a cut, because musically they are ready for the next beat, the next phrase or picture.

After the editor makes his first pass on a scene, there might be an area that needs some tidying up. Perhaps you have struggled with discontinuity and chosen the best performance instead; there might be difficult angles to mesh together because the director has 'crossed the line' or covered the scene in 180° reverse angles.

Sound effects, backgrounds and walla make great Band-aids®. A Doppler horn-by, a distant train whistle, crowd noises, a door slam and many more help an edit. The sound can be introduced on the 'A' side gently, at first just

a part of the symphony of sounds, and slowly reaches the audience's consciousness before the cut, so that when it finishes on the 'B' side they are unaware of its visual purpose. Be sure that these additional sounds do not fight the dialog. The editor must never fall in love with their soundscape so much that the levels overwhelm the written word. The SFX are just a Band-aid® in some places, but the story must always take precedence and the extra sounds must fit around the dialog the way instruments in a symphony layer together to become part of the whole experience. Every once in a while, they get a solo. It is the editor alone who will know the intricate patterns of where and when the sound intermingles with the dialog and picture.

One of the great uses of a Doppler sound is letting it reach its *apex* on the cut. For example, when cutting away from a car-by, we let half the car exit frame (see Chapter 4.13). Add the SFX of a car-by, with the highest arc of the sound on the cut.

If you cut your scene with the cadence of your dialog paced carefully, you will make fewer passes and save so much time. The second line of dialog you cut in will help determine where your next picture cut should be. The editor has to choose the selected take, the size of the coverage, but the sound will dictate where you cut away on the 'A' side and where you come into the dialog on the 'B' side. If the sound is right, the picture will follow, and you will only have to adjust a frame or two to compensate for dirty frames, stray movements or awkward moments. This shortens the amount of time it takes to make your scene architecturally sound.

Using MX as a Band-aid® is even easier than finding the cadence for your dialog. If you have ever edited a music video or even a home movie, you know that music is a saving grace for many cuts. This is because there is a beat we can easily identify and use to our advantage. Cutting on the beat is simply keeping the cadence of the music as we try to do in a dialog scene (see Chapter 4.1).

The problem with adding the sound effects before you are pleased with the scene is that you will not know if the scene plays 'dry' (without SFX or MX). This can come back to haunt you in case your director or producers wish to see the scene without any dressing. There will always be cuts that improve with sound effects and music because they obscure awkward cuts to a certain degree. Make sure your scene plays on its own. If you have cut the dialog with cadence, you should be able to lay almost any music to it and not need to adjust the picture to be on beat.

There are many sound Band-aids® for your splices that help smooth a cut. If you have exhausted your film cutting options, and the splice remains challenged, your sound becomes your next resource. Use a train-by to span the cut, use an offstage waiter calling out in the background, add the sound effect of a glass breaking, anything that will bridge the 'A' side to the 'B' side of the cut.

4.17 SOUNDSCAPE

One of the ways to elevate your worth as an editor on a film is to take total responsibility for the soundscape, from dialog (cadence and selection of performance), to a full palette of backgrounds (presence, walla, exterior sounds of traffic, horns, birds and cars), and music (score and needle drops). Sound is more than 50 percent of your creative input while sculpting a film. It supports, it heightens and it is a vital component without which your first assembly is incomplete.

A simple rule of thumb about what sound effects to put in is, 'if you see it, track it.' For example, if there is a pigeon flying by, a child crying in the crowd, a cash register in the restaurant, you must add these sounds to your editor's cut. They are elemental. Go above and beyond with these sounds, and add your own backdrop of sounds that add relevance to the scene.

The editors from whom I have learned the most about sound were Lou Lombardo ACE and Danford B. Greene ACE (*Blazing Saddles, Mash, Fun With Dick and Jane*)who were both part of director Bob Altman's (*Gosford Park, Nashville, McCabe & Mrs. Miller, Mash*) school of editing. They were originally sound editors and they taught me how important sound is in your cut. It is almost more important at times than the actual image. I will change my picture to make the sound, the dialog cadence and the music just right. I will certainly change picture edits to better accompany a needle drop. That beat is what drives the scene. This is why I like to add the needle drop before we lock. I can send it to the music editor and say "Can you help with this edit? It's not quite right." They might change the music cut by frames or half a beat, and I will then adjust the picture to make it work along with their improved music edit. That was what I was able to do with the incredibly smooth and talented music editors, Michael Dittrick and Sharyn Tylk Gersh, on *Picket Fences.*

There is an art to adding SFX to the movie. Many editors leave it to the SFX editing team, allowing them to formulate a sound design. There are many

brilliant supervising sound editors who will not only elevate the picture with their innovative techniques, but contribute to the 'stories' that are told off stage in the backgrounds. However, the SFX department works in a bubble. They often do not communicate with the MX composer, or know which needle drop will be played during the scene or when it starts or stops. The sound department divvies up the movie amongst many editors—the SFX editor, dialog editor, ADR editor, foley editor—creating a cluster of sounds that might occur at the same time which will compete for the audience's attention. There is a supervising editor, who is charged with overseeing these glitches, but oftentimes the only opportunity to hear all of the tracks played together is on the dub stage. It is too late to make substantial changes. However, your sound work will be archived for the dub stage so that if the producers or director want to revert to your original work, it is available.

A fix for this possible occurrence is to take charge of your film and carefully lay in all the tracks that will complete the picture. If there is a bicycle in the road, cut in the sound of the spokes turning, the brakes squealing, the whoosh of wind as it goes by. If there are people in the street, hear their footsteps as they come by camera, cut in a general walla, with a few specific 'call-outs,' and Doppler conversations as they pass by your actors—perhaps in a language other than English. Sweeten silverware, glasses clinking, dishes rattling, cash registers, wooden seats creaking, doors sliding, allowing walla to raise when the door is opened to the outside world, and then lower it as the door closes. There are countless sounds you can use to your advantage.

Your assistant can order all these sound effects from the sound department or download them online. These sounds should be gathered and available in the SFX bin after breaking down the script (see Chapter 3.1). Eventually you will have a library of your favorite sounds that you can keep on an external hard drive and carry from one project to your next. If you take the time to sweeten all your scenes, your first cut will look and sound like a finished product, which is a good way to impress your director and producers.

After you are content that you have tracked every sound you need to, you may add music if the scene calls for it. If you feel music will elevate the story or heighten the emotional content, you must identify where the music will start, where it will end, which character or story point you are scoring. Some editors prefer to wait until they have watched the entire movie before they score or add a needle drop. I am more inclined to wait to add music on

features when I have the luxury of time to screen and feel where the music belongs. However, in television, the editor often has to hand over their cut without the benefit of a day or two to ruminate about music and I feel that I have done a disservice to the film to deliver it without both SFX and MX. The editor is the only person who has full knowledge of every dialog track, every sound effect and every picture cut, and therefore sits in the best seat to determine how to layer all the elements that work symbiotically in a scene. For example, you do not want to have a musical drumbeat on top of a horn honking, or a walla call-out if it steps on an important line of dialog. Your editor's cut is sometimes the last time you get to have input in the overall feel of the film, from pacing, to shot choices, to performance choices and the soundtrack package. Make it count.

4.18 MUSIC

Placing music is a bit tricky and ultimately subjective. There are so many decisions to be made—where to start the cue, where to stop it, what emotion are you playing to, should it be a needle drop with lyrics, should it stop and start again, where does the mood shift—these are just a few of the issues. The biggest problem, however, is that music is a matter of taste, and it becomes a challenge to please different producers' sensibilities. Be mindful of the generation gaps between you and the producers and know which audience you are playing to. There are minefields in some venues.

> One thing I know is that when I read a script, I 'hear' music in my head at certain points of the story. Write these thoughts down as you break down the script, and carefully describe what sort of music you feel works—tension, emo, comedy, romance, action—and at which point of dialog it will come in or go out. The first reading of the script happens only once, and your initial reactions are raw and most likely spot on.

One task that you should accomplish is to archive scores from movies. Give each cut a description—which genres it supports. Listen to the scores in your car driving to and from work, at home, and every chance you have, to familiarize yourself with an eclectic array of composers. Listen to all sorts of music—rap, hip-hop, classical, rock, techno, house, R&B, soul, urban, opera, country and world music. Stretch. Being able to temp track a show will set you apart from your contemporaries, which allows you to shine in one more area.

Understand that songs are comprised of intros, choruses, verses, bridges and outros (or codas). Mark the first module of sound, the first frame of the lyric, the first downbeat of every verse, where the chorus starts and ends, the start of the outro, the last mod of the lyric and the final phrase of the last measure. These are the cut points when tracking, and the editor determines where these hits should be placed in conjunction with the dialog as well as the start and end of a scene.

Music makes the heart soar. It is a powerful tool in your film because it can make your audience cry, or laugh or feel more involved and a part of the actors' world. It adds a sense of fun, sex and entertainment. It can change the entire tone of the movie.

> While cutting *Personal Effects*, written and directed by David Hollander, (*The Guardian, Heartland, Ray Donovan*), I temped in seven songs written by Sufjan Stevens, which were bittersweet declarations of faith, sorrow and love. It was a perfect counterpoint to the film, with an upbeat sound to the songs and an underlying message of simmering discontent. Just as the filmmakers had accomplished in the soundtrack for *Garden State*, I had hoped to get a younger demographic to embrace the film because of the soundtrack. However, our budget was for a small indie, preventing the licensing of Sufjan's songs. We replaced it with some adequate tunes, but the overall effect of the music was lost in translation, and I think it hurt the film.

Knowing how to choose your score comes naturally, especially if you take some time to listen to your favorite films, and reverse engineer how these films were scored.

Here are some standard rules:

- **Play-on (score)**
 This is the piece of music selected for the start of an act in television. In general, most acts have a play-on. They add energy at the top of an act, they invite the audience to the screen and offer up a bit of intrigue or fun, and set the tone for the incoming story. Towards the end of the film, the play-ons can be darker and more mysterious. Not all acts have a play-on, but it is wise to have one selected for your first cut. It is easier to delete it than to search for one with a room full of producers or your director. It might not be exactly right, but it will be in the ballpark, underlining the right emotions. Some editors prefer to track the movie after their first cut viewing, when they have a better idea of where the

story as a whole needs to be supported with music. This is a personal choice. Just remember to save enough time before your cut is shipped to the director to address the many scenes that will need music.

- **Play-on (needle drop)**
 Sometimes it is a needle drop that fits the opening, and your main obstacles to overcome will be to decide where the lyrics should start, how long they will play before dialog begins and how to elegantly segue the drop to a 'quieter' section of the song or a part with no lyrics. One trick is to ask your music supervisor to send the instrumental version of the song as well, making it easier to switch back and forth, in and out of lyrics. There are at least three or four cuts you will need to make in the drop: an intro, cut to lyrics, cut to instrumental to make room for dialog and an ending (that hits the last cut and spills over into the next scene). It is important to make these cuts and stay in cadence so that no one can hear your edit. I like to tap my fingers starting with the music on the 'A' side, and when we get to the 'B' side, if my tapping is in sync with the meter of the song, then I have not butchered the song too badly. As a backup—if you are pretty sure that the song will be used, and the picture will not change drastically, you can ask your music editor to take a look at a QuickTime of the scene, and help you with the MX cut. They might suggest shaving a frame or two, or adding a beat to one side of the cut or, if you are in good graces, perhaps they will make a better MX cut for you.

- **End of act cues**
 There are some occasions when sound design alone can end an act, but more often than not, the editor will have to find a musical out. There is usually a second or two of black that the editor is allowed to add to the end of the act over which music can resonate. Choose a wonderful downbeat to hit the last splice, whether it is a needle drop or a bit of score. Be aware that you must leave the audiences during the early acts with hope, the middle acts with mystery and problems to be settled, and the ending act with resolution—these emotions are communicated with the piece of music the editor chooses and can often be found in your MX bins from previous seasons.

- **Naming the tracks**
 When the music editor numbers and names the cues from a locked show, there is a roadmap for finding your play-ons, end-of-act cues

and a title that will indicate the kind of music you might be looking for. For example, 2M01 is Act 2, first bit of score. If it were a needle drop, it would have been labeled 2ND01. The final piece of score in Act 2 might be 2M15. The first bit of score in Act 3 is 3M01. They have names assigned to each piece, 'Annie finds the safe,' or 'Auggie chased by terrorist,' or 'Joan and Arthur kiss.' Using this numbering and naming system will help the editor track the current project. When looking for a play-on, you simply go to 1M01, or 2M01, or if you need an act out piece, use the last bit of music in the bin labeled 2M15, or 3M16. The rest of the score you need will be obviated by their titles, so that you can quickly find chase music, love scene music, or mystery music. It will also help if you tag the score in the comment column so that you can sort them by play-ons, act outs and various emotional signature pieces.

- **Temp track**
 The question arises about which score to use in your temp track. I like to use my composer's library, or past seasons' score for several reasons. I like to honor my composer, and I know that the composer's body of work is what my producers like. I know which pieces of his work are successful for chases, love scenes, fights, danger, montages and play-ons. When I cannot find a piece from this body of work, I will look outside and find film tracks that will work. Oftentimes, my favorite scores from movies are too big for the small screen, and I have to narrow my search away from large orchestral pieces. On features, the sky's the limit, but I still prefer to use the composer's body of work. The chances of the composer on a television show being able to replicate a James Newton Howard score in five days is small. If the producers have fallen in love with my temp track, and the composer does not have the time, nor possibly the talent, I will have set an impossible task for him. The flip side of this is that there are some successes with an incredible temp track that the composer will be able to emulate, pushing him to stretch beyond his normal palette. It is great when this works, but ever so disappointing when it does not.

- **Where to start the cue**
 This is a subjective decision, varying amongst producers, directors and editors; differing between television and features. A good guideline for choosing where the music comes in can be ascertained by asking yourself some key questions:

- *Who does the scene belong to?*
 There is usually one character in the scene who is more important than the others. Ask yourself, who do you most want to see and who do you most care about? Chances are you will need to underline *this* character's emotional journey with temp music. If the scene belongs to both characters in a scene, integrate a separate cue to underline the counterpoint emotion.

- *Which emotion are you underlining?*
 Is it the tension of the moment, the love triangle that is blooming or the long arc foreshadowing of the tragic affair? You must make a decision about which emotion you want to highlight and elevate. Sometimes it is a combination of all of the emotions that need to be supported and the temp score will have to be cut so that each story shift during the scene is honored.

- *What part of the dialog triggers a cue?*
 First and foremost, allow the dialog (e.g. "Let's go!" or "I love you!" or "You're fired!") to reign, and let the music follow its lead. If the music precedes the story point, you will have 'telegraphed' the incoming dialog. In television this is an absolute 'no-no' since it is a writer's medium. There is more wiggle room in a feature, and there are times when a cue may start, often insidiously, foreshadowing the soon to be revealed drama on screen.

- *Do I really need a cue?*
 Ask yourself if the scene is made better by the tracks you have added. Does it make you cry harder? Does it make you laugh louder? Does it make you more scared? Does it hold your interest longer? If all the track is doing is hiding some ill-conceived dailies, or rough spots in your cut, then be ready to take criticism for hiding behind the music as a saving grace. The scene must stand on its own without the Band-aid® of music.

We have talked about the dialog being your melody and as you add sound effects and temp music, it must be in cadence with your dialog, carefully entering in between phrases and forming a harmonious counterpoint. These meticulously placed sounds combine to make the overall effect of your symphony that much more heightened.

- **Where to end the cue?**
 Here are some standard guidelines on where and how to end a cue. In television, the cue can:

- End on a downbeat on the splice.
- End on the splice but allow some ending notes to resonate over the cut to the 'B' side.
- End on the splice but allow the last measure of the music to play into the next scene.
- End the MX before the end of the scene, allowing the last few lines of dialog to be the dramatic end of the scene.
- Music in a scene can end anywhere. It can end towards the beginning of the scene or the middle, if the emotion it is scoring has played out and the scene shifts to new ideas.

Once you have enhanced the emotion in the scene with your cue, it is sometimes wise to let the cue shift to a less informative tone and allow it to finish. It has run its course and accomplished what you needed. Take the time to find a part of the temp cue, often the last few phrases of the piece, to end your piece gracefully and not allow the audience to hear the cut. On features, the editor is able to play music through more than one scene, allowing the music to segue into the following sequence. This is rare in television, perhaps because it fights the dialog-driven medium of the small screen.

- **Mixing the cue**
 Take care to alter the levels of the cue, feathering it in, weaving it under dialog, and raising it for emotional effect in between or after the dialog has paused. Sometimes just lowering the level will sell a track to a producer as it does not fight dialog.

One of the producers on *Covert Affairs*, Gene Klein, (*Cry Wolf, Suits, I Just Want My Pants Back*), once caught me in this trick, and said, "You can't hide behind the level. Either go with it or take it out." He was right, as usual, but I still lower the level when I do not have time to search for a better temp cue.

- **Over-scoring**
 After the dailies are cut together into scenes and sequences, and the editor views it for the first time as a film from beginning to end, it will become obvious that there might be too much music in the show. The overall effect of that is numbing, diminishing the effect of the viable cues. If you have time, play the movie dry, then decide which scenes were most enhanced by the presence of music. Then re-infuse a portion of your temp score into the show. Change out the cues that need a bit

more bite or charm or tension—whatever is lacking emotionally. Less is always more when it comes to scoring, and producers are put off by the 'wrong' bit of temp music more than the absence of it.

- **Use several tracks to compose your own score**
 There are scenes that are hard to score because of the countless shifts in story and attitudes. After searching your composer's database, and trying separate scores of your favorite composers, and you find there is still nothing you have in your bins to perfectly underline the myriad of emotions, then it is time to 'create' your own score. Find a bit of MX tone, and place it under the scene. Find the heartbeat, the rhythm track to drive the scene, and start it underneath the tone at a precipitous moment in the cut. Find a 'melody' that you can now infuse in your MX tracks that combines them well and pulls at the audience's heartstrings during a pivotal moment in the scene. When you add sound effects to this 'symphony' it will increase the audience's emotions that you are playing to. A careful placement of a church bell, a distant whining ambulance, the roar of an ocean—these will add immeasurable heights to your final tapestry.

In summary, watch a few of your favorite films and listen to the score. Make note of where/when it starts, how/when it stops. Does it creep up on your consciousness with a single note or tone? (strings, wind instruments). Does it start with a concussive chord? (guitar, piano). Note the emotional impact these different approaches have on you. Watch your producers' and director's body of work and discover how they use music. See if there is a pattern to whether they like to have music play through more than one scene. If you take the time to analyze the use of music in your favorite films or television shows, then you can begin to emulate, and then to finally infuse your own natural instincts.

4.19 THE ART OF JUMP•CUTS

Anyone can jump cut through a scene. However, to do it gracefully and with impact is an art.

There are scenes that lend themselves to jump cutting:

- Active searches—an actor looks for evidence, opening drawers, closets, looking behind curtains.

85

- Passage of time—the performer writes a love letter, tosses it towards basket, writes more, crumbles paper, leaves room, slams door.
- Comedic moments—interview montage, a bevy of faces; dressing montage, an assortment of clothes being tried on and disposed of.

One of the problems that editors must help solve is trimming the picture down to format length for television. There are also features that are over three hours in first cut and must abide by certain studio and distribution rigors regardless of the director having final cut. The first bit of film to go is usually the grand openings of scenes, the crane shots that swoop down onto the set and then find the actors in the scene, before starting any dialog. David E. Kelley calls this shoe leather and these shots rarely survived his pass. Next candidate to go is the comedy, the jokes that do not further the story but only provide the usually much needed comic relief. The next extraction will be deleting a line here or there that is repetitive, or speaks only to sub-plot. The subplots are the next to go, resulting in lifting your 'C' or 'D' story. And yet, you find yourself still over footage. Short of lifting entire scenes, the editor must determine innovative ways to trim the movie without 'hurting' the story. One fix is to jump cut through scenes that lend themselves to this technique. The editor might even be able to preserve some of the director's vision, and the writer's carefully interwoven parallel stories, by taking out enough time through jump cuts.

There are unwritten protocols that every editor should be aware of when choosing to jump cut through a scene that was not scripted that way. I learned this the hard way. Working with my director Mick Jackson on our fifth project together, *Covert One: The Hades Factor*, I made the decision to jump cut through a sequence of an assassin searching an apartment that Stephen Dorff ('Jon Smith') and Mira Sorvino ('Rachel Russell') had just vacated. There was a lot of shoe leather on the exterior staircase, hallway, entering the apt, walking through the first room, all of which was beautifully shot. I cut the scene with all the coverage, and was scoring it when I realized the MX was not heightening the tension much since each room the assassin checked resulted in no threat. I decided to use jump cuts to infuse a higher level of anxiety. I sent the scene to Mick, all trimmed up, and his response was, "Don't you think I should choose which parts end up on the screen?" He was right of course. Always cut the dailies you are given, to length, honor all of the footage by placing it somewhere in your cut and then cut an alt version of the scene any way you feel it will help. Ask permission to change the original idea before shipping it off and surprising your director or producer. That is the safe way. Perhaps other directors would have been pleased, but I overstepped my boundaries with Mick on that occasion.

Another problem that jump cutting can fix is when a scene is too long, and the audience's interest begins to wane. Trimming out the fat, and getting straight to the more engaging parts of the scene, will preserve this scene in the movie. In the film *Erin Brockovich*, Annie Coates ACE (*Lawrence of Arabia, In the Line of Fire, Unfaithful*) did a beautiful job of jump cutting the scene in which Julia Roberts ('Erin') and Aaron Eckhart ('George') are chatting in bed. Stephen Mirrione ACE inspired a generation of editors with his artful jump cutting in *Traffic* as Benicio Del Toro ('Javier') and Jacob Vargas ('Manolo') have their car searched by the reigning junta.

One of the key ingredients to successful jump cutting, is to find the 'eye candy' (see Chapter 3.3) that encapsulates the gist of the story, and to use 'cycles of motion' (see Chapter 3.9) to give the scene energy. It is important to discover which bits of coverage capture what the director placed importance on, and what snippet of that visual furthers the story. For instance, in a search scene in *Runaway Jury*, Nick Searcy ('Doyle') is riffling through John Cusack's ('Nicholas') apartment. In my first cut of the scene, I jump cut through every room in which the director, Gary Fleder (*Kiss the Girls, L.A. Doctors, Don't Say a Word*), had placed the actor, from the living room to the kitchen to the computer room. In the final version of the scene, the first editor, William Steinkamp ACE (*The Fabulous Baker Boys, Tootsie, August Rush*), trimmed it down to just one or two snippets from each room, before getting to the computer room—which remains intact from the first cut. This is where the main story is, the download of the hard drive, and it deserved the most screen time.

Jump cutting adds power and energy to the scene, what I refer to as 'testosterone cuts.' There are no stray frames at the beginning or end of the splices, no time to contemplate feelings or thoughts—the action starts immediately and ends decisively. There is a certain brevity to the pace, an intensity to the cuts, which will hopefully bring the audience to the edge of their seats.

Jump cutting can also enhance a comedic tone, underlining the story and allowing the audience to join in the moment with the character. For example, in *Personal Effects* Michelle Pfeiffer ('Linda') is preparing for a working date with Ashton Kutcher ('Walter') and stands in front of the mirror with a variety of outfits to choose from. Each dress is examined, rejected, thrown onto the bed, finally chosen and with the final toss of clothing we reveal her teenage son watching television and getting buried by her discarded outfits. The cuts add an element of humor to an otherwise contemplative scene.

4.20 MAKING LIFTS

When you break down the script, there might be whole scenes and passages of dialog that strike you as repetitive or superfluous, and it is wise to notate these parts before you see the dailies. It will be a first blush reaction—purely visceral, uncolored by the director's vision and not yet a topic of discussion. Keep this list to yourself, as it transgresses your position as editor at this point of the movie.

Later, when the film is shot, the director has finished his cut and the producers have had their pass, you will all be faced with the task of identifying the parts of the film that drag, deciding where to tighten and how to get the picture to time. By this pass, you have already removed the 'chaff,' pairing down the 'C' or 'D' storyline, the light comedic dialog that does not further the plot and all the 'shoe leather.' Now comes the hard part, deciding which scenes can be lifted and determining which lines of dialog the writer/producers are willing to take out. When they are ready to hear suggestions, the editor will be well prepared with a breakdown list of timed, suggested lifts and a slew of additional helpful dialog couplets to excise. Gently suggest these thoughts. Remember—these are lines of dialog and stories that have been agonized over by the writers, each plot written and rewritten, the syllables honed. There are hard-earned shots the director envisioned and fought for that took hours to shoot and cost tons of money to produce. The editor must be prepared to defend his thoughts, and to rescind them without rancor should they be shot down. The harder you fight for a lift, the more obstinate the producers might become.

When you lift an entire scene, be careful to address the new transitions into and out of it. The editor must consider whether the transition to night or day still works, and might consider inserting a stock shot to help. Sometimes the cut out of the previous scene will need to be trimmed or lengthened now that the incoming shot is different. Most often the music and the sound effects need to be revisited and recut. It might only be two new splices in the film when you remove a scene, but it affects a multitude of sounds and visuals.

When you lift a few lines from the start of a scene, or a line or two from the end, you have to again address the new transitions and the background sounds. Also, the master you used at the start of the scene within the first few cuts might be lost in this lift, leaving you without the architecture you had carefully built. Make sure you rework the scene, replacing one of the interior

cuts with the master to keep the structure sound and your audience oriented. If you take out lines from the last cut or two, and you have music designed to hit the last splice, try to preserve the MX cut to button the new ending.

When you lift the middle of a scene, there is a high probability that you will remove one of the center poles and some of the eye candy the director shot that you have meticulously infused into the scene. You might have lost the 50–50 or the tracking shot or the beautiful close up in the lift. The editor must take the time to go back into the scene and infuse this coverage into the shortened version if possible. Rework the scene from top to bottom, and make the lift work story-wise, as well as construction-wise. Your director will thank you for making sure his vision was preserved.

4.21 SUMMARY

Use these rules as a guideline, a way to organize your thoughts and instincts. You will then adapt them to your own liking and style. They will only help to speed the process. As you grow into the headset of being an editor, you will become more confident and your individuality will shine through. Be empowered, and make the cut yours.

Additional Skills

Excellence is not a skill. It is an attitude.

Helen Keller

So many times, I have watched a scene or film edited by a new editor, and end up thinking, "Yes, pretty good. It's all there, but could we elevate the emotional experience? How could we laugh more, or cry harder, or be more surprised? Have we done everything possible to heighten each moment?" Have we infused enough subjectivity (watching events unfold through the eye of your main character), or have we approached the scene with a more objective view? Have we culled the dailies for every tidbit of emotion? Have we infused every moment-to-moment to tell the story as it reads on the page as well as the unwritten story?

Have we achieved excellence?

When you have finished your first assembly, go back through the dailies to see if you have missed any eye candy, better performances, facial nuances, impactful coverage and any eye contact between characters. Make sure you have exhausted every possible emotive response from the coverage and have included it for the audience. See if you have added every beat of everyone's thought process, even if you have to create it by extending pauses. If you incorporate every moment in your first pass, you will be confident, and prepared for questions that will arise during notes. You can trim the moments that make the scene too slow, or lift out a created expansion during your final editor's cut, but you will have archived the first pass that contains every possible moment of storytelling. I would rather have a note to trim a scene

than be asked to infuse some tension or looks between the characters. It takes much less time to delete than to create a moment while there are people in the cutting room.

Picture editors are tasked with more than individual scenes: we are responsible for each scene's connection to the prior and following scene— the transitions. Remember that every splice is, at first, an assault on the eye, and the editor must soften this attack with multiple layers of editing magic. Of course, there are times when you need to make the audience uncomfortable and use an edgy cut to your advantage.

The editor is also expected to add a multi-level soundscape—music and sound effects. We add chyrons, subtitles and credits to the scenes as well. Each additional tidbit of information (sound and picture) changes the length of time we hold a shot, and how long we allow the film to breathe while the audience's eyes and minds are taking in this new visual or audio information. Since you have custody of the audience's eyes, you need to determine the amount of time it takes your audience to fully receive this information. Remember, the amount of time is determined by the size of the screen. For example, theaters with large screens take a bit more time, several more frames, for the audience's eye to digest all the information as opposed to the smaller screens in one's living room.

Let's take a look at some of the areas where you can excel, and what opportunities might arise as you try to make the producers take note of your existence.

5.1 TRANSITIONS

A script might have between fifty and two hundred and fifty scenes, depending upon the format. Let's say that your current show has ninety scenes; that means that you have ninety-two transitions to come up with. From your opening cut or fade in, to the last frame of picture, the editor has to decide where to start the scene, what to end on, and how you will join the last image of scene 01 to the first image of scene 02. If the transitions are lacking in the script, if the director has not planned them, or if the producers or studio omit a magnificent opening crane shot due to length, then the transitions must be created by the editor. Whereas the first cut of a scene is the hardest, the next largest challenge is making sure all the transitions are seamless.

Usually, on the written page, there is a description of the setting for the new scene without much regard to how a visual transition from the previous scene will take place. For example, the script reads: Sc. 21 Int. Doctor Office. We know where we are because we read it in the script. But the audience does not know that. The editor hopes that the production will schedule and shoot an establishing shot of the medical building, or perhaps the director will shoot a sign that reads Medical Offices. To be fully prepared either way, the assistant editor should order a selection of stock shots. If the above alternatives do not work, then the editor can add a chyron that reads Dr. Jones' Office, if that is an accepted device on your show. Whichever solution is determined, the editor will have to let the audience know where we are so that they feel safe and the sounds of the interior of the office might start to bleed through at the end of the establishing shot, preparing the audience to move on to the next bit of story. The sound pulls you in and gently pushes the story along its path.

In other parts of the script when we are moving from a dialog scene in the interior of a house to a dialog scene in the interior of an office, and we do not want to interrupt the story with a transitional establishing shot, the editor must conceive of a way to gracefully join the images from these back-to-back dialog scenes. If the characters are not talking about parallel issues in both scenes, and the two stories do not connect on any level, then this transition fix is up to the editor. Sometimes the director will carefully plan an opening and ending shot for both scenes. However, in my experience with some very fine directors, they plan the opening shot on a large number of scenes, and perhaps an ending shot for several scenes, but never for all the scenes. When the writer does not write the transition, and the director does not direct it, the editor will need to create it.

In my forty-three years in editing, I have had the great pleasure of working with two people who paid particular attention to transitions. David E. Kelley wrote witty, sound oriented transitions, and Mick Jackson directed incredible opening and closing shots for most every scene. On the pilot of *The Practice*, which I was lucky enough to cut for both of these creative geniuses, my favorite transition is when Dylan McDermott ('Bobby') spits into his paper cup, and instead of cutting to the cup we cut to a mop splashing noisily into a pail. This was all Mick. In all the scripts I have read through the years though, my favorite was written by Amy Spies (*Melrose Place, Beverly Hills, 90210, My Alibi*). It was her feature, *Girls Just Want to Have Fun*, and every scene was thoughtfully transitioned to the next scene with grace and humor.

Some of the tricks that we use for transitions:

- A stock shot—over which dialog is often pre-lapped.
- A wipe—a car-by, person-by, or moving object which helps to distract the audience's eye from the cut.
- Pre-lap the dialog.
- Pre-lap the sound effects.
- Continue the music from outgoing scene to new scene.
- Use a person turning their head toward something.

> If your subject matter is a comedy, the editor can use a wipe from the visual effect palette. However, if you are working on a drama, the only time a VFX wipe is good is when it is invisible and drawn to outline an actor or object passing by the lens with a matte, and followed by the incoming shot. Don't get caught being too kitschy. Visual magic can be used only once or twice.

While you break down the script, add a breakdown of the transitions between scenes so that you will know in advance which ones will need close up coverage, wide coverage, a simple establishing shot or an interstitial stock montage. Identify in your breakdown which scenes present the most challenging transitions in your story. For example, in our breakdown of *Mandy and David*, you can see that we go from Sc. 03—Mandy makes cupcakes, to Sc. 04—David leaves home, says goodbye to his ill wife, Claire. As you read this in the script, you can imagine the last image that you might be on in Sc. 03; a CU of the icing going on the cupcake, or perhaps a wide master, that intimates Mandy's feelings of solitude, and foreshadows troubled times to come. If the close coverage in Sc. 03 is great, then the transition to the next scene, the master shot of David seeing his wife alone in bed, fighting her illness with a brave smile, will be an effective way to tug on our emotional heartstrings. If you leave Sc. 03 in master, then a complementary angle for the incoming scene would be a CU of perhaps the medications scattered on the bedside table that surround a terminally ill Claire. These two scenes should be an easy transition with enough coverage. However, in Sc. 42 and Sc. 43, the editor is tasked with transitioning from Mandy to Mandy. If the director has shot only masters of these scenes, then the transition between the final shot of Mandy arriving at work and the first shot of Mandy in the conference room might be challenging. It could be solved with blowing up the master into closer coverage and jump cutting through it from one office to the next office (see Chapter 4.19). If the director

has provided coverage, the editor might want to cut to the boss in the conference room first, with a pre-lap of sound, instead of a Mandy-to-Mandy cut. Unless the director has provided a well-conceived shot with this transition in mind, then the cut might be awkward. While breaking down the script, recognize this as a transition that would merit a note on the script for further discussion with your director before or after the tone meeting. Sometimes the director will listen, and take the editor's concerns and suggestions into consideration, when submitted in an organized fashion.

5.2 PLACING CHYRONS AND SUBTITLES

A chyron is a geographical and/or time title digitally generated (e.g. Los Angeles, California—1968) and is superimposed as a layer on your principle photography shot. The font is chosen to match the style of the movie, and often has a specifically chosen sound that accompanies it. They are brief, perhaps two seconds, depending upon the length of information, but long enough for a slower reader.

Chyrons can start at the beginning of the scene, or can be backed in from the end of the cut, or can be spaced in the middle of the cut. They can fade-on/fade-off, they can cut-on and cut-off, or fade-on and cut-off. Sometimes they can bridge two background cuts, as a stylistic choice. They can be spelled one letter at a time or appear as a whole thought. Whichever style is set as a precedent for that movie, or television show, note that there is an art to its presentation. The substance of the story being told and the dialog in that scene, the composition of the background shot and custody of the audience's eyes (see Chapter 3.5) should play a role in the editor's decision about placement and duration of the chyron or subtitle.

The most important component in cutting your scene is the story. The editor must make sure that the audience's attention is never drawn away from the forward thrust of events, and that they do not miss any crucial dialog due to the distractions of a chyron. With this in mind, the editor must place the added caption organically into the cut, in between the lines, or at least carefully integrated into the dialog so as not to detract from an important story point. The editor can always change the duration of the background shot to add the time you need for the audience to see the shot, hear the dialog, read the chyron and move onto the next cut. Sometimes, the cut is long enough to allow your audience to finish reading and then go back to the visuals before the next cut. Your aesthetic senses must guide your choices regarding fading

in/out or cutting in/out. When in doubt, try it both ways, saving one as an alternative cut (alt), and then you will have preserved the other choices for the director and producers. If your picture is locked, and you cannot add to the duration of the background shot, then I like to fade my chyron in, but cut it off on the splice, without wasting twenty frames in the fade out. This also works in the opening credits.

When choosing where to place your chyron in the frame, if not constrained by precedents set by previous episodes, it is always a good idea to make sure that the composition of the shot is complemented by the chyron, that it is not fighting other visual information in the background, such as a sign post that must be read. Never let the chyron cover someone's face. Try to balance the visual with this added information. For example, if your chyrons are on the left lower third of the screen, you might search for a background that is heavily occupied on the right side of the frame.

Remember, you have custody of the audience's eyes, and you must always be aware of where you left their eyes in the previous shot. The editor should then choose the next background cut to help the eyes move fluidly. The same care must be taken with how, when and for how long you have the audience use their eyes to read the chyron, and whether you give them a long enough shot to allow the eyes to travel back from reading the chyron and continue to view the same background. The smoother the journey for the viewer's eyes, the more elegant the effect will be. Of course, if you want your audience to be on the edge of their seats, filled with tension, you break these rules and do quite the opposite. It will create a frisson of excitement that lends itself to the storyteller's purpose.

Placing subtitles, though similar in its rules to chyrons, is slightly more complex. The same rules apply as stated above; however, your task is further complicated by making sure the subtitles are accurately translating what is being said on screen and that the audience has ample time to read all the words without distracting from the ongoing action or sentiment of the scene. I find that cutting in your subtitles as you go, instead of doing a pass after you have cut the scene, will save you a good deal of time. Invariably, the duration of the cuts will need lengthening if you add the subtitles in after your first cut. I always ask my assistant editor to create all the subtitles, chyrons and titles before I cut a scene, so that they are ready to cut in as I go. All these preparations are unnecessary if you do not mind the subtitles bleeding over the cuts. I find this distracting because I feel as if I might have

missed some visuals. In some cases though, it makes a cool statement. In general, the audience will look at the picture, hear the foreign dialog, look down to the subtitles to get the translation and then revert back to the character speaking. The editor needs to leave enough time on screen for this process.

If you have the responsibility of picking the font, the font size, the color of the chyron or subtitle, make sure you keep it simple. Remember you will be dealing with background footage that is sometimes dark or very light, and this becomes a factor in your choices. There might be times when you need to add a drop shadow to the font to help with visibility.

These are subjective choices. Take the time to watch films and shows that use chyrons (*The Bourne Identity*), subtitles (*Covert Affairs*) and pop-up text messages (*Sherlock*, *House of Cards*) and make a mental note of which styles appealed to your preferences. Steal the good ones.

5.3 PLACING CREDITS—THE MAIN TITLE AND OPENING CREDIT SEQUENCE

The Main Title (MT) sequence in television is sometimes confused with the opening credits (OC) sequence. The MT is designed to be repeated each week. It usually remains the same throughout the season—unless an actor is written out or a producer leaves, and then names are omitted, and new names are added to the MT. The Main Title includes the title of the show, the returning cast, the creator of the show and the executive producers. It is often outsourced to a MT design company. Sometimes, the editing staff will edit it together and do such a great job that the producers go with it. It can consist of 'beauty shots' of actors, juxtaposed with a montage of eye candy pulls from exterior action sequences, or identifiable shooting sets from the show. Sometimes the Main Title is simply chyrons over a black background, or a set of artful pictures depicting the times and places visited in the film.

The Main Title most often follows the teaser—which is also referred to as the cold open. It is called this because it is meant to intrigue the audience with some juicy footage and a hook in the story, hopefully guaranteeing that the audience will stay engaged and tuned in. The teaser has no commercial advertisement before or after it, and usually cuts straight to the Main Title. Sometimes, the editor will be able to pre-lap the MT music into the end of the teaser to make for a smooth transition. After the Main Title, there is

usually a commercial break, but the current trend is to join the first act of the show to the cold open, again designed to make the audience stay tuned.

> Main Titles were once a minute in duration, though the network tendency currently is to minimize that time, and/or eliminate them entirely. In the early days of television, the Main Title was a welcome visitor in your living room, heralding the start of your favorite show with a well-recognized musical theme. It gave you enough time to make your way to the living room, find your seat, and grab a snack and drink. Those days are long gone. Now, the network likes to join together the very end of the previous show to the start of the next show. In theory, this prevents the audience from changing the channel. I love a good MT, and am sad to see them go.

The editor, assistant editor or the post supervisor place the opening credits (OC) over the beginning of the first act. If the editor places them before the show is locked, then he will be able to alter the background durations to allow for a perfectly timed credit.

> It is oftentimes a battle to get the editors credit up front, instead of at the end of the show. Writers/producers generally dislike the length of the opening credits, fearing that it takes away from the story, and that the story has not really begun until the credits are over. The credit for the DP, production designer and the editor go as a group—if any one of these three people get credit up front, then they all do. With the length of the credits being a charged subject (the network gets into this too—sometimes not allowing credits to go beyond two minutes into the story), it is necessary to carefully lay them out so that the least amount of story time has been used, while making sure they are not popping on the screen one after the other in an annoying fashion.

As with chyrons and subtitles:

- The credits must fall in between important dialog.
- The credits must not be placed over an actor's face.
- The credits most often do not go over a splice (starting on the 'A' side and continuing onto the 'B' side)—unless that is the style of the show.
- The overall opening credits must not linger for more than two or three scenes.
- The credits should be spaced out according to groups. For example, keep the actors together, the technical credits together (editor, production designer, director of photography), producers together, executive

producers together and the writer and director together. For example, if you have all the actors divided into two backgrounds, except for the last person, and you place this stray actor credit on the next available background, it is best not to have the producer share this background. Start the producers on a different background. Then go back and divvy up the three backgrounds amongst the actors evenly so that the one stray actor at the end is not alone. The reason I pay close attention to these backgrounds is because I want to honor each individual for the work they have done. If your co-producer gets a credit up front—make sure you give them a great background too.

- If a credit contains two names or more, provide a wide enough background (e.g. a master) to make sure an actor's face is not obscured, and you might want to add frames to the duration of the credit if there are three credits, so that the audience will have time to read everyone's name.
- Protect your producers, writers and director with well-chosen backgrounds. You can let the writer credit or perhaps just the director credit bleed over to the final scene with credits for punctuation.
- Make sure there is a cadence to the application of the credits, so that they come in rhythmically, not on top of each other, but not too much space in between—we want them to end as soon as possible, but gracefully.
- When there is only space for one credit on a given background, choose your 'in' that allows the audience to orient to the shot (several frames) before introducing the credit. You can center the credit on the background if there are no specific emotional moments to guide you.
- Usually, television opening credits are 2:20 in duration—two seconds, twenty frames. '10 up and 10 down' means that you fade in for 10 frames, hold credit for two seconds, and then fade out in 10 frames. These are numbers you can play with, as long as you honor the contracts the producers have signed—not giving one actor a longer duration than another. When a background duration is short, but you must use it for a title, then you can cut from the credit instead of fading out, thereby lengthening the duration of the screen time by 10 frames. When I do this, I use the splice to take the credit off—it makes it cleaner and smoother, keeping the credit through the last frame of the cut.

The opening credit sequence in a feature is a combination of what we discussed about the MT and the OC in television. Opening credits in features can be spectacular—they are often created by a bevy of talented MT

designers, editors, cameramen, and many times the director designs the footage himself. There are fancy wipes, visual effects and graphic effects that support the sequence. Oftentimes, the picture editor is not involved with the editing—only in an advisory capacity. When the editor *is* involved with the placement of credits for the Main Title sequence of a feature, then the same rules apply as in television. The credits must not interfere with the story or the visuals. Their placement is choreographed meticulously to blend with the whole tapestry of picture, sound effects and music. Many times the editor has the added advantage of having a Main Title needle drop that has been licensed early, or the composer has written before the lock, and can alter cuts to fit the music perfectly. In many cases, the duration of individual titles as well as the length of the title sequence is longer in a feature than in television.

> Watch some Main Titles of your favorite shows and movies. You will see how much attention is paid to MT artistry. *Seven, The Mothman Prophecies* and all of the Bond films, especially *Skyfall*, are my all time favorites. Choose your favorites and emulate.

5.4 THE RECAP FOR AN EPISODIC TELEVISION SHOW

In the world of television, the assistant editor is often tasked with cutting a thirty second to one minute reprise, which is also referred to as a recap. It is an opportunity to show that you can edit well, in a timely fashion, and take change notes with aplomb. It is also a time for you to bond with your producers and let them know that you have hidden talents heretofore unrecognized by them.

The first step in your education about the reprise is to watch as many as you can and decide what you like. Reverse engineer these reprises and note the use of sound pre-laps, sound bites, on camera dialog used in sync and as narrative over other shots. Check out the use of the eye candy, the heightened pace and the order of images. Are they in chronological order or character order? Styles vary, though there are a few cut and dried rules that I will share with you.

- Breakdown your script before you cut the recap. This way you know what storylines will need to be clarified for the viewer who might be watching the show for the first time. Unless this is a 'stand alone'

show—one that has nothing to do with any previous episode—you must remind the viewer of events that took place in an earlier episode that are germane to the current show about to be viewed.

- Make a list of the stories you need to touch upon in the reprise. When possible, ask the producer or writer for input about what they would like to include. This will help preempt unnecessary work. It does not happen very often, so do not be surprised when they have only a few suggestions.
- View the previous episodes that contain references to the story points you need to clarify. Pull all these scenes into a bin, then label and archive which story point they underline. Pull all sound bites that pertain to transitioning from the 'A' story to the 'B' and 'C' stories. Pull eye candy for action transitions and for pretty footage to put sound bites over. String these bits together, without intercutting the 'A,' 'B' and 'C' stories. Save this as Version 1—uncut with all the coverage. Archive this cut so that when the producers do have notes about what should have been in the recap, you have already prepared it. Duplicate.
- In the duplicate cut, hone the important bits of dialog and eye candy. Cut the story lines that go together in order—start with one story—complete it, and go to the next story. Try to start the beginning of your reprise with a sequence that has the star of the film. Always end your reprise with the story you will be going to at the start of the show. Archive as Version 2. Duplicate.

This is a good place to stop and show a producer what you have so far, so that they can tell you which story points are not needed, and which story points they would like to add. Once they have a visual, it is easier for them to judge what it is they are looking for. Take their notes, and always infuse them. Do not interpret—yet. They have to see what they have asked for first.

- Find ways to transition from one story to the next. Use pre-laps, wipes, sound effects and visual treats to help. Archive as Version 3. Duplicate.
- In this version, pull out all the air in between sound bites. It is the same as a radio edit, no dead air.
- The choices made about what remains are as subjective as choices about music, so be prepared to have many versions.
- Use soundbites over eye candy that tell your story, not only sync dialog—be creative in this juxtaposition.
- Put a MX track under the reprise that adds energy, but does not interfere with the dialog ever. It is a quiet undercurrent that invites the audience

in without them being aware of it. Be sure to make MX edits to support the shifts in the tone of the recap. Archive as Version 4. Duplicate.

- Show it to your producer for input before trimming any more. Check to see if you are on the right track. It is still long, but before you get it to time, you need to identify which story parts the writer/producers are willing to abandon. Remember to do the notes they suggest, whether you like them or not, and archive an alt if you have a way of helping their note editorially.

5.5 GAG REEL

When an assistant is asked to cut a gag reel, it is an opportunity to shine and please the executive producers as well as the cast and crew—and most especially the co-producer who is the head of your post department. After five or six times of cutting one, it will not feel like an opportunity—it will feel a bit like a burden.

The use of music is a wonderful way to make sure your gag reel is a hit. Remember, there are no licensing fees to pay, so you can choose whatever music you think is best, without the normally limiting choices you must make due to budgetary factors. Think big. Use score too, and steal from the best.

The most common gag reels touch upon:

- Bloopers—actor mistakes—trying to get a line right, and the repeated attempts, forgotten dialog, laughing through a take, camera problems.
- Expletives.
- Actors kissing, love scenes, dancing.
- Repetitive lines throughout the season (e.g. "I met him in France," "I met him in England" or "I love you" said to various people).
- Use of slates for transitions, and in between flubbed lines.
- Actors looking at camera—grinning, waving, blowing kisses, making faces, talking to camera, winking.
- Crashes (remember 'cause and effect'—use the projectile from one scene to get you to another scene).
- Beauty shots.
- Crew members—include post personnel.

One of the pitfalls is not including everyone on the crew. No one likes to be the one who was overlooked in the gag reel when you are all gathered at the wrap party. One other bit of shenanigans to avoid is showing actors being too flirtatious after the camera has stopped shooting. You never know whose husband or wife will be offended at the wrap party. And lastly, it is best to excise the footage of an actor misbehaving on the set—becoming angry or impatient with themselves or others—this might have been funny on the day, but out of context might make the person feel humiliated when viewed in a room full of his peers.

5.6 COMEDY

Are there rules about cutting comedy? I think so. But, like people's taste in music, it is extremely subjective. Here are a few guidelines that I have gleaned from mentors, watching my colleagues' work and lessons learned from films I have cut.

When there is physical comedy between two actors, (e.g. actor 1 hands the baby with a full diaper off to actor number 2), it is more satisfying to the audience to see this in a 50–50 shot. This shot is when the two actors face each other in a medium master—maybe 'cowboy' size—down to their thighs). This way you have shared with the audience both actors' discomfort, as well as the funny visual of a baby being held by adults with poop issues.

This rule, about using the 50–50, is also helpful when there is rapid back and forth monosyllabic dialog. The audience can choose who to watch, and the dynamic between the actors is not lost in the cutting pattern. It helps to avoid the note "Seems a bit cutty here."

Cutting out to the 50–50 for physical comedy is another way to reintroduce a master that most probably will not be used for the duration of a comedy scene. For example, the punch line of the joke will always be in close up. Watch umpteen sitcoms and one-camera comedies and you will see this is so. Make sure the pattern of your cutting allows for a natural integration of this CU. If the CU punchline does not cut well with the previous coverage, change the previous shot.

The cut after the punchline is also very important. This cut will either make the audience stop laughing so that they can hear the next line, or it can extend

the laughter by cutting to a reaction that is equally funny. Be aware that you, the editor, have control over the duration of the laugh, whether it is extended by cuts to another actor, or if you progress the story and move on. Be sensitive to how long you can extend a joke before you kill it. Adding four frames does not necessarily make it funnier. Always leave the audience wanting more.

The editor has to pay close attention to the cut that follows the joke. The splice itself will make the audience stop laughing—unless you cut to a reaction of an actor in the scene being amused, disheartened, appalled or laughing along. This will hopefully help the laughter continue. If there is not enough format time to add this laughter prolonging moment, the next cut should keep the story moving, without stepping on the joke time or losing too much of the incoming dialog.

Leave the audience wanting more applies to dramatic editing as well. It does not mean that you do not infuse moments that resonate. The editor must determine exactly how long you have 'custody' of the audience's funny bone, and their emotional state of mind.

5.7 ACTION

The action scenes are the most fun to cut. Once you follow some basic rules, the prospect of putting together a riveting, nail-biting, edge of the seat, action sequence might well be one of the easier sequences to tackle as an editor.

Follow the ball

When you cut a sports scene, (e.g. a soccer match) the eye goes to the progression of the ball. This team is shooting for the goal left to right, and the other team is kicking right to left to score. We establish 'sides.' We have the team's coach and on-lookers helping us confirm which way our team is going. The director, along with a team of stunt coordinators or sports consultants, has choreographed certain skirmishes that will allow one team to kick a goal, steal the ball, or tangle with an opponent and finally score the winning points. You support each skirmish with reactions from the crowds on both sides of the field, with their eyes looking in the proper direction. The use of the masters will help in reorienting the audience occasionally. Scoreboards need to be infused and updated during the match.

When in doubt, cut to the ball, and the person kicking the ball. No headless feet.

When you are cutting a different sort of action scene, e.g. a car chase, a foot chase, or a fistfight, you must identify 'the ball.' In a car chase, that would be the car. We have to establish who is in which car, who is in front or behind, how aware they are of each other, as well as their proximity. The biggest factor in a chase sequence is to clarify for the audience where our character is in relationship to the character chasing him. Using the shots that include both your characters is essential to infuse into your scene. The closer they are, the higher your audience's blood pressure.

As in a dramatic scene, each cut should further the story. Multiply the importance of this exponentially in an action sequence. Always remember to keep your audience oriented—otherwise the thrill of nearly getting caught is lost.

The use of slow motion (slo-mo) is often a key factor in highlighting important moments. Use it wisely; it must be a treat.

If you are overwhelmed by the amount of footage that comes in, I suggest that you break down the scene moment to moment. Watch and know the footage for the beginning without even worrying about the second curve in the road or the second goal that gets scored. Cut the first part to your satisfaction and then move on to the footage for the next bit of the scene. When you finish your first pass of the action sequence, you can go back and trim up. This way, the architecture of the scene is there. All you have to do now is put in the ancillary coverage—the inserts of feet kicking, hitting the gas pedal, the looks in the rear view mirror—the crowd reactions, the scoreboards and the exuberant winning team. Once your scene has its backbone, you can add the SFX and MX to support and highlight the key moments and give your sequence its unique personality.

Cause and effect

This is one of my favorite rules that I learned from Lou Lombardo. There are cuts that are meant to be together: throw the ball, cut to the ball being caught; throw a punch, cut to the punch landing; shoot a gun, cut to the bullet hitting something.

On a larger scale, in a scene with dialog, every word that is said should be the 'cause' and the 'effect' is told by cutting to the characters listening in the room. Even when the actor has no line of dialog, his facial expression is his unwritten dialog and must be included in the scene. This helps create a moment-to-moment telling of the story.

Geography

To entrance your viewers, who are in your custody, the editor must make them feel safe. This means, letting them know where everyone is (the master). The editor must infuse enough information about the proximity of the bad guys (a chase), how close the knife is to our hero's body (fight), how many seconds are left before the clock runs out (sports). Once establishing geography, all the wonderful close coverage (gears shifting, tires screeching close to the abyss, guns dropped just inches out of reach) mean so much more to the viewing audience. Of course, you can start this process in reverse, beginning with a few close eye candy shots, before revealing the master. But the editor must always reestablish geography and proximity.

Eye Candy

We know eye candy is the aesthetically pleasing visuals that the director and director of photography have handed you in your dailies. There will be visually stunning wide shots, tracking shots, rack focus and long-lens shots. These shots take lots of production time. Make sure they are in your cut. The close coverage is essentially eye candy too—hand gestures, smiles, winks. These shots, and many more, comprise your eye candy choices.

Ear Candy

When your action scene is tight and working well, and you are sure that the audience will understand how we got from point A to point B and beyond, then is it time to infuse your ear candy.

First, lay in all of the sound effects—kicks, punches, tires squealing, acceleration, braking and horns. If a pigeon flies by, cut in the sound of their wings or coos, if a car goes by, put in its Doppler effect.

If you have enough time, make sure you put in the sound design effects—the Etoll sound effects library which includes unique whooshes, booms, tone and drum hits. This will elevate the scene tremendously and be a great guide for your sound effects team.

If you haven't been cutting to music before this moment, now is the time to infuse your choice of needle drop or score. Sometimes it is fun to use both, and have the score complement your drop, making sure you mix the tracks carefully and do not let them overwhelm the story you are telling. I like to get my needle drops sent to me with both the lyric version and the instrumental-only version. This enables the assistant editor to group clip the two so that the track can be toggled back and forth. That way I can control the balance of dialog and lyrics.

> When I first asked my assistant, Ray McCoy, to order up the instrumental of a needle drop for a scene we were doing on *Covert Affairs* he thought I meant the lyric version and the instrumental version had to be grouped together. I had never thought of that, but when he handed it to me that way, and explained that I could toggle between the two, I was ecstatic. No more trying to make a music cut between the two versions.

Most of the time, a single drop, or one cue, will not be sufficient to score an entire action sequence. The editor will have to take the time to cut in an assortment of musical pieces to support the shifts of tempo and mood. Remember to build to a climax, which will either end the music or tail out to the following scene.

5.8 COURTROOM AND MONOLOGS

There is a specific flow to cutting courtroom scenes. The first thing for the beginner to understand is that the inordinate amount of footage you receive for a courtroom, just like an action scene, is not a problem—it is a blessing. It gives you the footage you will need to make this very stagnant stage a riveting experience. Just break the scene down into its parts—the beginning, the middle and the end.

The basic tenet for all courtroom scenes is to show the audience where we are (the master), who's on the defense and who's on the prosecution side (we can see their faces from the judge's POV), and where the jury is and who might be a key juror (coverage from the defendant's and prosecutor's

POV). Once we have established all the players, and have seated the judge and the rest of the courtroom, we begin the dialog.

Either pre-lap calling the first witness as everyone is settling, or start on the witness on the stand answering the attorney's question. If there is eye candy for the opening of the dialog that establishes where people are that would be a good place to begin. Once you have the opening lines started, it is an opportunity to cut around the room to see the reactions of a few characters, and then end the testimony by cutting back to the person on the stand. Remember to include the judge's reactions, the juror who is looking at the defendant, and interactions between attorneys. The audience becomes informed about how much to believe of this testimony by these reactions. When we finally cut back to the person giving testimony, we have a greater understanding of what to believe.

There is little action in a courtroom—the judge entering, the courtroom rising and being told to be seated, attorneys addressing witnesses, and witnesses arriving and then leaving the stand. The courtroom is almost a still life, and with little movement to motivate cuts, the editor must find another way to navigate around the room. If you follow people's eyes, it will weave the cuts together organically. Whenever you have coverage of your main characters looking at each other, use it to your advantage. If the judge looks at the attorney or the plaintiff, if a juror shares a moment with another juror, if the defendant looks towards his family or accomplices, if anyone looks at anyone, use it to further your story. Most of your audience will be watching more than listening. Keep the dialog going, make sure your 'click track' is flowing, with builds to important moments. The pivotal moments can be played on the person revealing the facts, immediately followed by the impact on the defendant or plaintiff. These moments can be stretched to accommodate all the reactions of the players in the scene. It is like juggling, except you have more than three balls to keep in the air.

Remember that you have a wide shot that can help in the geography, but it usually diminishes the intimacy of the scene. Use it judiciously.

For long monologs, opening and closing statements, use the camera moves as much as possible, and the same rules apply that were discussed for your cutting pattern of the witness. Establish who is talking, go to the other players, the jury, the judge, and then re-anchor with the person giving the monolog. This pattern will get you through most of the dialog.

5.9 TELEPHONE CONVERSATIONS

It appears simple at first when you cut a telephone conversation. But it is far more complicated than cutting a scene between two people in a room. The editor must make the audience feel as if they were in the same room to support the intimacy of the story, while at the same time keeping the audience aware of the contrasting worlds around the two actors. We must focus the audience's attention on the important dialog, the reactions to that dialog, plus keep the two characters' geography within their different worlds believable, matching their placements from cut to cut.

Usually the dailies for phone conversations are shot on different days. Hopefully, the script supervisor has kept careful notes about which way the actors were facing, and/or the director has made a mental note of it. It is wonderful when character 'A' is facing left to right and character 'B' is facing right to left. This way it actually appears as if they are looking at each other. However, that is not always the case. The camera is panning around them, crossing the line back and forth. The actor is on the move, hitting marks, turning their heads right and left. But it is still the editor's task to use the pieces that keep the conversation intimate, and this is accomplished in part by having them face each other when possible.

The use of pre-lapping dialog and staying longer on a character's face for the off-camera dialog will help smooth out the inherent bounciness of a telephone conversation. Stay a tad longer with each character than in a dialog scene. When you cut back to the other character, make sure you pick them up where you left them. For example, if the character has moved from the plaza to an alley, we must see them change their background. It's the same as seeing an emotional change on camera—the audience must not feel left out of these changes. This might change your cutting pattern around the dialog. Perhaps a cutaway to show the character leaving the plaza to bridge the different locales will help smooth out this problem. The editor cannot allow mismatched geography to interfere with the audience's orientation.

Use the telephone filter effect found in your audio tool for offstage dialog before putting your scene to bed. You will see that it will affect the timing of your scene. Some cuts will have to be lengthened and adjusted for a better sound transition between futzed and non-futzed dialog. It is easier for the dialog editors to prepare for the dubb stage when certain words or letters are chosen for the cut point carefully. Making the split on consonants, like 'f,'

's,' 'm,' or sh, ch, th sounds, is infinitely smoother because these letters consist of more than one frame and can bridge the cut.

Remember to cut in the background sounds for each character's world. Interior, exterior, phones, office walla, street activity, horns. Some of these sounds will bleed through to the other person's world, and that only helps to smooth out the abruptness of a cut.

> The beginnings and endings of phone conversations are predictable. To mitigate boring your audience with this, pre-lap the phone rings, and maybe the first bit of conversation as well. To clean up the endings, I learned a trick from Mick Jackson, that is magic. To move it along, he had me start character 'A' putting the phone down and complete the action of the phone being hung up on character 'B.' This trick works in several situations—door openings, door closings, throwing projectiles.

There is a tendency to over-cut a telephone conversation. Keep it calm, keep it simple.

5.10 CROSSING THE LINE

The 180° rule is used as a guideline regarding spatial relationships. Character 'A' looks left to right at character 'B' who looks right to left. However, this rule is broken all the time, and there are ways to use it to your advantage, as well as ways to cut around it.

Crossing the line helps intensify desperate situations, heightens fear and puts the audience on edge. This is a choice that the director makes when deciding on his coverage for the scene. However, it is up to the editor how to use this footage effectively.

When cutting an action sequence, knowing where all the players are in relationship to each other is essential. First establish where everyone is before you cross the line into coverage. Remember, there are just so many times that you can cross the line before losing your audience. Be prudent.

When cutting a dialog scene with footage that crosses the line, it is important to identify exactly where this helps the emotionality in the scene. Do not fall prey to form over function. To help alleviate poorly planned coverage, and cross the line gracefully, use the power of motion to hide crossing the line.

Use a head turn, an arm gesticulating, a wipe, or someone crossing the room. Another disguise for crossing the line in coverage you must use is to blow up the complementary shot to take the onus off of being disoriented.

5.11 SUMMARY

Do something wonderful, people may imitate it.
Albert Schweitzer

Editors are storytellers. We invite our audience to join us on a journey that promises to keep them engaged. As the picture editor, we have incredible gifts that have been handed to us—a script with characters and plot twists, danger and love; a DP's visual feast along with a director's banquet of choices—wide vistas and close intimate coverage; we also have at our fingertips a full palette of music and soundscapes that serve to further capture our audience. It is our job to sculpt and contour the final story, which is the product of the amalgamated talents of so many contributors. It is quite a responsibility. And the amount of time in which we do this is, well, never enough.

When we first start to edit, we hear many tapes in our head—words of wisdom from professors, filmmakers, colleagues and our own soon-to-be discovered fancies. We sit before our editing platforms and watch/scroll through the dailies, hoping to shape the scene into its best form. The guidelines set forth in the previous two chapters are meant to give the new editor a starting point. However, one thing you must begin to cultivate is your own sense of empowerment. Be bold, try the unthinkable and feel free. Let your gut and heart guide your hand as well. Trust in your own judgment, your own taste and instincts. When you can do this, and let go of all the rules I have just laid out, you will partake in something marvelous.

Some of the rules of organization, creative approaches and editing styles are far different in reality and documentary filmmaking. The following three chapters delve deeply into these worlds, as seen through the eyes of my co-author and editing colleague, Diana Friedberg ACE (*Dog Whisperer, Renegade, Founding Fathers*). Diana began her career as a child actress, winning countless trophies and awards. She learned the art of editing which led to becoming the first female director in South Africa. She has had over fifty years of experience cutting documentaries, reality and dramatic films all over the world. Though all editors are storytellers, there seems to be no

limits to the amount of structure and story line development that the non-fiction editor and documentarian are asked to contribute. These shows require an incredible amount of patience, perception and editorial skills to achieve excellence.

Guidelines for Editing Non-Fiction

In feature films the director is God; in documentary films God is the director.

Alfred Hitchcock

Editing Scripted Documentaries

I think it's inevitable that people will come to find the documentary a more compelling and more important kind of film than fiction. In a way you're on a serendipitous journey; a journey which is much more akin to the life experience. When you see somebody on the screen in a documentary, you're really engaged with a person going through real life experiences. So for that period of time, as you watch the film, you are, in effect, in the shoes of another individual. What a privilege to have that experience.

Albert Maysles

6.1 INTRODUCTION TO NON-FICTION

Non-fiction film presents a narrative of real-life events and facts. It covers a wide range of styles, formats and subject matter. One of the earliest forms of non-fiction motion picture was termed *documentary*. Scottish documentary pioneer John Grierson defined it as a 'creative treatment of actuality.' Early American film critic Pare Lorentz defines a documentary film as a "factual film which is dramatic."

In the past, network television provided a platform for documentary films. On the whole however, they were not regarded as prime viewing material. The National Geographic Society first began its telecast on CBS Primetime Specials from 1964 until 1973. They presented informative documentaries covering a diverse range of subjects examining the natural world, wildlife, foreign cultures, exploration and other topics. Series like *Victory at Sea* (NBC 1952—Isaac Kleinerman—editor) and *The Valiant Years* (ABC 1960 —Aram Avakian, Walter Hess, Jean Oser, Lawrence Silk—editors) played

an important role in establishing historic 'compilation' documentaries as a viable television genre.

Documentaries have always served a vital service to society. The persuasive power of non-fiction is undeniable. During World War II newsreels and propaganda films were produced to keep the public aware of that great conflict or to lift public morale. Examples include the series *Why We Fight* (Frank Capra—director; William Hornbeck, William A. Lyon—editors) and *Memphis Belle* (William Wyler—director). On the other hand, the Nazis swayed public opinion and rallied support with productions such as *Triumph of the Will* (Leni Riefenstahl—director and editor).

With the proliferation of cable during the 1980s, non-fiction films gained popularity. Because they were more economical to produce than dramatic films, they began to fill broadcast slots. From 1985 to 1995 the Discovery Channel popularized documentary television programming and focused primarily on science, technology and history. In recent years it has expanded into reality television and pseudo-scientific entertainment. Another major force promoting this genre has been HBO. Since its inception, HBO with Sheila Nevins at the helm has produced documentaries and docu-series that have examined new fields and braved new frontiers, championing films which examine unusual and controversial subjects. Films showcased were edgy, dramatic and provocative. *Real Sex* is an HBO original series exploring human sexuality in all its forms and even in reruns still draws a wide audience. These shows are broadcast without commercial breaks, allowing the audiences to stay focused and to enjoy the experience without distraction. The National Geographic Channel, the Discovery Channel and A&E have also helped popularize the documentary as a viable form of entertainment.

The parameters of non-fiction film are continually evolving and today cover many innovative new forms and styles. There are compilation films where segments from other movies are edited into a new show. *100 years, 100 movies* was a series profiling 'the hundred greatest movies' chosen by the American Film Institute in 1998. Segments from the best feature films were montaged into ten themed episodes. Editors included Sue 'Spyke' Hirshon, Tim Preston, Diana Friedberg, Victor Livingston, Don Priess, Tom Donahue, Ali Grossman, Debra Light. Documentaries without words *Baraka* (Ron Fricke—director; David Aubrey, Ron Fricke, Mark Magidson—editors) and *Koyaanisqatsi* (Godfrey Reggio—director; Ron Fricke, Alton Walpole—editors) presented experimental compilations of different photographic

techniques with compelling soundtracks highlighting music and effects and no commentary. 'Mockumentaries' are now an accepted satiric format popularized in films like *Borat* (Larry Charles—director; Craig Alpert, Peter Teschner, James Thomas—editors). Biographical and historical documentaries *Eyes on the Prize* series (Charles Scott, Betty Cicarelli, Jeanne Jordan, Lillian Benson, Thomas Ott, Daniel Eisenberg, Ann Bartholomew—editors) and *The Civil War* (Ken Burns—director; Paul Barnes, Tricia Reidy, Bruce Shaw—editors) tell their narratives by relying heavily on photographs and archival footage. Human rights are dealt with in *Harlan County U.S.A.* (Barbara Kopple—director; Nancy Baker, Mira Bank, Lora Hays, Mary Lampson—editors) and *Don't Look Back* (D.A. Pennebaker—director and editor) covers Bob Dylan's tour of Britain. These two films both provided important statements about society using a free, roving camera.

The popularity of non-fiction film is on the march. Feature length documentaries are rapidly finding a home on the theatrical circuit. They are attracting the attention of viewers with their provocative and compelling subjects. *Fahrenheit 9/11* (Michael Moore—director; Kurt Engfeher, Woody Richman, Chris Seward—editors), *Super Size Me* (Morgan Spurlock—director; Stela Georgiva, Julie Bob Lombardi—editors), *Food, Inc.* (Robert Kenner—director; Kim Roberts—editor), *BlackFish* (Gabriela Cowperwaite—director; Eli B. Despres—editor), *Religulous* (Larry Charles—director; Jeff Groth, Christian Kinnard, Jeffrey M. Warner—editors), *An Inconvenient Truth* (Davis Guggenheim—director; Jay Cassidy, Dan Swietlik—editors), *20 Feet from Stardom* (Morgan Neville—director; Douglas Blush, Kevin Klauber, Jason Zeldes—editors) and *Citizenfour* (Laura Poitras—director; Mathilde Bonnefoy—editor) are some of the more successful of this genre. They all deal with pertinent issues even though their format and storytelling techniques vary greatly. They all present information in an entertaining manner. That is key.

From the 1950s technological advances in smaller, lighter, handheld cameras together with more portable sound equipment changed the way films were made. The filmmaker was now able to capture events as they unfolded in the field. They were in the center of the action and could present the story with immediacy. Cameras recorded the subjects' real emotions as they experienced them in a live situation. Conveying candid realism, a new movement known as *cinema-verité* was born. An offshoot of this genre gained popularity in the 1980s and 1990s and became known as reality television. This genre documents unscripted situations and actual occurrences. It often

features a previously unknown cast. Often highly dramatized, it exposes real characters in vulnerable and intimate moments and caught in a floodgate of emotions. Reality shows have taken the non-fiction world to inventive new arenas of entertainment.

Non-fiction film has always played an important role in reflecting issues, portraying actual events, investigating truths and examining life in all its diversity on our planet. Whether told in the giant 70mm IMAX format or recorded on small digital devices it has become a way of sharing stories about our world. Smartphones, tablets and cameras all have digital capturing capabilities, giving everyone the tools to document extraordinary moments and occurrences in everyday life. Events can easily go viral on the internet as the world shares the excitement or drama of some unusual or breathtaking occurrence. Witness the events of the so-called 'Arab Spring,' for example. YouTube is a popular site for viewing real-life incidents posted by amateurs. Social media has made non-fiction immediately available to everyone. Today the cyber world is commanding a large swath of the public's attention in TV's multichannel, video-on-demand and streaming landscapes.

What will distinguish your work as an editor from the amateur short clips uploaded to the internet will be the skill, craftsmanship and art that you bring. Each and every documentary film that you edit will be a journey into some aspect of life on earth and often far beyond. You will learn something new every day. With a sense of enquiry your life will be enriched beyond imagining. Being a documentary editor is a privilege. It will provide a highly rewarding and fulfilling career.

6.2 EDITING DOCUMENTARIES

> *Film editing is now something almost everyone can do at a simple level and enjoy it, but to take it to a higher level requires the same dedication and persistence that any art form does.*
>
> *Walter Murch ACE*

Every documentary film sets out to tell a story about an event, a person, a situation, or perhaps even a controversial issue concerning the world. How that story is told depends on how the film is crafted in the editing room. Footage can be cut many ways and lots of different stories can be cut from

the same material. The editor has the capability of seeing all these possibilities but his position is to interpret and give voice to the intent of the director. Often he works with suggested guidelines or director's notes. There is a form of documentary that is prewritten and will provide the editor with a guide script that will evolve during the editing and refining of the show.

To edit documentaries you need to bring along the skills you have acquired editing fiction. You will use them all. Everything discussed in previous chapters applies to cutting non-fiction. In addition, you will need to master sound editing. You will be more involved with the online process, mixing, color correction and general completion of the film than you would in most scripted fiction venues. A variety of different visual materials will form part of your palette. However, like editing scripted television, movies of the week or long-form features, your primary job is to tell the story in the most entertaining way you can with the material available to you.

- A strong sense of storytelling is the primary attribute that an editor can bring to the table. Understanding how to create a narrative arc that is compelling with a beginning, middle and an end is crucial. In fiction, the editors are given a script with all the action shot according to that final script. With non-fiction, many times there is no complete script only hours and hours of coverage. You have to craft a tantalizing and compelling story from the raw footage.
- The editor has many additional visual elements to aid the cutting process that are not commonly used in dramatic storytelling. Photographs, stock or archival footage, dramatic recreations, interviews, B-roll, animation, artwork, VFX and graphics are some of the tools available to help create the narrative. They need to be seamlessly integrated to highlight the story points.
- Unlike feature films or scripted television, the editor in non-fiction is often entirely responsible for creating the final soundscape of the production. Because of budgetary constraints in the non-fiction world, your responsibility will be to weave a finely balanced symphony using production tracks, interviews, MX, SFX, narration (voice-over—VO). The editor is the manipulator of what the viewer will see, hear, think and feel as the story unfolds.

Because of the vast scope and nature of documentaries, it is vital that you broaden your sensibilities to the world around you.

Widen your knowledge of music by regularly attending concerts, both classical and contemporary. Familiarize yourself with country, ethnic, pop, hip-hop, world music and folk songs. Experience as broad a spectrum of musical genres as you can. Listen to the music of the master film composers from the golden age of Hollywood like Miklos Rozsa, Elmer Bernstein, Max Steiner, Ernest Korngold, Alfred Newman and Jerry Goldsmith, among a list of many of the greats. Include contemporaries like John Williams, James Horner, Alexander Desplat, Carter Burwell and Danny Elfman. Watch their films and note where the cues begin and where they end. What effect does the music have on the story at each point? Identify themes and leitmotifs for characters. Note how these recurring musical phrases are associated with a particular person, place, or idea. Listen to the orchestra and identify instruments and the emotional impact they evoke. A cello, a French horn, an oboe, the double bass, or the twang of a sliding guitar can set a tone and heighten the emotional impact of a story. These choices will help you find ways to add heart and soul to your story.

You should attend live theater and scrutinize the acting. Be able to distinguish great performance from mediocrity. Pay attention to human behavior and analyze how and why people react the way they do. Learn how to decipher body language. This will strengthen your choices when cutting human interaction. Visit art galleries and sharpen your sense of composition and color. On a tight budget you may even be called upon to color-correct your own show.

Listen to the sounds of the world in all its complexities and understand nuances and subtleties. Hear the repetitive rhythms of a train on the tracks, the waves washing on a shoreline, the wind whipping through a canyon or howling between buildings in a city. Be aware of your environment and how you can reproduce sounds for dramatic effect. Sharpen your senses in every way possible. All these new perceptions will ultimately motivate your choices as an editor.

Cutting is a challenging task. Your instincts, tastes and knowledge of the world will be a great asset in your editorial decisions. With a heightened sense of awareness, you will accumulate a comprehensive kit of tools to draw on.

6.3 THE PROCESS BEGINS WITH THE SCRIPT

Scripted documentaries are written before the editing begins.

- The writing process commences with the producer/writer's concept of a story he wants to tell. Before production, he conceives questions that will probe the subject matter. These will be posed to the interviewees.

- Once shot, the producer/writer has a transcript made of all the interviews. His task is to select relevant bites and piece the elements together. He uses his subjects' voices to tell a story and redirects the beats with a written commentary interweaving the elements into a flowing narrative. This script is referred to as a 'radio cut' and becomes the guideline for the editor to begin crafting the film. You maintain the creative freedom to make your own visual and audio choices.
- The narration is often rewritten in the editing room when scenes are cut and sequences polished for the various screenings. A final draft of the narration will be refined before the show is locked. There are always last minute tweaks to be made to fit format and timing before recording and onlining. Be mindful that the script you are given is a blueprint for the completed production. Get used to the fact that the show is invariably rewritten and refined during the cut.

This style of documentary is often created for television networks as a single show or part of an ongoing series. Catering to advertisers' needs, the networks created formats for their documentaries based on those designed for dramatic television shows. They often fill one- or even two-hour slots. The format follows a template of set lengths with commercial breaks inserted at particular time intervals.

- A standard one-hour format includes a tease or cold-open, followed by a Main Title sequence and four or five acts separated by bumpers and commercial breaks. End credits roll at the conclusion of the program. The body of the show will comprise selected interview bites interwoven with narration. Act outs are written in the form of mini-cliffhangers to entice audiences to return after the commercial break.
- Most shows incorporate a mix of production footage, interviews, B-roll, stock, archival footage, newsreels, clips from other feature films, photographs, graphics, VFX, artwork, reenactments as well as any other visual elements that the producer deems necessary to help flesh out the story. The different elements can be written into the script with directives for the editor.

In television the director is sometimes referred to as the producer of the show and the term 'director' is not used. On independent non-fiction productions, the director will still be acknowledged as the 'director.'

If the scripted documentary is an independent production, then the director/ producer determines the format, length and style of the film. Subject matter can be as broad as human imagination will allow.

6.4 GET STARTED

Before getting started on your scripted documentary cut, determine if the film is a stand-alone production or part of a series. If part of a series, review completed episodes and take note of the style of cutting. Make sure you are comfortable with the task ahead and ask the producer about his editorial expectations.

- Like prepping for cutting episodic fiction, make sure you have all the elements used on other episodes digitized into your bins. Opening series titles and music, graphics, music that might be generic to the show, SFX with any special material used in previous cuts available to you through the shared media. (See previous chapters about having access to MX and SFX libraries.) All the same rules apply as you begin this journey.
- If it is a stand-alone production, you still follow the same prepping with regards to the media. Organize the bins and prepare for your assembly and cuts.

Remember, each film presents creative opportunities as well as a new set of problems. Be prepared to handle challenges in stressful circumstances because, be assured, there will be many.

6.5 THE FORM OF THE SCRIPT

When you come onboard you will receive a script written by a writer or the producer of the show and approved by the network.

- Read through the script and get a feel for the story. The writer or producer might suggest visuals to cover specific bites or narration. Every writer or producer will have his own form of laying out a script, but all will present the basic information for you to follow.
- On scripted television producers call for tone meetings to discuss any issues related to the show. This is an opportunity for the editor to

voice any concerns or thoughts he might have before he tackles the cut. So too with documentaries, it is key to discuss any issues you may foresee with your producer before you begin. He may have directives on a style or transitions, a tone for the show, or suggestions for the kind of music he envisages for the score. Split-screens or special transitions may be important. Make sure you understand any specific requirements before you begin the cut.

- Dramatic films use slates and a numbering system to identify everything shot. Slates might be used in non-fiction to identify an interviewee or to indicate a location but time codes (hours, minutes and seconds notated) are the feature most used to locate and organize material. All the interviews will be transcribed with time codes. The writer will indicate the time code of a selected bite on your script. This timesaver enables you to find the desired clip very quickly. B-roll will also be broken down by time code and a written description of the shots included in the clip.

A storyline is written in the AUDIO column interweaving narration and bites while suggested visuals are indicated in the VIDEO column. The time codes and digital card numbers for interviews and suggested B-roll are also noted for the editor.

Here is a sample of a layout for a scripted documentary.

TIME CODE	VIDEO	AUDIO
*CARD B0004 T/C: 07:40:01	Clear water. Sparkling. Sunlight reflecting on a lake, creek or river.	NARRATOR: ONE OF THE MOST PRECIOUS COMMODITIES AT STAKE IN THIS ARID REGION IS WATER.
*CARD B002 T/C: 03:11:10	Rain slashing against a window. Rack focus to buildings in a city.	NARRATOR: IN A LAND WHERE RAIN IS SPARSE AND WATER RESOURCES FEW, CONSERVATION OF THIS PRECIOUS ASSET IS CRUCIAL.
*Card A006 T/C: 00:37:11– 00:38:06	Interview John Doe.	Interview John Doe: The problems of river pollution and ground pollution are serious in our country. We have many, many wells, which have been polluted, so the problem of water pollution in our country is certainly widespread.

*CARD B003 T/C: 13:45:03– 13:55:09	Start on bird strutting next to water. All looks well and peaceful. Zoom out. This is a heavily polluted river that flows through the city. On either side of the concrete channel traffic and trains run by.	*First we hear the call of a gull. Mainly silence and nature sounds as the camera zooms back, the sounds of traffic and city noise override the natural sound and rises to intensity. (It must shock the sense to discover where we really are—a big city, not in the countryside.)*
		NARRATOR: THIS IS THE ORANGE RIVER THAT FLOWS THROUGH THE HEART OF THE COUNTRY'S BIGGEST CITY, BIG ROCK.
		NARRATOR: NORTH OF THE CITY, THE ORANGE IS SO POLLUTED THAT MERELY TO SWIM IN ITS TOXIC SLIME WOULD BE LIFE THREATENING. MANY BLAME GOVERNMENT AND PUBLIC SHORTSIGHTEDNESS AND A LACK OF AN ENVIRONMENTAL AGENDA FOR DISASTERS LIKE THIS.
*CARD A005 T/C: 00:37:18– 00:38:34 T/C: 00:49:12– 00:51:14	Interview John Doe.	Interview John Doe: The rivers are just open sewage canals. //0// the environment crisis is quite serious. We have to find ways to prepare for the future.

This writer has clearly visualized how his story should flow with the visuals. The last interview bite has slashes marked which indicates that the writer has lost some words in the middle of the bite. The second part of the bite is from another part of the interview and the time code is indicated.

6.6 VIEW THE MATERIAL

You always have tight deadlines to meet. The aim is to be able find material easily and make creative choices quickly. Be very familiar with your footage.

- View all the material. Scroll through the B-roll, stock footage, stills and other media that has been digitized into the system. It is vital to have intimate knowledge of all the elements you have been given. When cutting fiction the editor usually only views the selected takes and, if

he has time, will review the outs in search of alternate readings for lines. In non-fiction editing situations, it is essential that you are familiar with and sometimes even memorize all the footage. These are the colors of your palette with which you create your art.

- You will receive transcripts of the interviews in a binder with time codes marked throughout. Do not waste time reviewing all the interviews on the screen if your script already indicates the exact bites you need to use. These, as noted in 6.5, will have corresponding time codes marked in your script for easy reference. If you find during editing that a story point needs further highlighting, then the transcripts in the binder will become handy for finding the additional bites rapidly.

Remember in the editing room deadlines drive the activity. You are always looking for shortcuts to speed up your editing pace particularly with regard to finding material. Tensions mount when you are racing to finish. Be in control and know where all your material is located.

6.7 ORGANIZE THE MEDIA

Be smart and spend extra time upfront organizing your media on your desktop. This will save you hours of search time during editing.

- Organization is key to cutting non-fiction. If you do not have an assistant who has organized your material, you will need to create bins and separate the material labeling each element: INTERVIEWS, STILLS, B-ROLL, STOCK FOOTAGE, RECREATIONS, ART-WORK, ANIMATION, GRAPHICS and so on. Create bins for your cuts. Decide how you want to label and number all versions of your cuts. Generally you will follow systems set up for dramatic cutting but it is up to you to choose the labeling system that suits your needs.
- Break down the B-roll into ten-minute segments. This will allow you to scroll rapidly through footage when looking for an appropriate cutaway. Breaking the B-roll down into individual shots and labeling each one is labor-intensive and unproductive. It will also slow down your search processes. You may have to load up fifty individual shots to find a three second cut. A waste of time.
- When viewing footage indicate your selects with markers. These are easy to see on a timeline or in the source monitor. Write comments where necessary. Highlight the eye candy. Keep notes with ideas where specific shots could be used. If you have time, write up physical cards and pin them on a board in your room.

- Review the still images (e.g. photographs or newspaper cuttings) and see that they are all clearly and correctly labeled. These static images are low-resolution placeholders for editor's use only. You will create your own zooms or pans on these shots in the computer. Later they will be replaced with high-resolution versions on a motion-control macrophotography unit or rostrum camera.
- Check any recreations or dramatizations and determine where they fit into the story. Sometimes these dramatic reenactments can be enhanced with special visual effects. The action can be slowed down, ramped, or color-drained. They can be layered under a still. These are creative decisions you will make as you work through the cut.
- The producers view potential stock footage and order temp footage with visible time code. When the show is locked the final selects—matching your cuts—will be ordered from the stock house and will replace the temp footage before the online.
- In most non-fiction shows the editor is responsible for creating the soundscape. Establish a SFX library that you can easily access.

 - If provided by the production house, is it digitized into your system?
 - Has it been properly labeled so that you can find specific sounds easily?
 - Does your assistant have an extra library that you could access as well?

- Make sure you have a choice of different whooshes, which are helpful to punctuate dramatic moments or help emphasize dissolves and transitions. The library should be separated into categories and every sound identified for speedy access. Choosing the right SFX is vital. It gives the film a sense of authenticity.
- Determine what MX is to be used for the production.

 - Has a library been set aside for your use?
 - Has it been categorized for quick referencing?

- Classify cues into broad groups like dramatic, stings, ethnic, world music, jazz, pop, tones and other headings. As with fiction editing, if a composer has been hired to score the show, check whether he has any tracks from other films you can temp in before he writes the score. Talk with the producer about the tone and mood of the show. Keep your music track varied, interesting and relevant to the intention of the film.
- Series have established graphics that are repeated in every episode. There will be a Main Title sequence with music and a lower third banner over which to superimpose the name of the speaker (interviewee) and

his or her designated title, sometimes referred to as an affiliation. Make sure you have them digitized.

- You need to create temp banners to indicate components like commercial, end title, missing shot, temp graphic and stock footage. Put them all in the GRAPHICS bin. These will be used in place of the footage not yet available.

Now that you have organized your bins and have become very familiar with all the footage and elements at your disposal, read your script and have understood the story you are about to tell, you are ready to begin the assembly.

6.8 CREATE THE ASSEMBLY

Before you begin to make cuts, you need to create an assembly of the whole show based on the script you have been given.

- Find the bites from each interview as indicated in the script. Use the time code referenced in the transcripts to guide you to an approximate position of the bite in the dailies. Subclip the selected statement and place it in the INTERVIEW SELECTS bin or choose a name you prefer to use. Label it with the name of the person speaking. Follow this with the first three words of his statement. Add some dots and then add the last three words of his sentence. This gives a quick visual guide to the beginning and end of the bite.

INTERVIEW BITES

JOHN DOE: "I was walking down . . . gave him the gun."

JOHN DOE: "Giving up was . . . under the shaded tree."

JACK BROWN: "When we were . . . never to return."

"That was the last time . . . to see such a man."

- Go through the script and pull all the bites for each person and label them. Create a group of subclips of every interviewee with each bite clearly marked. The writer might have chosen to combine several statements from an interviewee to make a story point. Do not get stuck if the sentences do not follow each other in the footage. You can always

use the transcripts to find the second part of the bite if the time code is not indicated. You can group each interviewee together in the bin or you can rearrange them as they appear sequentially in the script. Decide what works best for you.

- You are responsible for creating the temporary narration or scratch track, which will be replaced by a professional narrator's voice when the show is locked. If your voice is not suitable, find someone around you who can give a read at a moderate pace with good inflections. Do not rush the delivery. Record the voice-over in your editing room.
- Begin your assembly by laying down the narration on your timeline. Cut in the bites according to the script leaving at least two seconds of black between the narration and the bite. These pauses will be adjusted as you mold your cut.

You now have a radio cut or a spine for your show. If over-length, it leaves room to trim as you feel fit. You need to report an assembly that is under-length to your producer. He will then take appropriate action to add more material to bring it up to time. The narration will undergo many changes during your cut, which you will record, lay in and notate in your script as you work.

With your bins organized, MX and SFX at your disposal, and a radio cut on your timeline, you're now ready to edit the show.

6.9 MAKE THE FIRST CUT

Where to begin?

This is a daunting decision facing any editor. As in any fiction venue, making the first cut is always the hardest. In episodic television or on a Movie of the Week (MOW), you cut sequences as they are shot, mostly out of continuity. The same applies to dramatic feature films. You begin cuts with the material on hand.

On scripted documentary shows you have all the footage in the bins. You have a radio cut assembled. You can logically start cutting from the beginning of the story.

Listen to the opening lines of the spine and decide how best to grab your audience's attention. Set a tone for the story you are about to tell.

Is the mood mysterious, mystical, lyrical or patriotic?

Experiment with music cues that could assist this intent. Find the right visual to accompany the cue in setting the mood. Allow the B-roll or other selected images to play with the music for a few beats before you get into the first bite of information or narration. Maybe a sound can introduce the show. An approaching ambulance with a siren screaming will set up the story that is about to unfold. This creates drama, excitement and tension. You must grab your audience's attention in the first few seconds.

Starting on a dry, 'talking head' can be boring unless the person has a startling and impressive statement to make. How to entice your audience to keep watching right from the very beginning is your responsibility. Use all the tools available and spark up those creative juices. You are the magician who has to weave this dry, voice-driven assembly into an exciting, dynamic, vibrant and engaging show.

6.10 EDITOR'S CUT

Once you have made your first cut you are on the road to creating your Editor's Cut. All the guidelines for cutting fiction as described in Part One and Part Two apply to cutting non-fiction. MX and SFX are all handled in the same way. Cutting rules are cutting rules. Transfer your past experiences of cutting fiction to the non-fiction world. Make the film entertaining. Be tasteful in your choices. Make your cut informative in as elevating a manner as possible. This is key to keeping your audience glued to the screen.

At all times, keep your viewers involved on an emotional level. Rely on your reactions to the material to guide your choices. Trust your instincts. If something moves you, it will invariably move your viewer. Heighten the emotional impact with the use of appropriate MX. Build the tension and create climaxes where necessary. Create ebb and flow to the rhythm of your piece. You are the one who manipulates the story and gives cadence to the finished film. Every editor will ultimately contribute his talents to achieving these ends.

- Work systematically through the radio cut embellishing the spine with all the cutaways, B-roll and whatever elements you have at your disposal. Tighten the bites taking out all the "umms" and "aahs," air, fluffs and phrases that you feel detract from the point the interviewee is making. Keep the bites smart and sharp. Remove any point that is

not well articulated. Remember, if it is essential to the story it can always be written as a VO.

- Remember to checkerboard your production tracks and interviews on audio A1 and A2 and keep the VO on a separate track, A3. Use A4 and A5 for SFX and A6 and further tracks for MX. This is a guide as each show will have different requirements. Keep all narration on a separate track for ease of mixing.

- You have to ensure that your narrative is working and it may be up to you to write or suggest a new line. If you are uncomfortable writing, ask the producer/writer to rework the wording for you. Record the fix and lay it down on the scratch track. Update your script with the new additions. Invariably the rough cut will be over-length giving you room to modify bites and adjust the narration. Keep track of all your narration changes and notate them on the script.

- Allow the show to breathe. Open it up. Let the lyrical moments play out. Don't make it so dense that it confuses or, even worse, bores your audience. Remember with fiction, the drama and action is written into the script and the coverage allows the editor to make it work to its full potential. In non-fiction, it is up to the editor to create the drama that will make the viewer's journey exciting and engaging. Use moments to influence the audience's involvement emotionally or intellectually. Let your creativity shine in those breathing spaces.

- The tease precedes the title sequence. It is a good idea not to cut the tease till you have completed your rough cut. By then you will be even more familiar with your material and you will have a better sense of which bites or shots will make the most impactful opening.

- Insert your still images when appropriate. Make your digital moves in your editing system to heighten the story elements. Plan movement on all stills for emotional, dramatic and intellectual impact. Images of your characters and events have to come to life. They represent real people and real locations. You are dramatizing their story, recreating events in their life or revealing their personalities. The zoom, pan, tilt, or other movement heightens the emotional and intellectual reaction to the image. Where appropriate, allow the audio track to guide the timing. Keep your zooms and pans even-paced and smooth.

 – A zoom into a character's eyes will lead the audience into the window of their soul. The camera movement could be accompanied with a dramatized line of the character speaking. The emotional impact could be further enhanced by the use of a sustained musical note.

- A static long shot of a house will act much like an establishing shot on a dramatic film. It sets the scene. Use movement with purpose. Zoom in if you want to take the audience into the interior or pull out, if you are ending a sequence and want to take the audience out of the action.

- Make sure there is a consistency of style throughout your show. Try and keep the speed of your zooms or pans uniform where appropriate. This adds to the continuity, style and fluidity of the visuals. However, if you are creating a special action sequence, you will need fast moves and whip pans to help create the illusion of action.

 - A still of a battlefield can be dramatized by using many CUs from the image. With short cuts, fast zooms in and out, and whiplash pans accompanied by appropriate SFX, you can simulate action with dramatic force.

- Some editors like to cut on the camera move to keep the visuals active and the scene energetic. Others like to leave a handle before the camera moves begin. Ken Burns, in *The Civil War* documentary series, lingered on his photographs and used slow-paced camera zooms and pans to engage his audience. It worked superbly. Measure how you cut on moves with relation to the pacing and the mood of your show.

- Cut in reenactments and decide on the best way to present them. This is a creative choice usually left to the editor.

 - Do you want to slo-mo them, partially drain color from them, or do you want to layer them over a still image?
 - Do you want to accompany the images using just SFX or maybe use only music to stir the emotions?

- Use these embellishments to the best effect. Dramatic recreations are nuggets of gold that bring the film to life adding excitement and visual interest to the story.

- Create montages if necessary, using either MX or SFX or both to highlight a story point. Cutting a series of beautiful images together with gentle music will create a lyrical sequence. A fast cutting montage with gripping music and appropriate SFX creates a tense action sequence.

- Enhance your cut with creative beats utilizing all your elements. Ensure you have selected the best eye candy from the B-roll to enhance the overall look of the show. Experiment with split screens, picture in

picture, or other visual FX in your toolbox. Transitions become an important stylistic in a show. Check with your producer if your ideas are acceptable before you get too deep into the cut. Do not be afraid to take risks but cover your tracks.

- If special VFX are scripted, use temp images or add a banner to indicate a shot is missing. Replace it when you receive the final footage from a VFX house. Banners remind you and your assistant to chase material that you need to complete the cut.

Some editors prefer to cut their music and add all the SFX as they edit sequences. Others prefer to do a visual pass on the whole show first, concentrating on making the story work. Then they go back to the top of the cut to integrate all the music and SFX. Find what works best for you in the given situation and time restraints.

Leave your first cut long giving room for producers to make lifts and cuts. Receiving notes from others are par for the course. Don't take criticism personally. And remember, you don't want to be in the position where you have to add time. It is only when the network approves the show that you need to fine cut and polish to time and specs.

Some general pointers to guide you along the way:

- Plunge right in and complete your first editor's cut. Review and recut till you are happy that the sequences flow and the story works. Incorporate the MX and SFX and create a soundtrack seamlessly blending one aural element into another. Adjust visuals where necessary to work with the soundtrack.
- If you have time, cut alternates and view which version works best. Overtime might be necessary until you refine your skills. Hard work and long hours are par for the course. The challenge is to finish a cut, meet the deadlines and present a show that reflects your best efforts.
- Schedules for the cut could vary from one week to a month or more depending on the size, scope and budget of the production. There is never enough time to linger in the editing room. With tight schedules and deadlines looming, choices have to be rapid.
- As in episodic dramatic television shows, you have act outs before the commercial breaks. Use a good music sting to create tension for the cliffhanger. Punctuate the moment. Fade out on your visual as you allow the cue to echo into the black.

- Some shows include an on-camera host who introduces the story, appears again after commercial breaks and does the wrap-up at the end of the production. This may be prewritten and is shot during production. Often the host's voice will provide the VO for the show. In some cases the host's on-camera appearance is only written once the first cut is completed. Leave scene missing banners in your cut until you receive the footage.

Watch the show many times to check the story flow and make sure it is as tight as you can make it. If you are happy with your cut, insert all the necessary graphics, format and prepare for a screening with the producers. It seems easy but the road to getting to the editor's cut is long and arduous.

Before a formal screening, mix the levels ensuring that the narration is audible and clear throughout the cut. Do not drown what is being said. Keep the MX and SFX low under the narration and bring it up when there is no VO. The MX should be mixed for dramatic effect. The SFX must punch in where needed. You are the conductor of your orchestra. Balance the levels. The cut and soundtrack must be seamless before you invite anyone to view. Always make the best presentation you can. Working as an editor requires passion, patience and perseverance.

In some instances a producer may want to sit with the editor during the rough cut. He may be keen to guide the cut and help mold the show. If this is the case, show a great attitude and be respectful of his position. If you prefer to work alone as you zone in and engage in cutting the story, voice your preference. If the producer agrees, offer to review the material with him upfront. Take notes of his suggestions and ideas. Be enthusiastic about his recommendations. If you do not include his ideas, you have to be answerable as to why they did not work.

There are so many options and choices to be made during the editing process that in the beginning it can be overwhelming. As you gain more experience or work repeatedly with certain directors/producers, you begin to understand how to interpret their vision. You will begin to grasp the subtext of what the director is trying to convey. You will gain speed in decision-making and will be able to complete cuts in shorter periods of time. You will develop your instincts knowing what is needed to make a scene work or what should be added to finesse a special moment onscreen. As you gain confidence in your skills, getting to the finishing line will be easier. You will find that you learn something new on every show. The process never ends.

6.11 INTERVIEWS

There is an art to cutting an interview. An audience quickly tunes out when they have to stare at what is known as a talking head, which is usually a medium shot of the interviewee.

- Generally the rule is not to stay on the person talking onscreen for very long unless he is really compelling. When you first see the interviewee, hold his image long enough to identify him with a lower third title. Cut away at an appropriate part of his bite and choose whether you want to come back to him onscreen for a few seconds to wrap up his statement. Use cutaways or other material that will best illustrate what he is discussing to cover his bite.
- If you have two different talking heads butted together make sure it does not jar or bump. If it does, use a transitional cutaway to smooth the cut. In this case, do not let the second talking head speak for too long before you bring him onscreen so he can be identified with a chyron.
- After characters have been introduced in the show you can use only their voices over appropriate illustrative visuals. You can also string various interviewee bites together over a montage if collectively their statements propel the narrative. Some documentaries use the interviews as voice-overs only and never cut to faces. They are, however, identified onscreen with a chyron allowing the audience to follow who is talking.
- Earlier in the book, we suggested rules for cutting dialog (see Chapter 4.1). Finding the cutting points in interview bites follows similar guidelines. When cutting away from a face, always try and cut at the end of the phrase. If you come back to the talking head after using cutaways, cut back to the interviewee at the beginning of a phrase. Use the natural speech patterns to create the rhythm of the cut.

> Each show dictates its own style. Check with your director before you make drastic choices of not ever showing the interviewee. It should be part of an overall style if you choose to go this way.

There are many creative ways you can improve and strengthen the story. Use the frankenbite technique to create something new. This is a term adapted to describe pasting words together from different statements to create a new phrase. Sometimes you need to cobble words together to clean up bad sound. In documentaries you should not cut words together to change

the meaning or the intent of what someone said. In reality editing however, you might have the freedom to make the characters say things you wish them to express.

Be creative in making the best possible narrative from the material. If an interviewee really does not cut the cloth and it is impossible to edit around his bites, eliminate him from the show. Of course, always get the approval of your producer before doing this or justify your actions when questioned. If the person delivers relevant information, it can always be transcribed in the narration.

6.12 LOWER THIRDS AND CHYRONS

In documentaries onscreen identification of the interviewee and his affiliation are placed on a special graphic. These lower third titles are created on a colored background for quick and easy viewing. Each show or series has their own template for the graphic. The producer will give you the correct spelling of each name and job title or affiliation. Enter it in the required font, size and color. Check your spelling.

There is a method to placing the lower third title.

- When you first see an interviewee leave him onscreen for at least five to six seconds. Let the audience see and feel the character before cutting away from him at the end of a phrase. Allow him to begin his statement and find a rhythmic moment to apply the graphic to the shot. As a rule of thumb, fade up the lower third for ten frames, hold the title card for three seconds and then fade out for ten frames. This gives the audience enough time to read the information. Lower thirds can cut in and out with the shot if the interviewee is only onscreen for three seconds.
- If you dissolve from the interviewee to the next cut, dissolve the title off with him. Do not identify the character again in the same act unless there is a specific request to do so. A lower third will reapply when you see the person for the first time in the next act after the commercial break.
- Should the interviewee speak a foreign language, a translation in the form of visual text (chyron) indicates what is being said. Create the translation sentence by sentence in the title tool and save it in a bin. As the interviewee says a line onscreen, place the matching text in the lower third of the screen. Fade up the title for 10 frames and hold it

for as long as it takes to say the line onscreen. Fade out (10 frames) or cut to the next chyron for the next sentence.

- Choose appropriate font styles to enhance your storytelling when using a chyron to set a location or a time. A title with a font of an old fashioned typewriter with each letter appearing onscreen one-by-one, accompanied by the sound of the clicking of a typewriter key, could endorse a feeling of being set in the past. Similarly a hi-tech font indicating a place or a date could set the scene for action in the future.

One of the golden rules is to keep the eyes and the mouth clean. Do not cover them with lettering. Shift the positioning of the title to make the adjustment. Lower thirds usually do just that—they are placed on the lower third of the screen. Use a font and color that can be read easily. Usually white or yellow are strong colors for reading over backgrounds. Use a drop-shadow on the titles if it makes the wording stand out and easier to read. If the person is speaking poor English, has poor diction, or there is a noisy production track, use the chyron to paraphrase or translate what is being said.

An alternate for using a chyron where the track is not clear is to have a VO repeat the lines. Let the interviewee begin his statement, fade his voice to a low level and then introduce an actor's voice reading his statement. This technique works well if the interviewee is speaking a foreign language. The dramatic effect can be further enhanced if the actor pronounces the words with the appropriate foreign accent. It lends authenticity to the scene.

Every choice you make in the editing room contributes to the overall story of the film.

6.13 STOCK FOOTAGE AND STILLS

Stock footage is obtained from a stock house specializing in licensing clips for public use. It could be from a library or an archive or could be sourced from personal home movies. It could even be clips from feature films essential to the subject of the documentary. The producers view potential shots, make selects and order a low-resolution digital version with visual time code to use during editing.

Be assertive but not aggressive in your attitude and demands. Producers will welcome ideas but do not accommodate assertive or unnecessarily argumentative personalities. You will not be asked back to their cutting room.

- The editor chooses the portions of the stock he wishes to use in the cut. Licensing the footage is costly and is often charged by the second. Be aware that using it extensively can become very expensive. If the post supervisor says your choices exceed the stock budget, look for other visuals that can replace some of your choices. If you feel that your selects are vital to your cut, fight to keep the footage and compromise for cost somewhere else.

- When you lock the show, the hi-resolution version of your selects will be ordered from the library or archive and will replace the time-coded working copy before the online takes place. Sometimes the stock footage could be home movies shot by a character in your film and the footage might be free. Check on the sources of your stock before incorporating it into your cut.

- Still images may be sourced and licensed from various libraries or may constitute photographs that belong to a character associated with the show. In this case, make sure there is permission to use them freely before including them. All paintings and artwork are also licensed from commercial sources like the Getty Library. Stills can be imported into your project as JPEGS, TIFS or PNGs. Design different camera moves on the images by using your program tools. Because of budgetary limitations on documentaries, check if the producers have a limit on the amount of stills you can incorporate. If you are over-budget on usage, be creative and use the same image in different ways. Always be mindful of the budget of the show and adapt your creativity to fit the monetary limitations.

- Try to create a pleasing visual flow. Historical black and white photographs which have been assembled from various sources may vary greatly in quality and color. Consider adding a sepia tone to give uniformity to the shots. Old color photographs may have faded due to age. A possible corrective device could be to drain all the color and present them as black and white images. Similarly, if you have historical black and white stock footage, sometimes adding a sepia tone or a color will improve the look of the scenes. Experiment to present the most pleasing visual results. Be creative with your options.

- Historical and biblical shows rely heavily on artwork or paintings to tell their stories. *Washington Crossing the Delaware*, portraits of Queen Elizabeth I, the Spanish Armada in flames, Moses on Mount Sinai, Jesus on the Cross, are just a few of the iconic paintings and images that producers rely on to illustrate their productions. If artwork is drawn

from many sources, try and keep oil paintings grouped with oil paintings and etchings with a montage of similarly styled etchings. It is visually more pleasing. Try not to juxtapose different art styles next to each other. Aim to maintain a visual fluidity throughout your cut.

When the show is locked the post supervisor will replicate the moves you have created in your system. The final shooting will be completed on a professional rostrum camera. These may be done in-house or in a post production facility. The motion control enables smooth and carefully paced pans, tilts, zooms and even multiple moves over the smallest of pictures. These actions will emulate the exact timings you have created in your cut. The hi-resolution images will replace your temp stills before the show is onlined.

Unlike the scripted world of fiction editing, when the show locks you may be required to make a cue sheet with the timings of all the stock or archival footage you have used in the show. Indicate the source of the footage (keep this clearly marked in your bins) and the lengths used. Stills used must be listed and, depending on their licensing rights, the number of times used in the show. Exact requirements will vary from show to show depending on the deal struck by the producers with the licensing houses. Check what specs are required for wrapping your show. On higher budget shows this task may be assigned to an assistant editor or a post production supervisor.

6.14 MUSIC AND SOUND EFFECTS

Everything discussed with reference to music editing in previous chapters applies to working with music in documentaries (see Chapter 4.18). Music plays a major role in the storytelling. It drives the narrative through a variety of moods. It sets the scene. It builds bridges between interviews, archival footage or reenactment montages. It can be used as source music or the underscore can be applied to enhance tension or set a tone. A lyric from a song can be utilized to propel the narrative or evoke a deep emotion. A sting can punctuate a dramatic moment. The music track is the driving force that helps sway the emotions of an audience. All documentary music may be scored or licensed from a library or could be a combination of both. Sometimes the producers rely on the editors to find needle drops for most of the show but will have a composer at hand to score sections that require special musical attention. On some network or cable documentary series

which turn over a show a week, budgets will allow for a designated composer to improve on some of the cues selected by the editor.

- Using music effectively will elevate your cut. Because you will be playing music under the voice it needs to be harmonious. Be aware that certain sounds do clash with the human voice. A single instrument sometimes jars with speech whereas rhythmic passages with no lead instrumentation will flow along with it. Experiment with the music to see that it subtly strengthens your intentions.
- Introduce unusual instruments. It can produce unexpected effects while amplifying what you are trying to convey. A slide guitar or a wailing harmonica will make that arid desert look even more remote. Unusual sounds immediately evoke deep emotional responses.
- Scenes with tension will benefit from thumping drumbeats. Use musical sounds that will intensify the drama.
- To set a tone or mood play a few bars of your cue with appropriate visuals before you add a voice-over.
- Don't forget to use your music thematically where applicable. Introduce melodies and instruments to signify ideas or characters or events. Use a melody played on a single instrument and amplify its effect by increasing the instrumentation to a large orchestra for the climax. Allow the larger sound to play under the end credits.
- Music can also add humor to your scene if used in a comical fashion. Glissandos on the piano or cymbal crashes can provide a surprising counterpoint to a visual. A series of atonal chords can create a jarring moment. Make your music work for you.

Because of small budgets for documentaries, you will probably not have a music editor to help with your selects. The score will be reliant on your tastes, choices and decisions. You are the music editor.

> Become familiar with musical terminology. A glissando, pizzicato, allegro, dissonance, chorale, a measure, a beat, a phrase, a coda, a finale, a monotone, a nocturne, pitch and prelude, resonance and rondo—these are terms that will help you gain an insight into the mystery, the magic and the potential of music. Know them and understand them. Use this knowledge to enhance your cutting skills. It is up to you to learn whatever you can about this vital component of editing.

Spot the cues and make decisions about when the cues will begin and end. Listen to the songs in the library and use the quick reference titles and

descriptions you will find listed with the CD. For example, from a music library album entitled *Epic Adventure*, the CD lists its cues under the following categories:

MAGICAL, ADVENTURE, EXCITEMENT

DRAMATIC, HEROIC, MYTHS AND LEGENDS

WONDER, IMAGINATION

The subcategory of MAGICAL, ADVENTURE, EXCITEMENT include cues with the following titles, duration and description:

Swooping and Hovering (1.23) Busy, scurrying orchestral adventure

Adventures in Magic (1.59) Creepy opening to rollercoaster adventure theme

Labyrinth (1.32) Secretive, tip toeing woodwind and pizzicato

Nautilus (2.15) Eerie, subterranean strangeness

Flight of the Pegasus (3.26) Heroic, fight of fantasy up into the woods

These titles, timings and descriptions immediately suggest the orchestration, mood and tone of the piece. Use this as a guide to begin your search for picking cues. Listen to different tracks. Find the score or song that will resonate for the scene. Very large orchestras with soaring melodies do not always play well in a documentary. Sometimes small groups or a single instrument will be more effective. Experiment with different cues and decide which is the most appropriate.

The length of the song indicated is useful information. Often long needle drops will have varying moods or rhythms in one piece. The extra length of the song might require that you edit selected parts to fit your visuals. On the other hand, you might need a cue that is 1 minute 5 seconds and the needle drop is only 30 seconds. View all the information to help make selections. With experience, you will learn to find potential cues very rapidly.

Trim the sequence or add shots to fit the music. Cut on beats. This adds a good rhythm to your piece. As you gain expertise you will find that you can drop in music with minimal adjustments to the picture because the rhythm of the score synchronizes perfectly with your cuts.

Be familiar with different instruments. Know the sounds they make and the mood they evoke. The solo cello or oboe stirs the heart. A didgeridoo or an Andean flute conjures up a mysterious ambience. A French horn is haunting. Cultivate knowledge of classical music from Baroque to contemporary. If someone asks you to use a Vivaldi, John Adams, or Gyorgy Legeti-style cue, you must understand the request. If asked by your director to lay in Beethoven's *Ode to Joy* over a wonderful sunset montage, do not be in a position where you have to ask, "What is that?" You will not be invited back.

If you are lucky enough to have a composer for your show, lay in a temp track that can be emulated in the final score. Use needle drops that you know the composer can replicate closely when scoring. A hundred-piece orchestra with male choirs and a solo soprano voice will definitely not fit the music budget for a documentary. If he has cues from other shows available, use them as a guide if it works for your project.

- A composer's original score can enhance themes, characters and ideas. Give suggestions for using a leitmotif, which can be developed as the show progresses. A simple melody played as a piano solo could be developed by a cello in another sequence to convey a different mood. These ideas should be represented in your temp track. Discuss your concepts during the spotting session with the director and composer and see if he can score what you have in mind.
- If you have a recurring visual element like an empty train traveling through a landscape to, say, a World War II Nazi concentration camp, establish a haunting musical association for this image. If the film is set in the rainforests of Africa and poachers are approaching unsuspecting animals, use a drumming motif to create tension when you cut to the threat of the poachers. Make your music work for you in subtle ways. It adds power and heightens the audience's emotional experience.
- As discussed earlier (see Chapter 3.7), try layering your music tracks to create a particular sound or an ambience that you visualize. A tone on one track can be melded with a melody played on a single instrument laid on another track. Mix the levels for the desired effect. You will

be amazed at how you can play with your music to create something totally original and fitting.

- Master music edits. Know when and how to cut on the beat or bar. The visuals might require two different moods in the same sequence. To achieve this you need to meld two different music cues seamlessly together. Dissolving music cues can work if done smoothly on the beat of the music. Sometimes just a two-frame dissolve can soften and ease a music cut.

- Every needle drop has a finale, a coda, or an ending. If you are using a section of the music from the beginning of a cue but want it to end to button up a sequence, you will need to use the finale from the end of the same cue. Lay in the music from the head of the cue on a track. Line up the finale of the same cue on another audio track from the tail of the shot where you need it to end. Use the visual wave-form on your system to guide you on the downbeat where you want to cut. Shift the tracks so you line up the downbeats on both tracks. Make the cut joining the two segments of music. The cut should be perfect. Giving an ending to your music is a great way to punctuate the end of a sequence. Even lift the sound level slightly as the cue rings out. Develop an ear for cutting music. Practice make perfect.

Vary the style and pacing of the music to keep the soundtrack dynamic. The audience will switch off if they have to listen to the same tone on a track for an hour. Apart from anything, it cheapens the show. Interweave the MX with the SFX, narration and production sound to create an audio spectrum.

One of the things that needs to be understood fully is that film is a medium of image and sound. And they are of equal importance. Know it, understand it and master it. The editor usually is responsible for laying in all the SFX. On larger budget scripted shows, there are sound editors who create the soundscape for the film once the show is locked. Often they use your temp tracks as a guide enhancing the sounds for the utmost dramatic effect. In the documentary world, your soundscape is the one that will live on the show.

Cutting non-fiction really does require great sound editing skills. On many documentaries, especially the independent productions, your sound track will become the final audio that will live on the show. Gain as much experience cutting sound wherever you can. Mastering picture-cutting techniques will follow once you have a firm grasp of working with sound. I began my feature-cutting career being

a silent observer in an editing room as a supernumerary at Pinewood studios in England watching and learning everything I could. When I returned to my home country, South Africa, I worked in the prolific independent feature film industry. Here we had the opportunity to begin apprenticeships working as an assistant—two-to-one in a cutting room—and worked laying in SFX and the MX, which was scored for the film. There were no SFX or music editors at all. As editors and assistants, we were all in on the mixing process whether we were finding extra sounds or lacing up the dubbing units. Those were the days when sound was on 35mm magnetic tape and was run in sync to the picture. The experience I gained before moving up to editor was invaluable. It gave me a sound basis for understanding the importance of the audio and how to create an appropriate and exciting soundtrack. Later when television was introduced I cut many documentaries and dramatic series, which again were completed without any help from music or sound editors. Assisting with sound on low-budgets features, scripted fiction television productions and independent documentaries is an excellent way for you to build your skill sets working with audio from start to final mix.

When selecting SFX, make careful and correct choices. Learn how to track sound. Listen to the world. Stand in your garden at night, close your eyes and become aware of the myriad of sounds that you hear. Night cicadas, distant traffic rumble, a police siren passing by in the distance, rustling of leaves as the wind gently disturbs the trees, a dog bark. Note them down. This is the level of complexity you have to recreate in your editing to create authentic soundscapes. Also be aware that there are many variations of a generic sound. The ocean is not just an ocean. It has many moods and deviations. A visual of a placid sea does not require the sound of waves thunderously crashing on rocks. The sound of waves lapping on a shore is different to the sound of waves lapping against the side of a fishing boat in a storm. The sound of a limousine car engine starting up is different to that of a racing car. Airplane engines all have different sounds. Be accurate in your choices for you can be sure that someone out there will recognize an incorrectly used sound. With many options at your disposal you can avoid errors in your selections. Make your soundscape as authentic as you can.

Also learn to use specific sounds to create and punctuate the drama of the story. Explore cutting sequences using only SFX for dramatic effect.

- The call of an African Fisheagle is an iconic sound used for evoking the African bushveld. Shutters banging against a clapboard house on a lonely seashore, a cry of a coyote in the open desert, the trumpeting of an elephant on the Serengeti, a fire engine siren echoing in the night,

a foghorn blast on a misty night—all these sounds, when placed judiciously in your timeline, provide powerful tools for punching story details and evoking emotional responses.

- A war sequence will comprise densely edited SFX on many tracks. Prompted by the visuals, lay in as many sounds as you can—human cries, cannon blasts, explosions, guns firing, sirens blaring and tanks rolling by. Create a textured and exciting soundtrack to accompany the picture. Lay them on as many tracks as required checker-boarding them as you go. When you are satisfied that you have added every sound that you deem necessary, mix all these tracks down blending all the effects to create a dynamic soundscape. Add the mixdown to your cut. This becomes a more efficient way of screening cuts. For the final mix, you can always replace your original sounds for the dubbing mixer so he can create a more polished and finessed track.

Once the show is turned over to the post producer, the dubbing stage mixer might make further additions or changes to SFX tracks. Don't be offended or take it personally, because remember everyone is trying to make this the best show possible.

6.15 CREATIVE TIPS

Editing documentary films will test your abilities. You could find you are lacking coverage to illustrate some story beats. Hard-pressed to come up with solutions, stretch your creative talents and solve the issue in a way that not only works, but elevates your cut.

- Use shots evocatively. A windswept beach speaks wonders about loneliness, for instance. Atmospheric landscapes often perform miracles. Suggestive imagery can be more exciting than a literal shot. Blowing autumn leaves with an accompanying SFX could be used to illustrate the fact that time has passed or someone has died. Don't be afraid to be poetic. Make intelligent and imaginative choices.
- A hole in the story can be fixed with added narration or a new bite from a character. If you are stuck, discuss other possibilities with your producer. Suggestions for low budget recreations or simple dramatic inserts often remedy a problem.

Your resourceful input is what differentiates your talents from others. For some, a shot of a waterfall is a stock shot establishing a location. The

imaginative editor will take this image and build a lyrical or dramatic sequence around it to create a mood or a special moment fitting and integral to the story.

A moment of foreboding can be created in a short montage:

Visual	Audio
Long shot waterfall	Sound of water gushing over the cliff
Close up tropical bird sitting a branch beside the waterfall	Bird chirps over the sound of waterfall
Long shot dark clouds with lightning flash	Thunder rumbles as a flash of lightning strikes
Medium shot bird flies away	Flutter of wings as lightning echoes and fades out

Always let your imagination soar above the literal when telling your story. You are the craftsman and you have the liberty to make magic with the material. Feel empowered, it is expected of you.

Every shot must contribute and further the story in some way. Check yourself by asking:

What does this shot add to my story and what significance does it have in the overall cut?

If it has no place, lose it. Always make sure that even the montages you create, propel the story and keep the audience involved.

- An important rule is not to repeat shots. It cheapens your cut. But under certain circumstances you might reuse a shot if it is integral to the storytelling and is being used to emphasize a point.
- A tightly edited montage driven by narration, MX and SFX is an inventive way to make a story point. Alternatively, using only SFX and matching visuals with the VO also has a powerful impact. Be mindful of all the choices available to keep the audience engaged and the soundtrack varied and interesting.

- Use transitions to add visual fluidity where needed. Some networks like straight cuts but sometimes a dissolve in and out of a talking head softens the edit. It takes the audience gently into a flashback, a recreation, stock footage, or a still. Experiment with different transitions to create a flow that is pleasing to the eye. Using white flashes as transitions varying from two frames to ten frames (or more) is a popular device used commonly in non-fiction editing. Add an appropriate sound whoosh and mix it high to punctuate the transition or mix it low if you want the transition to play more subtly. Avoid transitions that are self-conscious and jar. They take the audience out of the story.

Experiment with visual layering to create dynamic and energetic statements. There are many ways to be inventive.

- Try mixing B-roll with recreations to realize a special effect.

 - Place an image of a wonderful sunset on V1 and on V2 over this shot lay a silhouette of a lonely person walking in a desert. It will create a whole new ambience. Use rain falling on a glass window panel and layer a scene of some activity on another track. It gives a whole new dimension to the story.
 - Use B-roll of a printing press spewing out newspapers under dissolving stills of news headlines. Make the stills zoom in from infinity, spin and come to rest. This technique was rooted in features of the 1930s and 1940s. Even though it may seem old-fashioned in certain circumstances, it still works. Create interesting transitions between the moving images.
 - Similarly, creating old-fashioned montages of CU railway wheels layered over B-roll scenic shots indicates the progress of a journey or, perhaps, time passing.
 - Use stock shots of war scenes under B-roll of CU marching feet blending appropriate SFX on the track.

There must always be grace, form, elegance and taste in your choices. If it enhances your story use it. If it detracts, lose it. Dramatize story elements where you can. Use musical stings and SFX as punctuations, tones to create an ambience, MX to enhance the emotional impact of the story and beauty shots with underscore, to help the show breathe. Always keep the story flowing.

- Try and play natural sound open where possible. If you have a narration-and-bite-driven show, it really helps if you open up and break the monotony by allowing sound from a realistic sequence to play for a few seconds. Someone saying something relevant in natural sound, children in a class singing a couple of bars from a song, an elephant trumpeting, or a dog barking all add realism and interest to your sound track. This is also a good way to include a humorous comment from the production track. When you add color and texture to your cut ensure you are not detracting from the flow of the storytelling. Maintain the delicate balance.

- Slow motion and ramping shots are popular devices used to effect shots. These can be annoying and can date your film. Styles of filmmaking and editing constantly change. Use effect shots judiciously. Watch other filmmakers' work from around the world and make sure you are current with trends and technology. Use the tools available in your system to improve the visuals. Reposition your shots, blow them up (usually not more than 20 percent because of visual degradation) and utilize picture-in-picture and split screens in some of your scenes to bring new dimensions to your cut. Master the latest VFX technologies to augment the visual impact. Use special skills wherever you can.

Learn new programs. Keep up with technological advances and graphic tools. Be familiar with Photoshop, After Effects and other innovative programs that are on the market. Be aware of their capabilities and use them. The more colors on your palette, the richer the end product.

6.16 COMPLETE THE CUTS

Cutting scripted documentary shows for network, cable, or the internet follows the same procedures as cutting scripted fiction. You will create the editor's cut, producer's cut, network cut and the online version. If, however, you are working on an independent scripted documentary, you can create your cuts and name them as you wish. You will find that old habits are hard to suppress and you will more than likely end up using the same naming of cuts. Always remember to save backups of all your versions. You might want to revert to an older cut or use something you had created in an earlier version.

On independent productions, you will probably be responsible for overseeing the online, the mixing, the color correction, final titling, lower thirds and

other steps necessary to complete the post production process. Your schedules will consequently be longer and, depending on the project, you may have more time to experiment with cuts.

As in all fiction venues, the editor creates the first interpretation of the story in the editor's cut.

There are always last minute changes, additions and fixes to tweak before the producers arrive in your room to screen. Be prepared ahead of time so you are calm, collected and ready to screen. No doubt you will be nervous and filled with trepidation when you have someone view your efforts for the first time. Get used to it. Having an audience watch and react to your cut is humbling. You can immediately gauge reactions and feel the air when things are not working. Cuts you thought were brilliant can fall flat with an audience.

Always be able to defend your edits and choices if challenged. Offer alternative solutions to problems if asked. Demonstrate great attitude and take notes graciously. Be pleasant. Remember it is all about the show and not about you. You are the facilitator in this collaborative art. If there is a problem with the story or the visuals, the team will work together to find a solution. Everyone is trying to make the best show possible.

There will be a list of notes to address, which you will tackle immediately. Notes could cover any aspect of the show: find extra footage, stock, stills, or coverage of any nature; rewrite narration; change out a music cue; fix an incorrect title; or even replace a dissolve with a cut. Everyone in the room watching always wants to voice an opinion. You have a couple of days to make the changes.

When you have reworked the show and the creases are ironed out, prepare your producer's cut for another screening. You will be given a couple of days to address further tweaks before the show is readied for the network viewing. This is your network cut. The assistant will make an output with visible time code or will stream the show to the network for review and comments. In the best of circumstances they will love it. But that is not always the case. If there are notes, you will be given time to address them. Once a network cut is approved you will be ready to make final adjustments, get the show to time and specs, lock and prep for the online.

Delivering shows to the network and cable stations with their hierarchy of executives can try your patience. The show becomes subject to their tastes, whims and fancies. Be prepared for many executive notes and, like episodic television or a MOW, accept critiques graciously and make all the changes requested. If you cannot make the required adjustment, discuss it with your producer so that he understands the problem and can defend the cut with the network. You do not work alone. You are part of a team and must respect this fact. You should always be amenable to discussing issues with your producer. He wants to make the best film possible. This makes him and you look good. The right attitude and working cooperatively will keep you respected and employed.

6.17 ONLINE AND MIXING

After network notes, the editor makes the final tweaks. All temp stock is replaced with the final footage. Check that the time codes match the time coded digital working version and then do a visual check making sure all the sound syncs with the images. A good tip is to cut in the high-resolution stock on video V2 above the lo-resolution version on V1 so that you can toggle back and forth checking that the new shots match frame by frame. Replace the temp stills with the new images shot on a rostrum camera. Be prepared to make small visual or sound adjustments where necessary. If a composer has created the score, you will lay it in and make any picture fixes necessary to accommodate variants in the music timings. To record the final narration, the assistant times the scratch track for each sentence. The producer ensures that the professional voice reads and records his lines to time. A timed script is given to the talent to read.

Here is a sample layout for the narration timings the director will use to guide the actor during the recording of the final commentary.

FILM: The Baby Lion DIRECTOR: Jack White		
TIMINGS	VIDEO	AUDIO
3 seconds	Newborn Jenny	NARRATOR: THIS IS AN AFRICAN LION CUB NAMED JENNY.
8 seconds	Jenny nurses	NARRATOR: REJECTED BY HER MOTHER AT BIRTH, SHE WAS SAVED BY ZOOKEEPERS AND IS NOW BEING RAISED BY HAND.

3 seconds	Jenny peeks around a corner	NARRATOR: FROM THE START, JENNY IS FEARLESS.
	Jane Black	JANE BLACK: She knows she has no boundaries, she has no limits yet. We haven't found anything she won't do yet.
10 seconds	Jenny at two months	NARRATOR: BECAUSE OF HER EASY-GOING TEMPERAMENT, HER CAREGIVERS REALIZE THAT SHE'S AN IDEAL CANDIDATE FOR A VERY IMPORTANT TASK—ALLOWING PEOPLE TO SEE HER UP CLOSE AND LEARN ABOUT WILDLIFE CONSERVATION.
	Ellen Smith	ELLEN SMITH: We would like her to be able to go to events where she can be an example of why animals are so important in our life.
8½ seconds	Jenny with Ellen	NARRATOR: JENNY WILL BE PREPARED FOR THE ROLE OF WHAT IS KNOWN AS AN ANIMAL AMBASSADOR. BUT AN AFRICAN LION HAS A REPUTATION FOR BEING A DIFFICULT ANIMAL TO DEAL WITH.
	Ivan Jones	IVAN JONES: There are so many things that you have to consider. They're incredibly strong and can potentially be very dangerous.
3 seconds	Main show title with music	NARRATOR: ON RAISING JENNY

The final narration track is laid in replacing the temp VO. Sometimes minor visual adjustments have to be made to accommodate variations of delivery. Keep all the narration on a separate track as once the dubbing mixer has set the level of the voice, he needs make no further changes unless he hits a snag. It speeds up processes.

As sound editor, there are generally clean-up tasks you have to complete before the mix.

- Remove any background or unwanted noises on the production tracks. Use ambience or room tone (recorded on set) to cover the holes in the interviews, smooth any bumps on cuts and to create a background

atmosphere. Always be aware of what you see and what you hear. One is just as important as the other.

When every last detail has been checked and the show is in accordance with network specs precisely, lock the show.

- To prepare for an audio turnover you have to organize your sound tracks correctly. The stems of different types of audio have to be split to specific tracks. Production tracks (interviews, host on camera, dramatic recreations, B-roll, etc.) usually reside on Audio 1 and 2. Narration or VO is laid on Audio 3. SFX resides on 4 with MX on 5 and 6. Additional tracks can be added in this pecking order. Each set of tracks has to be output separately.
- Onlining the locked show follows similar procedures used for dramatic episodic television. The assistant prepares an EDL for the locked show, a reference QuickTime file with audio and burn-in information and a framing chart. He does the audio turnovers and preps the film for mixing. All the sound tracks are output flat as AIFF files with the keyframes removed. All the levels will have to be recreated during the mix.
- In documentaries as with scripted television, the post producer will control the final mix and oversee the completion of the film. There is usually limited time in the sessions to review and recreate every detail the editor has so lovingly laid in. Many details and nuances of his sound design will probably be lost as the dubbing mixer applies his talents to adjust the SFX as he sees fit. This is very disappointing when you watch your show and feel that they missed many of those special cues and sounds you sweated over. It is not customary for the editor to be involved in the final mix. It is time to let your show go.
- As in features and long-form television, if you are cutting an independent scripted documentary you will oversee all the final steps to completing your show. Together with your director, you will have final control on how the film will ultimately look and sound.

Now that your show has been delivered, you wait with bated breath to see your efforts televised or screened as you begin the challenges of cutting your next documentary.

Editing Non-Scripted Documentaries

Movies become art after editing. Instead of just reproducing reality, they juxtapose images of it. That implies expression; that's art.

Alejandro Gonzalez Inarritu

7.1 INTRODUCTION

Documentarians are often inspired to share their perceptions of the world. Some may want to examine subjects dealing with environmental degradation, wildlife decimation, global hunger or child abuse. Some may be driven by politics or social issues and be compelled to expose the atrocities perpetrated by cruel despots. Others may have a mission to examine extraordinary human situations or present a biographical tale of a famous personality. It is very difficult to write a script about these real-life situations before you have been in the field, explored the subject matter and captured events on film.

As with scripted documentaries, the germ of the idea can be developed in an outline. With further research the concept can be expanded into a more detailed treatment. This will express the filmmaker's intent, vision and how he hopes to achieve his aim. It will include potential people to interview, live situations to cover, references to archival footage that could be included and all the other elements that are deemed necessary to flesh out the story. This treatment will attract producers and persuade financiers to underwrite the production. Ultimately it will provide a useful guide to production requirements and shooting schedules. This outline and treatment, together

with notes made during the shoot, will be the editor's bible during the cutting process. There is no blueprint script for the editor to work from. The script for the show will be written during editing or after the first rough cut is complete.

Producing a non-scripted documentary is a complex task. Because of the lower cost of shooting digitally, the director has more freedom to shoot with multiple image-capturing devices. Smaller, lightweight, high-quality cameras capture unique angles and allow wider coverage of events. As in all forms of non-fiction, there may be many different elements that will comprise the final show. Interviews, live action, archival footage, newsreels, stills of newspaper articles, photographs, dramatic scenes or reenactments, artwork, graphics, B-roll, musical sequences, animation, visual FX, may all form part of the fabric of the film. With hours and hours of footage and coverage, the editor's role is to help find the voice of the story.

I was inspired to make a documentary film about humankind's tiniest creation—the bead. It was a story that had never been told on film. Everyone thought I was crazy. "What would the film be about?" they all asked. Being a confessed beadaholic, I had studied the subject and visualized segments needed to tell the story. Driven by my vision, I bought a small digital camera and, between cutting gigs, started traveling the globe documenting the world of beads. Over a period of eight years, the expeditions resulted in thousands of hours of raw footage captured on tape from the remotest atolls of Tahiti to the frozen realms of Alaska; from 4,000-year-old bead factories in the Indus Valley uncovered from the Harappan civilization to the tropical jungles of Guatemala in search of lost Mayan temples. Beads were made and used in cultures everywhere. The overall story for *World on a String* was how the bead links continents, cultures, religion, trade and people's passions throughout history. I set up my Final Cut Pro at home and digitized selects. The biggest task was to break down the material and organize the many stories covered into umbrella themes. Being an independent production I had the freedom to create a form and style that was best suited to tell the story linking the segments shot in over one hundred locations in forty countries. Plowing through the endless footage I began to weave together a story for a feature length film. Driving narration seamlessly linked the disparate elements. With the success of the first completed film, further films were revealing themselves and compelled me to continue editing. Eventually, all the footage was woven into five feature-length documentaries each individually themed. It was only through organizing the endless hours of footage that the story for each film began to reveal itself. The pieces of the puzzle found a shape and a form and each film found a voice weaving segments of interesting characters, situations and cultures into entertaining and educational documentaries. Organization is key to finding the story.

7.2 WHERE TO START

The challenges of cutting non-scripted documentaries require skillsets that are even more demanding than those required on scripted docs. Firstly, you must be able to manage and memorize large amounts of coverage. Then you must be sufficiently skilled to find the story in the coverage that will best represent the director's intentions. It can be overwhelming. Non-scripted documentaries have no defined length. They can vary anywhere from a half-hour to ninety minutes or more. It is a continuous narrative with no commercial breaks. With your input, the director will ultimately decide on the style, length and format of the film.

A story will only unfold during the editing process. You will get director's notes and an outline or a treatment prepared before principal photography. The director may shoot additional elements like backstories and reenactments as the film evolves. But whatever the coverage, you will be tasked with turning all the footage into a film that will tell a story and be honest to the intent of the director. This challenge will test your creative skills, talents and intellect. You have to be open to handling any or all situations. As editor, the director will rely on your input. He will welcome suggestions on storyline and structure. That is one of the reasons he hired you. The story and narration is created as the film finds shape.

Greg Finton ACE (*Waiting for Superman, The World According to Dick Cheney, He Named Me Malala*) has worked with Davis Guggenheim on several documentary projects.

Davis Guggenheim has this line, "With documentary the first time you have a script is your last day of editing." I think this is true. When you're starting a documentary, you are literally starting at the base of the mountain. You are asking, "How am I ever going to get to the top of that peak?"

Greg Finton

Overwhelmed by the daunting task at hand, every editor who begins a new project asks the same question:

Where do I begin?

- Some editors like to have all the interviews and the production tracks transcribed. This provides a quick visual reference that is helpful during editing. Upload the transcriptions to view on a tablet, on a laptop or into your system. Some editors prefer hard copies in a binder.

- If you are working without an assistant, collate any logs you may receive from the camera department.
- File notes from the director and check any special comments from the shoot. Organize all the materials you receive in a way that is easily accessible for you.
- ScriptSync is a useful tool designed to access shots very rapidly and find specific lines from the footage. Use all the short cuts you can to speed up processes.
- Be aware of technological developments and programs that could be helpful. Dropbox or WeTransfer are handy for sharing data.
- MX and SFX are essential and you need to establish libraries that you can use to create tracks. If the director decides to use a music library for the finished show, then the cues you choose will become the final music that shapes the film. If a composer is engaged, his score will replace the temp tracks. He will be guided by your musical choices so make intelligent selections that work for the film and can be emulated.

In the editing room, speed and efficiency are vital to meeting deadlines. Planning where all your media will reside on your desktop is a major undertaking. Organization of your bins is key. Label everything very precisely and keep all the different elements in separate bins. Refer to all the guidelines discussed in editing scripted documentaries (see Chapter 6.6 and 6.7). Ensure that you have organized all the material at your disposal as you begin the long journey ahead.

7.3 VIEW MATERIAL

On every production it is vital that you view all the footage thoroughly and carefully. Remember, the material speaks to you. Your first impressions are the strongest and the most critical. Trust your instincts and your visceral reactions. You can be sure that the audience will experience the events the same way. Let your emotional reactions to the footage guide your choices.

- Mark interesting, revealing or dramatic moments with markers.
- Notate dynamic or relevant bites, eye candy, story points or moments that move you emotionally.
- Highlight anything that pops out on first viewing.
- Start thinking about a storyline.
- Record story ideas on cards and pin them on a board.

- Color-code the dailies according to different characters. This allows for quick identification on the timeline. Customize your material to suit your editing methods.
- Find a system that works whereby you can remember what you have viewed.

All editors reviewing their material for the first time approach the process differently. Jason Rosenfield ACE (*Black Sky*, *The Race for Space*, *America Undercover*, *The Kennedy Detail*) and Kate Amend ACE (*Into the Arms of Strangers: Stories of the Kindertransport*, *The Case Against 8*, *Long Way Home*) express their views.

When I am watching dailies it is really a sense of discovery, of letting the story come through and looking for what speaks to me. Very often what the filmmaker thinks is happening when he shot it, is not what is working when you actually look at it onscreen.

Jason Rosenfield

I usually work on films that have been shot over a long period of time with lots and lots of footage, two, three or four hundred hours. I have spent six or eight weeks just watching all the footage. You do have to watch everything otherwise there is always this nagging feeling that you may have missed something. However, sometimes the directors will narrow it down to selects. For interviews it's essential to work with transcripts and logs. I like to work with paper and make lots of notes, marks, stars, asterisks and underlines. Every editor that I know says they cut from the gut and I am watching to check my emotional reaction to everything I see. I laugh in dailies. I have been known to sit there and cry when I am watching footage. I keep track of that because I figure if it moves me it is going to move an audience. Those are the moments that I build scenes around.

Kate Amend

On the films where I had all the footage shot before I start, I just screen for two months. I do not speed through anything. I always say, "You have to put that time in right at the beginning and must organize the material in some way in which you are going be able to remember it eight months down the road."

Greg Finton

In some instances the director sits with the editor and views the material together. It is an opportunity to exchange ideas and share thoughts about the story and the coverage. It gives pointers to what material the director believes is relevant and important and what material can be dismissed. These red flags help speed up your editorial processes.

Some editors prefer to view the dailies on their own and formulate their ideas without input from the director.

Every director I have worked with wants me to explore the material. Most of them do not have the patience to sit in the editing room any more. I absolutely love that. They want me to take ownership of the material. Of course that does not mean that I retain ownership.

<div align="right">Greg Finton</div>

The director hired you because he trusted you. Over time as the bond deepens, you will become more independent and confident as you edit the production. This bond can also lead to years of a working collaboration between director and editor, which is applicable to cutting documentaries as well as features. Michael Kahn ACE has had a notable and extended relationship with Steven Spielberg for more than thirty years. Sally Menke ACE had a long-time collaboration with director Quentin Tarantino, having edited all of his films until she passed away in 2010.

Try and develop a good understanding with your director. This could lead to a life-long working partnership.

It is vital that you persevere looking at every frame. View everything in real time looking for the tiny golden nuggets as well as the broad overview of the story. With endless hours of screening, the chore can become tedious. Enjoy your cappuccino as you absorb the material. Over time, you will develop skills that will allow you to memorize the footage and grasp the potential story beats as you view the material. Often you will go to bed with a million images dancing in your mind as you try to fall asleep. You will cut sequences in your head as you drive to work or you will ponder solutions to editorial problems as you take your shower. Shuffling shots and reorganizing sequences will preoccupy your thoughts during dinner. As you become more involved with your creation, it will rapidly take over your life as you eat, sleep and dream the production.

7.4 FIND THE STORY

There are many approaches to finding your story. Each one will be different according to the style of the film and the type of coverage. A character-driven story of a pop group performing on a nation-wide tour will present a whole different set of story challenges than a film about the complexities of the Syrian War. Be prepared to view each film with an open mind. Explore the possibilities in the footage you are given.

Remember, like with a fine piece of marble, the sculpture is present. It just takes a master craftsman to chisel and refine the material till it appears at its finest. So too, the story is there and you have to dig deep and refine it till it reveals itself.

When you have viewed the dailies you will have gained a perspective of the coverage. A story will begin to emerge. Bring in the director to discuss the narrative, purpose and intent of the show.

- Does the footage really reflect his initial intentions?
- Did a more interesting story line reveal itself during the shoot?
- Has the story sidetracked?
- Is there a specific message to convey?
- What audience are you trying to reach?
- What is the tone of the film?
- Is it a lyrical piece?
- Does it have a strong political opinion he wishes to disclose?

There are an infinite amount of questions you could ask. Discuss storylines, approaches, style, music and the form of the film. Share your ideas and thoughts. Give your input. Get editing directives. There are a million ways to cut a show and pointers are essential.

- View potentially problematic material together to get feedback.
- Understand your director's intentions. This will prompt your choices when you are alone in the cutting room. Filmmaking is collaborative and the more input from the director, the easier your work will become and less recutting will be necessary down the line. Editing is about re-editing until you find your story. The process will continue till the show is locked.
- If you are working on a personality-driven film, take time to understand your main character and how you are going to portray him. Find the scenes that reveal nuances about his personality or how he reacts in adversity. These subtle moments will come in useful as you start to build his screen persona. Find situations that best reveal his charisma, character or nature. Look for the dramatic arc in the dailies that will shape the story about the star and his foibles.
- Finding the story and the dramatic arc in the footage takes many paths.

After I have viewed the material I will very often make cards and figure out a structure and put them up on a board and then start at the beginning. This might not be the chronological or the shooting order but dramatically what makes sense.

<div align="right">

Kate Amend

</div>

- Use a bulletin board with index cards to help establish a story arc.

 - Is there more than one story line?
 - Which is the main one?

Write notes on cards and pin them up on the board. Identify the main story and list the subsidiary stories in order of importance. The less important stories may be lifted as you tighten the structure of the show. Use different color cards to represent different elements if it helps organize ideas. If it is a character driven show, use different colors to represent different people. In long-form television and feature films a card system is also used. The cards carry information about scenes and track the continuity of the story. When scenes are lifted or shifted this is indicated and the cards are reshuffled on the board. A speedy visual reference with the card system is a handy device to keep track of scenes and story beats. Utilize this system to track your ideas.

Some editors find it more practical to work directly with the material. Pam Wise ACE (*Secretary, Transamerica, Rory Kennedy*) has a different approach.

After reading everything and looking at most of it, I come up with a story—a beginning, a middle and an end in three acts. I start laying it out on the timeline. I do it roughly and fast rather than spending a lot of time on any one scene. I look at the show as a whole. I am just constantly shaping this big piece of clay.

<div align="right">

Pam Wise

</div>

Whatever methods you use, finding the storyline is the challenge. If it is difficult to visualize the narrative through-line, try a practical approach that is often used if you are cutting coverage that happens in real time like a concert or an event of any kind.

- As you view the production footage, select sub-clips of the story highlights. Create a timeline and string all the sub-clips together so you can have a condensed sequence of all the important action.
- Go through the raw footage again and sub-clip the subsidiary story.

- Repeat the process and create an assembly for each story. These are the building blocks for creating a structure for the film. Integrate the different stories into the timeline.
- Color-code each story if this helps identification.
- To strengthen the dramatic structure you might want to rearrange sequences.
- From this long assembly you will begin your cut.

You may never use this breakdown as your starting point for cutting. The dramatic structure might ultimately require a totally different sequence of events. It is not a wasted exercise because you will now have a more intimate knowledge of your footage. Save this assembly in a bin. It is a reservoir of all the best material from the shoot and can be referenced during the editing process.

Not all editors like to be responsible for finding the story. Some prefer to work with a more detailed outline from the director or even a blueprint script. As the editor, you will have to choose the projects that best suits your talents.

Once you have viewed all the material and have a concept for your story formulated, you are ready to make your first cut.

7.5 MAKE THE FIRST CUT

In feature documentaries, editors can be brought on before the shooting has begun, during the production or after the principal photography is completed. This always begs the question of where you should begin cutting. Which sequence is the one that will set the tone or impress your director the most? Every editor has different ideas and approaches of where to make the first cut. Use your instincts to decide which sequence will make strongest impact.

I always start with the most outrageous thing I have so that people want to see the next frame. I go through, pull out and mark everything I like and then I have all the moments that I want to weave together. I try to work every one into the story. I then take the most outrageous thing upfront and start asking questions as the viewer would and then I start answering them.

Pam Wise

I will often pick what I call soft landings to get going. I start with the easier scenes. I always try to keep it as simple as possible.

Greg Finton

I love to try to cut an opening right away even if it does not end up being in the final film; something that introduces the story, the tone, the themes and the characters. So I look for footage that would work as an opening.

<div align="right">

Kate Amend

</div>

Lillian Benson ACE (*Eyes on the Prize, Life is not a Fairytale: The Fantasia Barrino Story, Maya Angelou and I Still Rise*) has her own take on the first sequence she prefers to cut.

If there is a scene that a director has real reservations about or fears, I do it first.

<div align="right">

Lillian Benson

</div>

Watching dailies can be a tedious process and sometimes the temptation to make your first cut takes over.

There is a point at which you simply cannot watch dailies anymore. You need to give yourself a treat. You want to get juiced up; you want to create something that gives you a tone. Tone is really important. You will make a scratch track and throw some music in. It is just a beginning but you want to walk out of the room feeling, "You know, there might be a movie here." You want to put everyone else's fears to rest that you get the movie and you get the story they are trying to tell. This is important especially if you are new and the operation is new.

<div align="right">

Jason Rosenfield

</div>

Directors are always anxious to know if their footage is going to work, if you are the right editor and if there really is a film that they visualized in the dailies.

A couple of years ago I was working with two directors who were wonderful, and after we had watched most of the footage together they said, "Ok, what should we do now?" I said, "Well why don't you go away for three weeks or so?" They looked at each other like, "What?" But they did. I put together about twenty minutes and called them to come watch. I started rolling and within about a minute and a half I looked at them and they had tears in their eyes. They said, "You're making our movie!"

<div align="right">

Kate Amend

</div>

The director always gets excited about seeing his footage cut together for the first time. It reinforces confidence and allays fears. It encourages everyone to move forward in a mutually trusting atmosphere. Producers and directors are our collaborators. We spend months with them in the editing room, sharing views, opinions, discussing points and having amicable arguments over creative decisions.

<div align="center">

</div>

It is important that from the time we make our first cut to the time we deliver the locked show we maintain a cheerful disposition and cooperative attitude. Respect your director's voice. Be firm but not unpleasant if you disagree with his opinions. Always be open-minded about alternatives. Experiment with choices and save all versions. It is only through trial and error and an amalgamation of everyone's input that the final cut will be agreed upon. Eventually you hone the best version you can from the footage. It is at this point that you release the material even if the show ends up not representing what you believe is the best cut.

7.6 DEVELOP THE CUT

The biggest challenge for any editor is the schedule. Deadlines for the first cut loom large as you make your way towards the light at the end of the tunnel. There is never enough time or budget in post production schedules to allow the editor unlimited time to produce a cut. Some productions with large budgets and huge shooting ratios allow up to two years for the editor to deliver the final cut. Smaller-budget shows allow only a few weeks. Time is money. Deadlines are the goal. Speed and efficiency are the method. Be prepared to work around the clock and on weekends.

Is there a secret to being able to create a great cut and still meet the deadline?

I think efficiency is a big part of being quick. I'm not like physically fast. I don't push buttons with my elbows and fingers all at once. Working in the unscripted world really helped me build confidence and as I work more and more, I find that I work more efficiently.

Greg Finton

The editor has to be familiar with every frame in order to make the best choices quickly. In addition, he has to acquire a method of working that will maximize his speed. Can an assistant be an aid during this critical period? Again, every editor has a different take on utilizing the talents of the assistant editor.

I often will enlist my assistant to cut scenes. Or if it's a film with multiple characters I will give them a character to explore and develop. That's one way to speed things up when there is lots of material and pressure to get a first cut together. And I always make sure to acknowledge their contribution to the director and to audiences.

Kate Amend

One of the key elements to working efficiently on non-scripted documentaries is to master the organization of the material to enable access to shots quickly. A tremendous amount of how you work faster is dependent on the assistant and how well they organize all the elements.

Jason Rosenfield

However, there are times when the assistant can be over-ambitious.

One of the things that slow you down is when your assistant over-organizes or over-engineers your project. They take reams of exteriors, driving shots, beauty shots or night and day exteriors and they try to break it down to such a fine point that you have to look through eighty different bins to find the shot. A tremendous amount of expediency is really the assistant.

Jason Rosenfield

Initially you will include everything you believe to be important into your first assembly. When all the selects are placed together on the time-line the strongest and most relevant moments will reveal themselves. Focus on the highlights and whittle away material that is not relevant. The story will slowly begin to emerge and as you continue to eliminate material, the storyline will become clearer and stronger. Concentrate on building the structure with a dramatic arc. Find your acts. As you hone down the assembled material, the editor's cut will begin to emerge. If time permits, review your coverage again. This allows you to double check that you have included all relevant material for the story that you may have gleaned over during the first viewing. You may come across some small gem that may now be relevant to your story that didn't seem important at first viewing. These are the moments that elevate your cut and contribute to a fine polish. What follows is sound advice.

When I work in long-form I work very quickly and very roughly. It is not expedient to spend time on scenes at the beginning. You don't want to refine sequences that you think might be thrown out. Far less than twenty percent of the overall of what we cut makes it into the film.

Greg Finton

I agree with Greg. Many sequences will be lifted from your timeline as you work through the first editor's cut. It is advisable to find your story before you start creating a finished soundtrack to individual sequences. Sometimes it might be necessary to work with a piece of music or a specific SFX to make a sequence work. Include this but do not opt for a completed soundscape on your first pass.

During the editing process do not hesitate to call in the director to discuss any issues. Cutting in isolation without screenings and input from the director is definitely not advisable. You can get too close to the material and cut yourself into a corner. It is better to get feedback early on and know you are on the right track. Reworking large chunks of the show will result in many more hours in the editing room. If the director is still shooting on location, try and set up a video conference call and run cut sequences by him. Discuss any editorial problems you might be having and collaborate in trying to solve them. Nothing is more humiliating than completing many segments of a show only to discover they are not what the director wants. You are there to bring his vision to life. The more you collaborate, the more successful the outcome.

If you have a long post production schedule, there will probably be many screenings along the way to ensure the material is working. The process of completing a first cut is long and tedious but it is challenging and exciting. Eventually with experience you will be able to make good decisions faster, find the stories quicker and meet those deadlines with ease.

7.7 COLLABORATION WITH THE DIRECTOR

Knowing the preferences of how the director likes to manage the editing process will eventually dictate the projects you choose to work on. Many editors prefer to work alone in the cutting room. Without anyone in their space they have the freedom to zone in on their thoughts and keep focused on their cuts. They will call in the director when they are ready to screen cut sequences and take notes and share ideas. Others rely on the collaboration with the director who sits beside them directing each and every cut on a daily basis. You will choose the projects to work on that best satisfy your methods of working.

Most of us do not want the director there all the time when we are cutting. Some of the most productive sessions I have had with my director have been when we decide, "Let's take a fifteen minute walk." The physicality of being out of our cutting room and out of the office frees you up.

Greg Finton

Be aware that screening unfinished cuts, which are still very much 'a work in progress,' can be misleading. Sometimes it is hard for a viewer to visualize how the cut will work without the right MX and the right SFX in place. If you trust your director you will be able to explain to him how you intend

to enhance a scene. If not, it is better to spend the extra time completing your presentation with the full sound track.

The confinement and pressures of an editing suite can be overwhelming. Personality clashes with the director must be avoided at all costs. Be respectful of your collaboration with the director no matter his level of experience. You are there to serve his vision. Problems and pressures of getting the film realized can be disruptive and destructive. Keep a cool attitude. Seek out co-workers who will be great team players and who will look out for each other. Self-restraint, good judgment, patience and even simple humility are essential. Always be cheerful and never complain. Be cooperative and always be open to criticism. Encourage a supportive environment. Never allow your ego to get in the way of your professionalism. It is through working closely in the editing room that trust builds and a strong bond is formed. In this atmosphere you will thrive, create your best work and produce a fine end product.

7.8 NARRATION

As you are shaping the story, a narrative track will become necessary. Narration or VO is about writing in sync to the visuals to tell the story. It is the hook that unifies the show and grips the audience's attention. Make every word count and keep it conversational and easy to listen to. It needs to be compelling, informative and serves many functions.

- It imparts information that can guide the audience into viewing important features.
- It sets the scene or gives background information that brings the action into focus.
- It clarifies details that are not immediately obvious to the viewer.
- It foreshadows events about to happen.
- It summarizes the purpose of the film.

The writer, whether he is a hired hand or the director himself, becomes the most important contributor to the finished film. He has the task of writing the narrative in the most concise and relevant style suited to the story of the film. It will often take several rewrites to make his words fit the visuals of the film while making the point that drives the story.

Every film is unique and will offer a different approach to creating the narration.

- If a writer is assigned to the show he may be brought on to start creating the VO as you complete a sequence.
- When the director is the writer, he will work closely with the editor and create narration as the cut progresses.
- If the director has confidence in the editor's writing talents, he may leave it to you to create a rough working script. Use his notes if applicable and write to the visuals.
- Record a scratch track. Lay it in on the timeline as a guide.
- Collate the script and keep track of changes as you go along. The temp track will be rewritten many times before the show is locked.
- The designated writer will be brought in when the film is cut and will rewrite and polish the script that was created during the editing process.

The narration itself can take many forms.

- The most common is a single narrator reading the commentary for the whole show.
- Sometimes the narrator is a character from the show and the narrative will be told from his point of view. During the edit, you may suggest further lines for the character to say which will strengthen his story. Email him new lines for temping in. He can record them for you on his smartphone and email the audio track right back. You can drop in improvements as you work. This will ensure you have a clean and smooth narration for screenings. Nothing is more jarring than listening to a narration with different voices on the scratch track. Clean recordings can be redubbed in a sound studio once the show is locked.
- In other instances, the narration could be an amalgam of many characters, a tapestry of interwoven voices telling the story. Visual titles will help identify the characters speaking.
- Another format is to have an onscreen host who presents the story. His voice will carry the commentary. If you require fixes, record a scratch track with him as you work.
- A popular device used in historical documentaries is to have famous actors record quotes from personalities portrayed in the show. It helps dramatize the story and bring the character to life. This all forms part of the fabric and texture of the narrative. You will replace your scratch track with professional deliveries once the show is locked.
- Sometimes shows will be an amalgam of narrator and VOs of many characters portrayed. These choices will be made in accordance with the style of the show.

- Keep the language used for the VO simple, direct and easy to listen to.
- Sometimes a story is told from a specific person's POV. Make sure you temp the appropriate male/female age-appropriate voice into your scratch track.

Maintain a good balance between the narration telling the story and allowing the visuals to speak for themselves. Wall-to-wall narration is a death knell. Use commentary judiciously where and when it is needed to further the story. Allow the visuals to play with music or SFX. Let the show breathe. Allow the audience to be entertained and have a moment to absorb the information. Don't bombard them with too much information that they cannot take in.

Sometimes a writer will rework the lines said by a character in the film. This will be with the intention to replace bad sound, character fluffs or labored statements. There are many reasons to write a narration rather than have someone in the show say it. Mark Andrew ACE (*Beyond Scared Straight, If You Really Knew Me, Access Hollywood*) found he was fighting for authenticity in a film he was editing.

When I was doing a biographical two-hour piece on the Bee Gees I would have a constant argument with the director saying, "Who do you really want to hear tell the story at this moment of their life—the narrator or Barry Gibb? You might be able to write flowery language, but don't you think you want to have Barry's voice in here telling his own story?"

Mark Andrew

These are the creative choices that influence the outcome of the show. The commentary is vital and needs to be correct on every level. Narration and writing is about rewriting and tweaking as you create the film.

Decide on the type of voice required to read the narration. In selecting a voice make sure it is pleasant enough to listen to for the duration of the documentary. A poorly narrated commentary can significantly detract from the audience's viewing experience. Many actors may perform well onscreen, but cannot read a narration that is credible and convincing. To deliver a pleasing narration requires a special talent. As in scripted non-fiction, the final VO will be recorded with precise timings matching the scratch track after the show is locked.

Sometimes a documentary is constructed and formatted so that no narration is necessary. The characters and the situations reveal the drama and carry the story. There are no interviews and no VOs. Such shows are hard to construct and difficult to pull off successfully but, when well edited, they

are totally absorbing. Remember to keep this option in mind when determining the format of your show.

7.9 MUSIC

A film score serves the same purpose in fiction and non-fiction productions. The question arises:

Is there a right time to bring in the music when you are cutting?

Every editor has his preferences.

As a rule, I do not like to start cutting with the music because you end up cutting on downbeats and the music starts dictating the rhythm of your cut. If I find a piece of music that I think will work for a scene, I dial that track out and continue to cut and then bring the music in. Ideally that music becomes another voice in the scene. It becomes the subtext or part of the subtext. I think it is usually a mistake if you decide to cut to a piece of music that becomes the driver.

Jason Rosenfield

I end up working with a scene cutting with a rhythm in my head and then I will go back and start putting in music. Somehow the music makes the cut exactly where it was supposed to be. It is amazing! My rhythm was right with the cut of music I chose. It was like they were married to each other.

Mark Andrew

I do not use much music at all. On the narrative films I like to use it as transition, as a comment at the end of the scene and to take you into the next scene. Sometimes I use it to pick up the pace. I do not think I have ever used it throughout a scene in a narrative film and not much in documentaries.

Pam Wise

While editing it is up to you to decide when and how you introduce music into your cut. Pay special attention to all cues if you are using a music library and needle drops as these cues will become your final music track. If a composer is assigned to compose an original score, then the final spotting of where the music cues will begin and end will be done in collaboration with the director and often the producer as well. An output of your cut with visible time code and the music on separate tracks will be given to the composer. When the final score is delivered, you will insert the cues and make any visual adjustments necessary.

If you are using library music, you may be responsible for drawing up a music cue sheet for the producer. This indicates the exact amount of music

used from various libraries. This information is necessary for the royalties that will become payable to the musician's performing rights organizations in the United States and abroad.

- Keep track of all your cues and make sure you have the necessary information correctly listed. Check with your producer if you are missing details.
- If the movie uses scored material, the task becomes relatively easy.
- If you have a music supervisor or a post supervisor assigned to your film, he will perform this duty.

Here is a sample of a music cue sheet for use of library music.

Series/Film Title: *Water Crisis*	**Company Name:** *Free Productions*
Episode Title/Number: *N/A*	**Address:** *298 Sunset Blvd, L.A., CA 90027*
Estimated Airdate: *6-10-17*	**Phone:** *1-800-777-7777*
Program Length: *90 minutes*	**Contact:** *Laura Jack*
Program Type: *Documentary*	**Network Station:** *Alternate Channel*

Cue #	Cue Title	Use*	Timing	Composer(s)	Publisher(s)
1	*Crisis Theme*	*MT*	*0:10*	*Larry Brown*	*Go Doe Music*
2	*Running Water*	*BI*	*0:24*	*Larry Brown*	*Go Doe Music*
3	*Skies the Limit*	*BV*	*0:20*	*Jenny Green*	*City Music*
4	*Black Rock*	*BI*	*0:10*	*Larry Brown*	*Go Doe Music*
5	*Genesis Opus*	*BI*	*0:35*	*Larry Brown*	*Go Doe Music*
6	*Four Seasons Redux*	*BI*	*0:03*	*Grant McKay*	*Terracotta Music*
7	*Water Crisis Theme*	*ET*	*0:45*	*Larry Brown*	*Go Doe Music*

* Use Codes:	
VV = Visual Vocal	**MT** = Main Title
VI = Visual Instrumental	**T** = Theme
BI = Background Instrumental	**ET** = End Title
	BV = Background Vocal

Always make sure you are using music that can be licensed. Do not include a Beatles' song only to discover a week before the mix that you cannot clear the rights. If you are unsure that a piece of music is in public domain (PD) ask your producer to help investigate for you. You do not want to spend extra hours recutting sequences to a new cue especially before the dreaded deadline.

7.10 REFINE THE CUT

Be fearless in your choices and decisions. Take risks. If your cut is not working structurally, experiment. You might find that the end sequence of your show could make a fantastic opener. This could be the hook you were looking for. Reshuffle the sequences and see if it works. Be inspired. Be resourceful. There are countless obstacles to overcome as you create your cut. Keep the material at your fingertips. Try solutions and create and save alternates so you can compare versions. You must be confident that in the end you have made the best possible film from the material you have been given.

Over the years cable executives developed a common mantra: "Tell the audience what they are going to see, tell them what they are seeing and then tell them again what they saw." You might not agree with this philosophy but remember audiences are easily distracted. Your job is to keep them watching your documentary. Be wary of showing scenes that overstate their purpose. For instance if you are cutting a battlefield sequence, be aware of how many killings and dead bodies you include. Watching too much violence on the screen can cause the audience to change channels. Assess how far you want to go to shock your audience before it becomes distasteful. Use all the tactics you can muster to keep your viewer engaged. Create an elegant film that will inspire, educate and entertain—a film that everyone will want to watch. Implement your ideas with care and good taste as you leave your imprint on every frame of the show.

7.11 MIXING

The technical steps for completing a non-scripted feature documentary is much the same as for scripted non-fiction, dramatic episodic, features or MOWs. Editors working in long-form documentary have spent many months birthing their baby and want to oversee the final delivery. They choose to supervise the completion of their films to ensure that color correction is perfect and that every detail on the timeline is mixed to their satisfaction.

Each documentary will demand a specific focus. A film featuring a rock musician in concert will command many more music tracks to provide the multiple choices necessary to create a multichannel music experience. A film with many battle sequences will be FX-heavy and will require multiple SFX tracks enabling every gunshot and cannon blast to create a realistic ambience in which to immerse the viewer. As editor, you manipulate where the music level will rise slightly between the VO and where the SFX will play prominently; where you want the music to grow out of the FX; where you wish to fade the production track into the music. You manipulate how the audience will react emotionally to your story by controlling the levels of sound and blending it all into a harmonious and exciting audio experience.

Here are some of the post production duties that you might be responsible for as editor on independent documentaries:

- To prepare for your mix, ensure all your elements have been reassigned on the correct tracks as described in scripted documentaries (see Chapter 6.16 and 6.17).
- Don't cut one sound element onto another. The re-recording mixer has to set levels on each sound clip so split and checkerboard each element on a different track.
- Some clips may need head and tail handles to cross-mix to prevent the cuts bumping.
- Mark all the tracks with a pop at the 59.58 mark to coincide with the 2-second mark on an SMPTE leader cut onto the head of the video. This allows the mixer to align the sync on all the audio tracks with the video track.
- The tracks are transferred as AIFF files.
- An accompanying output of your cut as a QuickTime file will be used for referencing during the mix.
- Watch the cut with the re-recording mixer beforehand and discuss the overall design as well as the potential problem areas.
- Let him make the first pass so he has a chance to bring his own creative ideas to the film. In the process, he will clean, filter and equalize the tracks and solve all audio issues as they arise.
- It may be essential to add extra ambience and sub-mix music or SFX tracks to smooth out all the sounds.
- The mixer will first create a composite track called Music and Effects (M&E) combining all the production or dialog tracks, music and

SFX without the narration. This M&E can be supplied to a foreign distributor who may want to add VO in the native language of his territory.

- Generate a final mix from combining the M&E with the VO track.
- The director and the editor will listen to the final mix with the picture and suggest improvements where necessary.
- When the last tweaks are perfected, the final mix will be married to the color-corrected online with all the completed graphics and visual elements in place.

When all of this has been accomplished, you will have undergone an intense but deeply satisfying experience. There will be many months of blood, sweat and tears. But there will also be countless memories of moments of intense joy and fun that was shared during the show's creation. And there is that wonderful feeling of gratitude when an appreciative audience applauds the final outcome. You will feel proud to have been a part of the team that produced a production that will live forever.

Capture the Action

If chess has any relationship to film-making, it would be
in the way it helps you develop patience and discipline in
choosing between alternatives at a time when an impulsive
decision seems very attractive.

Stanley Kubrick

8.1 INTRODUCTION TO REALITY

Reality is the latest incarnation of non-fiction television. It is a genre that covers a wide variety of diverse programming. The unifying element is that all of these shows feature real people being themselves, hence the term reality. Even if the stars of a reality show are celebrities they are shown as themselves and not playing a character. In order to make programming that is entertaining and that uses regular people who are not professional actors or performers, the reality world is built on casting, producing and editing.

For decades, the American public watched hidden camera shows, game shows, nature films and documentary series like *An American Family: The Louds* (Pat Cook, Eleanor Hamerow, David Hanser, Ken Werner— editors). This groundbreaking series aired in 1971 and was originally intended as a chronicle of the daily life of the Louds, an upper middle class family in Santa Barbara, California. It ended up documenting the break-up of the family and subsequent divorce of the parents Bill and Pat Loud. Many consider this series to be the first reality show.

The popularity of reality programming as a genre began in the early 1990s with the breakout success of *The Real World* and has since mushroomed into

countless iterations based on a similar premise. Docu-series are a series of shows that are close to actual documentaries and show us true stories and real people. *Parts Unknown* is a widely popular series featuring the world-renowned chef Anthony Bourdain as he travels across the globe to uncover little-known destinations and diverse cultures. Producers heighten the tensions in docu-dramas by creating more interest in real people or in a real situation. *The Deadliest Catch* is a series that chronicles the real-life high-sea adventures of the Alaskan crab fishermen reputedly the most deadly profession in the world. Docu-follows are more of a slice of life or a character-driven piece instead of over-the-top drama. *The Simple Life* featured wealthy socialites Paris Hilton and Nicole Richie and follows them as they struggle to do manual, low paying jobs such as cleaning rooms, farm work, serving meals in fast-food restaurants and working as camp counselors. Docu-soaps sometimes have soft-scripted story lines and the cast may receive direction or coaching from the producers to enhance the drama. *Starting Over* was a docu-soap that ambitiously aired an episode every day. It followed the stories of women who are experiencing difficulties in their lives and want to make changes with the help of life coaches. There are also reality competition shows where real people are put into produced but unscripted situations. Here real people must learn to adapt to an unusual situation and to each other. *Billionaire: Branson's Quest for the Best* had contestants working alongside Branson for three months to win a million dollars. Some people also include the major singing or dancing competition shows as part of the reality genre. *The Voice, Dancing with the Stars* and *American Idol* are currently the most popular in this category.

The appeal of reality television is rooted in the real thoughts, experiences and emotions of the cast. Reality characters are not trained performers; the personalities they project are their own and their conversations are unfiltered. Casting is critically important. The success of a reality show depends on having characters that pop. That is why so many reality characters are seen as extreme in some way. They may appear raw, clueless, politically incorrect or sweet, funny, overly emotional or somewhat crazy. Their aberrant behavior becomes fascinating to watch. Truth is often stranger and more intriguing than fiction.

Reality television does not always present action captured in real time. Some shows feature recreations of events that happened in the past or off-camera, and some may be largely soft-scripted or produced. Sometimes cast members are given tasks to perform or challenges to complete and sometimes they are given pre-planned storylines to follow that are consistent with their character.

Depending on the show, there may also be pick-up interviews shot after the main reality has been captured. This covers new plot developments or provides clarity about what has already occurred. In many ways these shows do not truly reflect reality. They are designed to entertain and keep audiences watching. There can be no boring moments in these stories. As reality programming garnered greater viewership and commercial potentials increased, producers began to raise the ante. Celebrities unabashedly flaunted their vulnerabilities and the world gravitated to watching their relationships playing out in their living rooms. There is a growing resistance to the term 'reality' for those who work in this genre primarily due to its association with programs such as *Keeping Up with the Kardashians.* Many prefer the term 'unscripted.'

Alongside the commercial proliferation of sensational shows there are still serious filmmakers who continue to use the reality format as a means of discussing social issues and exposing topics of deep concern. Hoping for positive outcomes, they offer resolutions and present hope and redemption for the characters involved. Many reality programs choose to tell relevant stories that will make a difference in society as in *Beyond Scared Straight.*

Whether you work on a show like *Dancing with the Stars* or *Survivor,* you will find the editing approach and the experience totally different. Every show creates its own style and format that will best tell its story and entertain the audience. Workflows and editing responsibilities are different on every show. The amount of editors and the sharing of media and cuts on the acts and the whole show differ from production to production. There are no two venues that are organized the same way. More than in any editing venue, whether fiction or non-fiction, you will have to learn to be a consummate team player.

Like many documentaries, reality shows mix shot footage, generally referred to as the reality, with sound bites from the cast. These can be proper sit-down interviews, or short check-ins shot on-the-fly or in-the-moment during the action or on location. Some shows use confessionals where the cast members are given small handheld cameras and reveal their thoughts and feelings in self-shot video diaries. There are also some reality shows that use no bites at all and tell their stories through reality footage only.

Each reality show will have its own style, tone, manner of storytelling and workflow. There are two challenges that they all present. The first is to figure out how to tell the best story possible with the reality, interviews, music,

B-roll and coverage you are given. The second challenge is to get through a very large amount of footage in a never-enough amount of time to be able to hit the airdate. There is no one way of cutting a reality show. There are guidelines that can be adapted in each and every situation. The overriding commonality though is that each editor on the show is a pivotal storyteller who weaves all the elements together in the segments assigned to him. This storytelling talent is again the greatest strength you can bring to the table.

8.2 FIND THE STORY

Reality programming is not scripted. The story unfolds as it is happening on location or in a studio. Many cameras cover the action and events. The shooting ratios are high and coverage can exceed ratios of 400:1. There are many elements that go into creating the shows. There are often background packages of the characters, on-camera interviews, confessionals, B-roll, music, graphics and a variety of filmic elements necessary to create an entertaining story. Organizing all the material is key. Every post facility is a problem-solving environment. It is the responsibility of the assistants to organize the massive amount of material on the server. Today, with sophisticated media-share technology, everyone in post production is able to work on the same material at once and share cuts, footage, B-roll, SFX and MX and have access to all the files at the same time. Finding the story for the program is the challenge.

- Once all the footage is digitized and grouped, a story editor, also called a story producer, will review the media, select bites and footage and put together a paper cut that will be strung out by an assistant editor. This stringout is assembled on a timeline and constitutes a rough story outline for the editor to use as a basis for the cut.
- Some shows, generally the larger shows, do not use stringouts and schedule time into their post production schedules for the editors to watch all their footage and pull their own selects. Many editors like to view all the reality so they can familiarize themselves with other story options and choices.
- If you are an editor on a show that employs stringouts, you will soon learn to gauge if the stringout you have been given is workable or whether you need to go back into the footage and watch the raw footage for preferable selects.
- Cutting will begin from either the prepared stringout or from the editor's own selects.

- Every editor and every company has a unique way of working and the function of the story producer differs vastly from show to show.
- Many productions have multiple story editors and multiple editors working on one episode.

Marlise Malkames ACE (*The Bachelor* franchise, *The Hills*, *The Apprentice*) cuts reality episodes with several editors working on the same show. They have organized a method of finding the story that is unique to their situation.

At The Bachelor, *we do not use stringouts. When I start to cut a new episode, everybody who is working on that show will get together and have a story meeting to discuss the story arcs, the main characters, the big beats, and we all agree on a structure. Then, as we are putting the show together, we may need the story producer to pull bites for us. They will go through the interviews and will find all the bites where one cast member talks badly about another or where people talk about a specific event. I like to pull my own material because it gives me more ideas for cutting.*

Marlise Malkames

Stringouts so often depend on the abilities of the story producers and their gifts for storytelling.

Stringouts are a nice starting point if you have somebody who really is good and understands story. Story producers I find are a lot like assistant editors. A good one makes your world perfect, a bad one makes your life a nightmare. I have worked on shows before where I have relied heavily on story producers. I have worked on shows where I have thrown out their stringouts and said, "Thank you very much for that. Now I'm going to go back in and craft it myself." I have always subscribed to the notion that whatever a story producer gives you, look thirty seconds before and thirty seconds after because that is where the real gold is going to be.

Mark Andrew

But for some editors, like Sharon Rennert ACE (*The Bachelor, The Real World, High School Reunion*), the story editor plays a vital role.

The good story editors can be invaluable. When we are under the gun and we need to rethink the overall stories that we are telling, it is really helpful to have a great story editor around who can offer suggestions. They know all the footage and they understand the storytelling. When you are looking to locate a crucial line or piece of action that will pull the story together, they can be invaluable in helping you find the missing links. If an editor is under pressure and has to meet a deadline and has to work with someone who wants to help but does not get it, it can be a hindrance.

Sharon Rennert

Finding the best story hidden in the hours and hours of reality is the biggest challenge facing the editor. There are so many variables and factors that can influence the direction, style, tone and intent of the piece. Not least is the fact that your show might be a stand-alone episode in a series or one episode of an ongoing series. This again influences the role of the story producer in helping focus the story.

On The Bachelor *where you have a ten-episode arc with the same characters, the story producers become a lot more essential, because they're the ones who are really going to be able to tell exactly how episode 3 is going to affect episode 5, which is going to affect episode 7. These decisions are actually created by the producers and passed on down to the story editors. With a self-contained story on each episode, the editors need the story producers a lot less. On* Beyond Scared Straight *which is a self-contained episode where every character only appears in that show, we do not work with story editors or their stringouts for the main story. We look at every frame of footage and cut all of the reality.*

Mark Andrew

You can manipulate and shape the story and characters in so many directions. Remember, you are not alone as the creator on the show. With a guide from the story producer, there are always notes from various producers and the network that have to be acknowledged and incorporated into the cut.

Reality is a different animal than scripted episodic because in episodic, your script is pretty much the story that's going to air whereas in reality there are many variables. The story that actually makes it on air is dependent on what happens at the end of the show and how the characters resolve situations, on what happens in the field, on what the producers want, on what the network is looking for, on how the viewing audience responded to what has happened on previous seasons, on how your lead looks or how a character acts. Are they too harsh? Are they not harsh enough? Is this romantic? Is this not romantic enough? Is the action clear and does it make sense or do we need to tell the story a different way? You may go into a screening with an executive producer having given it your best shot at cutting the footage as it was produced, but by the time you are screening in post they may have something completely different in mind. Maybe something happened in the field, or maybe the season ended differently than everyone expected. Perhaps the network has new thoughts. Scenes you originally thought were important are often discarded and footage can be repurposed and recut in a completely new direction. It is really an editor's medium.

Marlise Malkames

The challenges of cutting reality can be overwhelming with issues you have no control over. The story editor has a great perspective on the overall series

story arc and could provide invaluable information to the editor about future episodes and where the story needs to go and how the characters develop or how and when they leave the story. Seek their participation when necessary and work their suggestions into your cut. Learn to be part of a team.

8.3 WORK AS A TEAM

If you work as an editor in reality, you will work as a team member with many players sharing a show.

- Every production company will organize the setup of the editing teams and their responsibilities according to the demands of the show. Post producers have to factor in the deadlines, the amount of coverage, turnaround of cuts, screenings or the number of assistants. These are some of the issues that influence how the workflow is divided between the various editors.
- Working as a team member in a multi-editor situation requires a whole different set of skills to working on your own as editor on a show. Good attitude is vital. Cooperation is key. It is common to find one editor recutting the work of another and it is imperative that the editor accepts this graciously.
- Most shows have different levels of editors working together to get the episodes cut and on air. A lead editor goes by many different names including showbuilder, finisher, supervising editor, sometimes even co-producer. His responsibilities vary from show to show, but in general he is responsible for ensuring uniformity of the series' style, getting the show to time and making sure that all executive producer and network notes are addressed successfully. This includes recutting scenes or sometimes entire acts at the last hour. He checks the graphic elements, the transitions and formats every episode ready to air. With so many editors cutting segments, he ensures that each episode is consistent in style and format. There is also an unofficial term for a lead editor who post produces his own work; he may be referred to as a preditor.
- In addition to lead editors, there are act-cutting editors who do the first or sometimes second pass on an act before handing it to the showbuilders.
- There are tease editors who are responsible only for cutting the teases for the episodes.
- Sometimes there are specialty editors who cut specific set pieces which could be challenges, boardrooms, live performances, competitions and other sequences specific to the show.

- At all levels, editors are expected to cut in all MX and SFX as well as the reality and all sound bites.

Part of working as a team means that somewhere along the line your work might be recut, shortened or changed before the show is locked.

The showbuilders—and there could be two or three per episode—will take over the show and finish the work. If we are designated showbuilders, we will recut or finish all our team's work as well as our own. You need to work as a team because sometimes you get hammered with notes and you have to hit air. Recently I had a big chunk of a show still to cut so they brought in another showbuilder who had less to do and he took over some of my stuff. Would I have loved to do it myself? Sure, but it's going to be a great show and the guy's a terrific editor as well and we're all friends who have worked together for a long time. You develop a collaborative attitude. It's not always the happiest thing to not be able to finish all of your own work but we all need help sometimes. Getting it on air is the most important thing.

<div align="right">Marlise Malkames</div>

Editors share a common loyalty to each other. A successful collaboration between editors is vital to the success of the cut. Camaraderie and trust should ensure that no editor talks disparagingly about another when there is a producer or director in the room. Personality often plays an important role and egos need to be sublimated. It is all about working together to create the best show possible. No matter the size of your team, it is teamwork that will give these shows coherence, uniformity and unity of vision.

On The Bachelor *when we're in full tilt in the middle of the season we have about twenty-six editors and seven or eight assists, some working day and some working at night and we cut in teams. The teams are assigned based on what is needed for each episode and every episode has a different combination of editors on it. We are assigned according to our ability and expertise. Editors with less experience cut easier segments while the more experienced editors cut the special acts when something unexpected has happened. On* The Apprentice *and* Survivor, *there are four four-person teams that move through the season as a unit doing every fourth show together. The lead editor is the showbuilder, the second editor cuts the scenes of the losing team, the third editor cuts the winning team, and the fourth cuts the setup moments and whatever else is needed. Speciality editors cut certain challenges. On some shows everyone cuts and finishes their own episodes and on other shows all episodes must pass through a single finisher. There are dozens of different workflows in reality.*

<div align="right">Marlise Malkames</div>

Cooperation is essential as a team member. There should be no hard feelings having someone recut your scene. Understand that it was done to improve or shorten the cut. Vince Anido ACE (*The Millionaire Matchmaker, Secret Millionaire, Celebrity Wife Swap*) understands the challenges of working as a team member.

You get used to this kind the process and working as a team. Sometimes the person who has the first crack on the scene will kill it and you won't ever revisit or touch it again, but then there's always those scenes where the whole episode hinges on it. Often those get reworked in five or more different ways till it is right. "Sorry it is your turn this week. You get to deal with that." It is just part of the process and some people take it better than others. If you're one of those people who are having your stuff recut, look at it and say, "OK what did they do differently?" This is a great learning experience especially when you're a junior editor. You have to learn to dissect that and then you grow and learn.

Vince Anido

Respect the ethics and the integrity of the editing room. Remember what happens in the cutting room stays in the cutting room. This is a safe, secure place where people are free to express their ideas without negative consequences. On the whole, keep your personal feelings and opinions to yourself. At all times be professional. Do your best work, develop a pleasant attitude and be respectful of everyone and everything. Adhering to these principles may ensure that you will be invited back.

We always try and share duties in the most respectful way possible. If anyone on my team sees something in the work and they have comments or notes, we discuss it privately within our small group. It's not brought up when we go into a larger screening where the supervising producers, the executive producers or the network are present. We represent a unified team when we present our cut. We support each other when the executives question something about the cut, even if we questioned the same thing in private.

Mark Andrew

Because you are part of a team, it is very important that there is conformity of timeline management in reality editing. Since your work is very likely to be recut by a finishing editor or someone else on the team, it becomes vital to use the same parameters and track assignments to make the workflow smooth and enable the next editor to do his work quickly and efficiently. These parameters are usually set by the supervising editor and are a part of a style guide for the show.

- An often-used format is to keep production sound on track 1 and 2, interview bites on 3 and 4, SFX and VO on 5 and 6, and MX on 7, 8, 9 and 10. More tracks can be added for SFX and MX as needed.
- Make sure that your track splits match the other cuts.

As editors you are always learning how to craft the best show you possibly can. There are so many choices and decisions about what material to include and what to exclude that it can be overwhelming. If you are stuck ask a co-editor for an opinion. Someone else might just have a fresh approach to something that you have agonized over. Revisit your cut after the re-edit. It will open another door to understanding how to handle problematic material and turn it into gold. Treat it as a learning experience from which you can expand your talents and grow. In the world of episodic dramatic television, if the editor's work is recut by another editor it is an ominous sign that you might be replaced soon. In reality shows, it is par for the course. Trust, cooperation and loyalty to each member of the team are of the utmost importance.

8.4 STACKING AND AUDIO TRACKS

In reality productions it is common practice to capture the action using multiple cameras. Many innovative angles captured from unseen cameras placed in hidden and strategic corners of the set allows for greater coverage. This in turn presents challenges for the editor as he wades through hours of footage trying to craft a show from the multiple editing choices at his disposal. All the media has to be organized by the assistant editors in a way that can be efficiently managed by both the editors and the story producers. One of the best methods of arranging the media is to create a stack of all the footage on the timeline.

- The assistant editor assembles each camera on different visual and audio tracks in the same timeline all synced to the same matching time code. In this way you will have matching action from different cameras stacked one on top of the other. This immediately facilitates the viewing of the dailies and the coverage at any point of the shoot during the day. When each camera turned on and off is represented on this timeline.
- The different cameras do not always cover all the action at the same time so you might find that one camera did not capture the action from a certain point but will pick up capturing at a later time code. On the timeline there will be a gap for this camera, which will sync up once

that camera starts rolling again. In this way it is possible to see where there is coverage for the sequence from all the different cameras at the same time or coverage from maybe only one camera at any particular point in time.

It is arduous to create the stacks but it is invaluable for the editor. Toggling between the different tracks will give immediate access to all the coverage available. He can review all the material with great speed. The editors do not cut with stacks. They cut with multigroups prepared by the assistants. The stacks are only used by editors as a reference for coverage. On scripted dramatic shows the editor receives detailed coverage notes from the script supervisor with a description of every shot and pickups clearly numbered. Even the director's choices of the best takes are circled for the editor. All this information is notated on a corresponding facing page. The reality editor will normally only receive minimal field notes from the location. The stacked timeline becomes the visible indicator of the coverage for the scene.

It is best to think of the stack as a painter's palette. I can look at this palette, this timeline, and I can see every bit of footage that was shot on that day. It shows me every camera, every piece of audio. After the assistants create the stack they have to take all of the video and group it, so that we will be able to do a live switch as we do with ordinary grouped footage.

Mark Andrew

In addition to the multi-cam setup used for this style of coverage, there are also many audio tracks that are recorded on set.

- The primary soundtrack for the show is recorded on a boom and syncs with the main camera. In many cases all the actors or participants each have a separate Lavalier radio microphone which records their audio on a multi-track recorder. All these tracks are delivered on a hard drive so the editors have the ability to pull the best sound from each person.
- Typically the editor will get a live mix on tracks 1 and 2 which is what the sound man in the field thought was the best audio at the time. Often a character may be off the main camera microphone but because he is wearing a Lavalier radio microphone, his sound will be clean on the multi-track recording. If the editor wants to look for better sound quality he goes back to the original 16 or 24 tracks of the multi-track recorder. This enables him to find a better take and improve the quality of the sound track.

FIGURE 8.1 Example of a stack from *Beyond Scared Straight*. It is a full day stack with three cameras and the grouped footage on the top layer, with audio tracks from two different sources synced below.

FIGURE 8.2 Example of a stack for an immunity challenge from *Survivor*. It has far more cameras and most run for the entire challenge and there are therefore, fewer gaps.

- If all the tracks are not usable, there is always an option to subtitle the inaudible or muffled line or to ADR it.

It can be quite tedious listening to all the tracks that were recorded at any one time but sometimes something magical emerges. You come across other interesting bites that could be vital to the cut. In reality editing you are always looking for something special, some little kernel that will enhance your story or add a special note about a character or a story point. These are nuggets of gold.

With the tapeless media of today the problem intensifies because there are many small cameras like the Pilko Cans and the GoPros and even flip-phones. These little semipro cameras are used to create exciting POVs or are mounted onto objects that go places where larger cameras cannot navigate. Even drones have cameras mounted on them to capture unusual aerials of a location. This factors into the footage received in the edit bay. Because of conditions at the location they might not have any time codes. They will probably not be stacked. You have to figure out where they fit and how best they can be utilized to add color and drama to your story.

A good guide to remember is to go with the flow. If things are not always to your liking, do not voice criticisms of the crew or producer. That is not your job. You are there to make the best film you possibly can with the footage and audio available. Use your stack and group clips to foresee potential problem areas where there might not be enough coverage. Be creative in finding editing solutions.

8.5 APPROACHES TO CUTTING

As the editor you are generally autonomous in looking for the story points, developing and defining the characters and enhancing the drama in each situation. You mold the story. It will be shaped by your choices and tastes. Tackling the material and deciding how to approach the narrative and finding the elements with which to work is different in every situation. Starting points will depend on the nature of the film and material you have been given.

When I walk in on the first day I am given a casting sheet, which lets me know who the characters are. Then I will watch the footage, every bit of it. As I am going through the original footage I throw markers on it and say, "This is a good confrontation. This is something that could be funny. This is an interesting reaction. This could work as a

transition." I just ignore the things that do not impress me. It is more about being selective of which moments will tell the story in the best, most understandable light.

Mark Andrew

On our show there is no script and there is no outline. You are just given the material you have to cut. Our schedules are pretty tight, but I look at all the material and pick selects. If I am doing an act, I will pick selects for a specific beat. Then I go on and create sequences of selects. I look at everything so that I always have that as a reference and because we might be questioned on it at screenings, I always know where everything is. The most important thing is to see everything and then work with that.

Sharon Rennert

In reality as with documentary, it is advisable to view all the material before making your first cut.

- If you are not working with a given stringout, watch all the footage and mark selects and create subclips of story beats.
- Assemble all the clips into a potential story line with all the beats from which you can create your cut.
- Find the dramatic moments, the moments of conflict, action that propels the story and defines the personality and make sure to include them all. From this lengthy stringout you will be able to mold your story.
- Go through all the interviews and pull important bites from each character. Bites that you feel will reveal the character, reflect their conflict and that will emotionally enrich the story. Find those moments that will propel the story and heighten the drama.
- View all the B-roll and be familiar with the footage so you can draw on establishing and beauty shots and material that will add color and texture to the story.
- If you are following a stringout, work through the timeline and embellish the tracks, both visual and aural, as you work through the story.
- Use the group clips or the stack to find additional coverage of parts of scenes that need building.
- If your show has confessionals, include them where applicable. They can be integral to linking dramatic situations and propelling the narrative.
- Work with MX as you cut to help create the mood or tension and punctuate the essential moments.
- Enhance the tracks with appropriate SFX.
- Follow any and all guidelines. Make sure you are editing in line with the established mood, style and tone of the show.

- Check that you include the correct graphics and transitions.
- Include titles and chyrons when you make your first cut.
- You will always be working tight deadlines and, at the beginning, will certainly be putting in extra hours, possibly unpaid. As you gain experience and master the craft, you will learn to work speedily and meet the deadlines with more ease.
- Do not rely on editing help from your assistants. They are overburdened with their own responsibilities. They have so many duties, from ensuring that the machines are all running to prepping outputs, that they do not have time to help you as they would on scripted shows. They are not available to add your SFX or to lay in your MX. Sometimes there are emergencies and it might be necessary to ask the assistant to help find a bite, some MX or a SFX. But do not rely on them to be there to help you complete your cut.

When you are working on large shows with many editors, you will probably just be responsible for cutting the segments and handing them over to the lead editor who will finish the show and take it to completion. The assistants and producers will ultimately be responsible for the overseeing the technicalities of getting the show to online and beyond.

8.6 CONCLUSION

There is no single way to cut a non-fiction film. There are umpteen guidelines but there really are no hard-and-fast rules that are set in stone. Every film is different, a unique world unto itself. Each show breathes its own life. A camera following a down-and-out musician desperately trying to reinvent himself going from one squalid dive to another is totally different to following a herd of elephants across the plains of Tanzania as they are pursued by poachers tracking them for their ivory. Exploring a subterranean world of unmapped caverns in New Mexico will require very different storytelling techniques to a documentary about young girls trying to defy religious extremists and attempting to get an education in the Sudan. Often there is no way to foresee what the camera will find. It is only in the editing process that the story will fully unravel and reveal itself. It is up to you, the editor, to expose its heart and soul and make it accessible and understandable to all who view it. But remember, moviemaking is a collaborative process. And no matter what film you work on, it is not yours. Never for one moment forget that you have to remain true to the intention of the director.

Editing documentaries and reality is excessively labor-intensive. It requires complete, unfettered dedication to the art and craft of the medium. Whether you have years of experience cutting fiction or non-fiction or if you are just starting out on your editing career, it is your personality, your experiences, your attitude and your perception of life that will influence and shape the work. Nurture an insatiable sense of enquiry. Stay current on world affairs. The non-fiction world embraces everything that makes the universe tick. Whether you are examining wriggling amoeba on a slide under a microscope or trying to make sense of an exploding star in a galaxy far, far away your instincts, your experience, the sum total of your knowledge will contribute to how the final product turns out.

Follow the guidelines, abide by all the rules passed down to you by your mentors and your peers and then know how, when and to what extent you can bend them. Every film is a learning experience. As long as you sit in a dark room manipulating images and sounds you will never stop learning. Every film you lay your hands on will improve your skills and enrich your life.

Words of Advice from Editors

Journeys

*To get through the hardest journey we need take only one
step at a time, but we must keep on stepping.*
Chinese Proverb

There are many paths to editing. Whether you choose scripted or non-scripted documentaries, features and television, or reality television, there is assuredly a way for you to succeed. We have outlined a few of these options, and given you guidelines for organizing your editing rooms, and how to start editing with finesse.

In this chapter we asked selected colleagues to answer questions about their paths to an editing chair. They are all successful, talented and incredible editors in their own fields. We have also included some of our ACE interns who have climbed that ladder recently. They are still forging their careers in film editing, and finding diverse paths to achieve success.

ALAN HEIM ACE (*NETWORK, ALL THAT JAZZ, INTRODUCING DOROTHY DANDRIDGE*)

Words of wisdom

My advice to young editorial aspirants is to take any job offered, in any subset of this field, work hard, learn your tools and only then decide where to specialize. Meanwhile, keep working.

A great amount of an editor's time is spent at the junction of what the director shot and what he thinks he shot. Your job is to navigate that space and deliver the best possible version of the project.

If you want to edit, my best piece of advice is to edit. Try to work with editors who are collaborators and will share both their scenes and their experience with you. While it is increasingly more difficult as an assistant editor to find a spare moment in the day, it is also vastly easier than ever to cut from anywhere. So, find the time on the weekends or after work hours to cut a scene. This is not just to show others that you can tell a story, but also to hone your craft and add tricks to your toolbox.

One you've reached the editing chair, it is important to remember that filmmaking is a team effort. Be someone that people want to spend time with, be open to ideas and willing to try something that you think won't work—you'd be surprised how often it does, or that bad idea leads you to something better. Most importantly, learn how to read the room and then lead the room.

Year you began work in editorial

I attended C.U.N.Y and started working in 1958 (nights and weekends) at a jack of all trades editorial house, doing a little bit of everything and keeping the music library in order. I then became a sound and music editor on some industrial films and a couple of TV series.

Year you received your first editing credit

My first picture editing credit was on *The Seagull* for Sidney Lumet in 1968, after editing sound on three of his films, *The Pawnbroker*, *The Group* and *Bye, Bye, Braverman*. This was my first real break, even though I had finished the picture editing on *The Producers* while doing the sound editing.

Did you have to go back to assisting?

I was never a picture assistant except for a very short stint at a commercial editing house, which I hated.

Did you remain in your chosen venue or did you cross over from time to time?

I had done several films for Ralph Rosenbloom as a sound editor and he suggested I finish *Newport* for Murray Lerner which led to my editing several additional scenes for the film.

Influential editors

Sidney Meyers was another stellar example of how to negotiate the editing room and Dede Allen was also a guide through the process. Of course my main guide was Sidney Lumet who taught me many things on *The Seagull* and Bob Fosse, who really gave me the confidence to let myself out and really attack material.

Awards

Emmy for *Holocaust*
Emmy nomination for *Liza With A 'Z'*
Emmy nomination for *Grey Gardens, Introducing Dorothy Dandridge*
Academy Award and Bafta for *All that Jazz*
Academy and Bafta nominations for *Network*
ACE Eddie award for *All That Jazz, Introducing Dorothy Dandridge*

MARY JO MARKEY ACE (*STAR TREK, STAR WARS: EPISODE VII—THE FORCE AWAKENS, STAR TREK INTO DARKNESS*)

Words of wisdom

As far as the most important quality an editor needs, I would say it's an elevated level of taste, so that one knows the difference between performances and material that belong in the cut and that don't, and so that one can recognize when a scene is working and when it isn't or when the piece as a whole isn't working. Without that sensibility it doesn't matter how fabulous the cuts, rhythm or pace are. I would add that an extremely important quality for an editor, right up there with taste, is emotional maturity. Considering the pressures of the job, how closely and intensely we work with producers and directors, the rounds of changes and notes not simply to be endured but embraced, the passion we all bring to the work, and how little credit we often get for major contributions, every editor had best bring his most grown-up self to work.

Year you began work in editorial

I began work as an apprentice in 1986.

Which venue?

Feature.

Year you received your first editing credit

I received a back end film editor credit on *Medicine Man* in 1992. In 1994 I had my first solo credit on *At First Sight*, but unfortunately it ended up as a straight-to-video release.

Mark Conte gave some small bits to cut when I was assisting him in 1989 on *Turner & Hooch*. I also worked with Charles Bornstein on several projects; he gave me scenes to cut, went over them with me very carefully, and was extremely kind and helpful. Seth Flaum also allowed me to cut a scene on *The Guardian* (1990) and recommended me for the first short that I cut.

Did you have to go back to assisting?

Most definitely I had to go back to assisting!

How many times?

My guess is that I took about three more assistant jobs before I firmly decided I was only going to take editing jobs. I was hired to edit *At First Sight* not too long after that and have been editing ever since.

Did you remain in your chosen venue or did you cross over from time to time?

I have always crossed over and done whatever interested me, or projects involving people with whose work interests me. Shortly before *Star Wars* I cut a pilot written by David Milch just because I've always admired his writing and wanted to work with him.

When I was first starting out, someone arranged for me to have coffee with Lynzee Klingman. I was naive and intimidated by the whole industry at the time, but she was so approachable and kind, and she made me feel that it was possible for someone without a taste for the jugular to succeed (that was my view of the business at the time). She wasn't really a mentor, because we did not see each other again for many years, but she was an inspiration.

Honestly, I don't believe I had any real, long-term mentors, but a lot of people offered me encouragement along the way, sometimes only a sentence or two, but I locked their words away, and used them to push myself forward at critical moments along my way.

Influential films

The Italian neo-realist films, especially *The Bicycle Thief, The Children are Watching Us, Germany Year Zero*—but really all of them. These films tell their stories from such a strong point of view; EVERYTHING is seen through a particular pair of eyes, so that the viewer becomes completely immersed in the experience of the main character. They show how powerful a perfect collaboration between director and editor can be. I am all about point of view in my work.

Influential editors

Dede Allen, because I worked with her first, and she was such a powerhouse. Lynzee, because of her incredibly beautiful dialog cutting. Tom Rolf, because he was so successful and still managed to have so much fun. Bud Smith, because he turned off the KEM at 6:00 and always stood up for his crew.

Awards

Emmy for single-camera picture editing for the pilot episode of *Lost*.

MICHAEL TRONICK ACE (*PREDATOR, MR. AND MRS. SMITH, SCENT OF A WOMAN*)

Words of wisdom

My best piece of advice about how to advance to editor is to participate in the process: have an opinion, your own honest opinion when asked about a sequence. Don't give the answer that you think will please someone else, express what you're feeling. Be reliable, give everything your best effort regardless of the task, don't be afraid to ask questions and keep a sense of humor.

As far as conducting oneself, as difficult as it might be, always try and take the high road. The quagmire of politics can be daunting and counter to how

things should proceed in the cutting room. Stand up for your crew. Be aware of hours worked and what is demanded and when. Personal lives and priorities supersede any deadline. Try everything, never say "no" to a request to change an edit or try something new. Being surprised by a note you might consider unworkable is one of the joys of editing. Avoid saying "it won't work" without giving the note a try.

The most important attribute an editor should possess is patience and having the conviction of your point of view.

Year you began work in editorial

I began work in editorial in 1975 for Gene McCabe Productions. I joined the Editors Guild in 1977.

Which venue?

My first venue was in Features (*Semi-Tough* for UA/directed by Michael Ritchie).

Year you received your first editing credit

I received my first Music Editing credit in 1977. I received my first credit as a Film Editor in 1984 (*Streets of Fire*) and my first Main Title credit as Film Editor in 1987 (*Beverly Hills Cop II* with Billy Weber and Chris Lebenzon ACE).

Who gave you your first break? On what show?

My first break as Music Editor was with Dan Carlin, Sr. on *Semi-Tough*. My first break to cut picture was with John Wright on a TV movie for Disney, *Double Switch*. My first feature break was given to me by Freeman Davies on *Streets of Fire* and Billy Weber and Chris Lebenzon ACE on *Beverly Hills Cop II*.

Did you have to go back to assisting?

I was never an Assistant Editor. My career took a leap from Music Editor to Film Editor.

Did you remain in your chosen venue or did you cross over from time to time?

I remained largely in features but crossed over to TV for one series, several movies-for-TV and one documentary for ESPN.

Influential mentors

Dan Carlin, Sr., Ralph Burns, Billy Weber, Dennis Virkler, Peter Berger, Dede Allen, Freeman Davies.

Influential films

City Lights, Best Years of Our Lives, everything by Kubrick, David Lean and Alan Pakula, *Bonnie and Clyde, Amadeus, The English Patient, City of God.*

Influential editors

Dede Allen, Billy Weber, Chris Lebenzon, Tom Rolf, Conrad Buff, Mark Goldblatt, Paul Hirsch, Richie Marks, Walter Murch.

MAYSIE HOY ACE (*WHAT DREAMS MAY COME, THE JOY LUCK CLUB, DOLLY PARTON'S COAT OF MANY COLORS*)

Words of wisdom

My piece of advice to all assistants making the move to editor is this—find an editor who likes to have two martinis and a glass of white wine for lunch. Before they take their nap ask them if you can work on a scene. If they say yes, voilà! Edit the scene and at the end of the day wake them up and ask them for their opinion. But not everyone can find an editor who likes two martinis and a glass of white wine. When working as an assistant ask your editor if you can work on a scene if they agree then work on the scene after all your work is done. Come in early or stay late to work on it. And when you are finished show it to the editor to get their feedback. Never take criticism personally.

When you are an editor it is important to be a good listener and a collaborator. Discretion is vital. What is said in the cutting room stays there. Be grateful. When you have to work the long hours remember what it was like to be an

assistant especially when a post production supervisor asks for an output at 8 o'clock at night for a midnight delivery to the director. Really, is the director going to be watching the three-hour cut at midnight! Or can the assistant make the output in the morning? Use common sense and always protect your crew. Don't argue over a cut. Know when to give it up. Friendly discussion is encouraged because at the end of the day it is the director who is in charge and it's his vision. You have the power to protect your crew—after all you are a department head. Make sure your assistants are not being taken advantage of by the producer or post production supervisors. When you show loyalty you will get it back a hundred fold.

But more importantly have fun and laugh. I encourage this because you spend more than half of your waking hours at work and away from your family. If you are not having a good time then it is time to do something else. Leave your personal problems outside the door. No one wants to be around a "debbie downer or a sad sack." Have a sense of humor.

What an editor should know is that it is important to get your wish list in writing. You may not get everything that you asked for but at least you tried. Having an upfront credit in your contract will make the difference in getting an Academy nomination for best editing and not getting the nomination. This happened to me on *The Player*. Even though I was the second editor and had edited half of the movie. Altman wasn't feeling generous that day and decided to give me the back end credit. The other editor had the upfront credit and was nominated for an Academy Award for best editing and I wasn't. The Academy rules only recognize upfront credits. So, make sure you see in your deal memo or that your agent has secured this for you before you start on any project.

I wish you all luck because it is a fun business and there are lots of people who are more than happy to help you along the way but you must be open and know when an opportunity is presented to you.

How did you get started in the film industry?

I started out as a whore. A Seattle whore.

I was cast in Robert Altman's *McCabe and Mrs. Miller* as a Seattle whore. Meeting Robert Altman changed my life. I left Vancouver for Los Angeles after the movie opened and never looked back.

Year you began work in editorial

I began work in editorial in 1976. I got into the union in 1977.

Who gave you your first break? On what show?

In 1976 Robert Altman has just finished shooting *Buffalo Bill and The Indians*. He had shot a million feet of film and there were at least twenty trim bins lined down the hallway outside the editor's rooms. One day I was on my way to see them when all I could see was film flying out of a bin. As I looked down the hallway I saw that almost all the bins were emptied and there were piles of film thrown everywhere on the dirty floor. I walked up behind the editor and tapped his shoulder, "Dennis, what are you doing?" With half of his body in the bin he said, "I'm looking for two frames." I said to him, "It looks like you need help reconstituting the film. I think I can do that." (Reconstituting the film was syncing the picture and sound back together into its original dailies reels.) "What do you think?" "Yeah, I think you can do it but you have to go ask Bob." Oh great, so I went into Bob's office. He looked at me and said, "This isn't a film school you know." "I know that but the editors need help." He stared at me for a minute and said, "If it's okay with the guys then it's ok with me." "It's ok with them," I ran out of his office so fast, worried that he might change his mind.

But I think the REAL reason I got hired in editorial was because I could roll the PERFECT joint. That was one of the many duties that I had as an assistant. I would clean the stuff. Roll the joints. Put it in a marked trim box and snuck it in with the rest of the picture and sound for later use.

I got my start in features but have worked in TV.

Year you received your first editing credit

The year I received my first credit was 1989. It was a shared credit on *Limit Up*. I was assisting Danny Greene on it. He left the show early and I finished it. He was very generous in sharing his credit.

Who gave you your first break? On what show?

My break came when Danny Greene asked me to assist him on *There Goes My Baby*. I didn't want to take the job because I had finished editing

Limit Up and *Boris and Natasha*. Not great credits but I had gotten a taste for being an editor and I was given editing credits on both films. I told Danny my situation and he said that this director always hired a second editor after principal photography. So, I told him I would take the job on one condition, that when it came time to hire the second editor it would have to be me. Or I wouldn't take the job. Well, Danny kept his word and because I got along with the director I was given the opportunity. I also believe that had one out of the five producers felt I wasn't capable of being an editor I would not have moved up.

While I was finishing *There Goes My Baby*, Robert Altman was in post on *The Player*. He asked me to come look at the dailies for the entrance of the museum scene. Apparently, his second unit film crew had shot the backs of the movie stars making their entrance. I went and watched three hours of dailies. I knew that after I finished watching them that Bob would ask me for suggestions. As I exited the screening room, just as I thought, he asked. "What do you think? How can I fix this?" Off the top of my head I blurted, "Well, you jump cut it like *ET*, Entertainment Tonight using the good stuff. Have an announcer introduce the stars as they make their way past the paparazzis. What do you think?" His eyes lit up and he turned to his producer Scottie Bushnell. "Hey, Scottie I have this great idea." So, that's the way the museum scene appears in the final version.

Did you remain in your chosen venue or did you cross over from time to time?

After I finished *The Player* I was unemployed for a whole year because when you are the second editor, agents and directors are leery of what part of the movie you edited. I would say, "the good parts."

At the time my sons were young and my husband who was in the film business was also unemployed. During this time, I was offered assisting jobs but I turned them all down because I realized that I had just finished working on a critically acclaimed movie and if I went back to work as an assistant no one would ever take me seriously as an editor. I have heard of editors who for a multiple sets of reasons went back to work as an assistant and it took them years to find work as an editor again.

During this time of unemployment, I got an agent who found me an editing job on a low budget film. When I screened my cut to the producer I knew

he didn't like it or me. So a few days later I was let go. That night I went home despondent and complained to my husband, "I haven't worked in a year. Where am I going to get another job?"

My husband who was watching the football game turned to me and said, "All this means is that something bigger and better is going to come your way." And just like in the movies, the sound of my telephone ringing overlapped his last line and it was *The Joy Luck Club*. What was a terrible day turned into a great day and a phone call that would change my life, forever.

Mentors

Robert Altman—because he cast me as an actress in *McCabe and Mrs. Miller* and later gave me an opportunity to edit *The Player*. Danny Greene who edited, *M*A*S*H* and *Blazing Saddles*. Hired me as an assistant over the phone and then moved me up to edit.

WILLIAM GOLDENBERG ACE (ARGO, THE IMITATION GAME, ZERO DARK THIRTY)

Words of wisdom

Moving up from assistant to editor is difficult because there isn't a clear path on how to get there. As an assistant you have to start developing the skills to be an editor by watching how your editor works, the way he or she approaches scenes, learning how to tell a better story through editing. Hopefully along the way you'll get to cut scenes on your own, because doing it is the only way to learn. Getting feedback on those scenes and interpreting the notes you receive is another invaluable skill you need to develop. As far as getting jobs, what worked for me was doing shorts films for free while I was assisting. Through one of the shorts I met a director who gave me a paying job on an HBO film. Once you're there you have to conduct yourself with as much honesty and integrity as possible. No matter how much pressure you're under you can never show it on your face. Take criticism in a positive way and remember that it's about the film and not you personally. The most important attribute you can have is having an open mind to any idea that might make your film better.

Year you began work in editorial

My first job was in 1983 as an apprentice for John Wright on *High School USA*.

Which venue?

Television movie for NBC.

Year you received your first editing credit

My first editing credit was on *Alive* in 1993.

Who gave you your first break?

My first big break was getting a job on *Heat* in 1995. Michael Mann saw a HBO film I did called *Citizen X* and hired me on *Heat*.

Did you remain in your chosen venue or did you cross over from time to time?

I have done one TV pilot called *Over There*, but other than that I've been doing features.

Influential mentor

Michael Kahn mentored me and it has been the single most important relationship of my career.

Influential films

The Conversation, Lenny, All That Jazz.

Influential editors

Michael Kahn, Dede Allen, Don Cambern, Alan Heim.

Awards

Oscar, Bafta and ACE awards for *Argo*.

PAUL RUBELL ACE (*COLLATERAL, THE INSIDER, BATTLESHIP*)

My best advice on advancing to editor: Be Lucky. It's a pyramid, not every assistant is going to make the transition. But you're fortunate to be living in a time when the market seems to be expanding exponentially, even as salaries are being driven down. Be prepared, know your shit, play the numbers—eventually you might get a break and be able to turn it to your advantage. Seek out every opportunity to cut anything, even freebies. Ask your editor if you can play around with the dailies in your spare time, meaning late at night when everyone else has gone home. When Lori Jane Coleman and I started out, the medium was 35mm film, which means you couldn't play around without leaving physical splices in the cut. You're lucky—you can edit the same scene a million times. And you will. If you're lucky. . .

My best advice on how to conduct yourself: be professional, don't be a prima donna, know when to stick up for yourself (and when to strategically eat shit).

The most important attribute that an editor should possess: Just one? Aside from LUCK? Maybe . . . the ability to edit from the gut as well as the brain. The right brain as well as the left. And to go back and forth, as if you were two different people.

Year you began work in editorial.

1977.

Which venue?

Very low-budget indie, though we didn't use the word "indie" yet . . .

Year you received your first editing credit.

1981.

Who gave you your first break?

Lou Lombardo. I was assisting him on a recut of a TV movie: *Kiss Meets the Phantom of the Opera.* He wasn't really all that interested, so he gave me a bunch of scenes to edit. The next project, *The Changeling*, was also a

re-edit, and the same thing happened. A few years later, he was offered a horror film, and recommended me as editor. I owe everything to Lou. He was a great editor and a great human being.

Did you have to go back to assisting?

Once I received my first editing credit, I was lucky enough to keep working as an editor.

Influential mentors

Lou Lombardo. Glenn Jordan, a hugely talented and successful TV (mostly) director, back in the golden age of TV movies and mini-series. I worked exclusively with Glenn for something like ten years. John Frankenheimer, with whom I worked on two cable movies, and who then gambled on me to cut his next feature, against the wishes of the studio who didn't want to hire a "TV" editor.

Influential films

So many I don't know where to start.

Influential editor

Lou Lombardo, Michael Kahn, Sam O'Steen (never met him), Verna Fields (never met her), so many more . . .

Awards

Nominated for two Oscars (*Collateral* and *The Insider*), one Bafta nomination, two Emmy nominations, nominated five times for an Eddie; only won once—an ACE award for the cable movie *Andersonville*, directed by John Frankenheimer.

PAM MARTIN ACE
(LITTLE MISS SUNSHINE, THE FIGHTER, RUBY SPARKS)

Words of wisdom

My best advice on how to advance as an editor is to cut anything you can get your hands on: student films, shorts, docs, commercials . . . anything! When

working as an assistant editor, make it clear that you want to be an editor. If you don't express any interest, how will your co-workers know whom to turn to when their friends or colleagues ask for an eager young editor to cut an independent feature? You must have a great work ethic, be personable and have a critical eye. As an assistant, you are a valuable sounding board for the editor, who needs honest and critical feedback, particularly during the assembly process. Work as an assistant editor and a sound editor so you know how these jobs are done. It helps improve the quality of your rough cuts once you are an editor. Most importantly, to be a good editor you must know your story (the film), be a good listener and be adept at reading the subtleties of human emotion. This enables you to find the best performances. Be flexible and able to approach your material from varying perspectives.

Year you began work in editorial.

1989.

Which venue?

Documentary.

Year you received your first editing credit

1989 or 1990.

Who gave you your first break?

Talked my way into an editing job when interviewing for internship at a documentary company. It was a three part PBS series on Samuel Beckett. I was editor on two of the three parts.

Did you have to go back to assisting?

Yes. I had not assisted at that point, and really wanted to work on feature films. A former professor of mine recommended me to Ang Lee when he was making his first film, *Pushing Hands*. That was my first assistant editor job. It was in 1991. I also worked as a dialog editor on the film.

I went back and forth between editing and assistant editing for approximately three years.

Did you remain in your chosen venue or did you cross over from time to time?

When I started out I would cut anything: docs, shorts, industrial videos, music videos, indie features. I also worked as a dialog editor for some time.

Influential mentor

Tim Squyres.

Influential films

Anything I watched and enjoyed must have influenced me, though I couldn't narrow it down to a list. I have so many favorites!

Influential editors

Anne Coates, Thelma Schoonmaker, Dede Allen.

Awards

2 Eddie Award nominations (*The Fighter*, *Little Miss Sunshine*)
Oscar nomination (*The Fighter*)

MARK HELFRICH ACE (*RUSH HOUR, THE FAMILY MAN, X-MEN: THE LAST STAND*)

Words of wisdom

If you're an assistant editor who wants to advance to editor—be lucky enough to work for an editor who mentors, or at least recognizes talent in others. Hopefully you'll be in an environment where the editor welcomes feedback. In that case, be an assistant with ideas and offer constructive criticism—suggest something. Maybe the editor will say to you, "Go ahead—give it a shot." And even if the editor doesn't—go ahead and try what you were suggesting on your own time (you've got your own Avid, why not?). You'll learn something. Edit as much as you can. The more time you spend editing—the more experience you'll have, and the more you'll learn from doing. Experiment.

Look for opportunities to get an editing gig, but be careful to be respectful and not annoying about wanting to advance. Once you get the break—be grateful.

There are so many attributes a feature editor should possess.

- Patience—because it takes a long time with many revisions to craft a feature.
- Confidence—because the director is relying on *you* to achieve his or her vision.
- A Point of View—You're not there to be "a pair of hands" for the director—you were hired because you're an artist. However, your POV may be overridden, and that's something all editors have to accept as part of the job.
- Enthusiasm—because you're working as an editor! That's awesome!
- Generosity—let your assistants be as involved as they want to be. Let them learn as much from you as they can because they might want to become an editor too someday.

Year you began work in editorial

1979.

Which venue?

Feature.

Year you received your first editing credit

1983.

Who gave you your first break? On what show?

Cannon Films—on the feature *Revenge of the Ninja.*

Did you have to go back to assisting?

No.

Did you remain in your chosen venue or did you cross over from time to time?

I mainly edit features, but occasionally cut a television pilot.

Influential mentor

I assisted Larry Bock, and watching him work made me want to edit.

Influential films

Performance, Don't Look Now, Quadrophenia, The Hunger, All That Jazz, Beyond The Valley of the Dolls.

Influential editors

Gerry Hambling, Alan Heim.

Awards

Won Satellite Award for Best Film Editing (along with Mark Goldblatt and Julia Wong) for *X-Men: The Last Stand.*

SABRINA PLISCO ACE (*SKY CAPTAIN AND THE WORLD OF TOMORROW, THE SMURFS, CHARLOTTE'S WEB*)

Words of wisdom

The best steps you can take to get into the editing chair are to work hard as an assistant editor to prove your diligence and work ethics, always have a positive attitude and to take an interest in editing and story. As an assistant editor one's focus tends to be very technical these days but to advance you have to have the interest in the creative! And once you get into the editing chair remember you always have to be pliable. Think of yourself as Gumby! You must roll with the punches everyday and meet the tasks that are asked of you. Some days you will just be able to do your job as editor. That is only part of the job, however. So many other moments you may need to be a cheerleader, listener, psychiatrist, babysitter, a mom or dad, referee, juggler or just a flat out magician! Just remember to have no fear and embrace the challenge.

Year you began work in editorial

In LA—1989 (prior to LA 1984).

Which venue?

I started in corporate/educational shorts as editor then edited an independent movie 1989, moved to LA—transitioned to scripted TV as assistant.

Year you received your first editing credit

1992.

Who gave you your first break? On what show?

Producers Jon Avnet and Jordan Kerner gave me a TV movie to edit *For Their Own Good*.

Did you have to go back to assisting?

Yes—once I moved to LA. I assisted for three years.

Did you remain in your chosen venue or did you cross over from time to time?

Have transitioned into features.

Influential mentor

First person I met in LA was Debra Neil-Fisher.

Influential editor

Alan Heim's work on *All That Jazz* woke me up to the world of editing.

Awards

Eddie nomination for *Uprising* (TV mini-series)
Emmy nomination for *Houdini* (limited series)

MARLISE MALKAMES ACE (*THE BACHELOR* FRANCHISE, *THE HILLS, THE APPRENTICE*)

Words of wisdom

Make the most of every opportunity and soak up information, protocol, technique and creative thinking from the people you respect and admire. Make yourself indispensable by being hard-working and dependable. When you have to make a superior aware of a problem, try whenever possible to suggest a solution as well. Be kind and respectful to everyone you work with because the kid who is the lunch runner today could be your executive producer in five years. Be a team player. Don't stay in a job you hate. And buy a lot of socks and underwear because you will never be home to do laundry.

Year you began work in editorial

1993.

Which venue?

I started assisting on small feature films and scripted television but got my break cutting non-fiction and doc television.

Year you received your first editing credit

1992. I cut two things in film school that went to air. One was on a documentary that aired on POV and my own short film made the festival circuits and also aired.

Who gave you your first break? On what show?

My sound teacher from USC got me an assist job on a low budget feature called *Treacherous*, which was non-paid. My first paid gig was an assistant editor/receptionist/runner job on a doc series called *L.A. Stories* about life in the year after the LA riots for *World of Wonder*.

Did you have to go back to assisting?

Yes, for a couple of years I would assist on scripted TV series and cut non-union non-fiction television.

Did you remain in your chosen venue or did you cross over from time to time?

I had gotten to cut a little on the scripted TV series I was assisting on, but I really preferred cutting the doc and non-fiction projects so I stayed with that and it morphed into reality television which I love cutting and still cut today.

Influential mentor

Kate Amend. She was my doc teacher at USC, taught me a lot about editing, but also that you could make it a life.

Influential films

I grew up at the world's oldest drive-in theater, so I was immersed in the films of the 1970s and early 1980s.

Influential editors

I was very inspired that women were such key players in the entire history of editing in Hollywood.

Awards

Emmy nomination *AFI's 100 years. . .100 Movies: 10th Anniversary*

MARK ANDREW ACE (*BEYOND SCARED STRAIGHT, ACCESS HOLLYWOOD, DEAL OR NO DEAL*)

Words of wisdom

My career has a stranger path than most. I came to Hollywood without a clear vision of what I wanted to do, only that I wanted to do something in entertainment. This led me to working in a wide variety of positions, from preproduction to post production and even international sales and delivery. I researched, wrote, gaffed, worked in the art department, was a post coordinator and producer and even did some accounting. Along the way I did edit sound on film for a couple of features, but I could not seem to stick in any one job.

Eventually, I began producing promos for network and cable TV. I was supervising people cutting, often doing paper cuts, but not cutting myself. I was recruited by a boutique promo company with the caveat that I learn to edit my own material. After two years, I realized I had an eye for editing as well as the sensibilities of a producer. Suddenly I was sought out by companies not only to edit but to be someone to help guide a project that might have younger, inexperienced producers.

Year you began work in editorial

Although I worked extensively with post as an international sales agent for film, creating deliverables for foreign countries film release from 1988–1991, my first editing job in post was in 1991 as an assistant sound editor.

Which venue?

When I was assisting in sound, I worked in features. I now cut reality TV.

Year you received your first editing credit

I started cutting promos and trailers in 1994.

I received my first 'on screen' credit in 1997.

Who gave you your first break? On what show?

Emily Aiken and Chris Berthelsen hired me to produce and edit my own promos.

Eric Schotz gave me my first show, when I recut a pilot for Lifetime TV called *New Attitudes*.

Did you have to go back to assisting?

No.

Did you remain in your chosen venue or did you cross over from time to time?

Although almost everything I have done can be labeled reality. Reality often expands to include the other genres. Many of my shows are mostly

documentary style. I have cut variety shows which has included scripted material, both single camera and multi-cam. And some features now (particularly comedies) use a freeform 'ad lib' approach which is similar to the soft scripted style of many reality TV shows.

Influential mentors

A post producer named Frank Merwald helped me to see how all the knowledge I had gained from my myriad of jobs fit together.

Chip Matzamitzu.

Influential films

The Cabinet of Dr. Caligari, All That Jazz, Raiders of the Lost Ark, Jaws, North by Northwest, Psycho.

Influential editors

Alan Heim, Michael Kahn, Dede Allen, Verna Fields, George Tomasini.

Awards

ACE Eddie Award in 2011 for Reality Series Editing for the MTV series *If You Really Knew Me.*
Nominated for the ACE Eddie in 2013 and 2014 for Non Scripted Series Editing for the A&E Series *Beyond Scared Straight.*
2012 nominated for an Emmy for Outstanding Picture Editing for Nonfiction Programming for *Beyond Scared Straight.*

HUNTER VIA ACE, ACE INTERN (*THE WALKING DEAD, THE SHIELD, THE 100*)

Words of wisdom

If you want to edit, my best piece of advice is to edit. Try to work with editors that are collaborators and will share both their scenes and their experience with you. While it is increasingly more difficult as an assistant editor to find a spare moment in the day, it is also vastly easier than ever to cut from anywhere. So, find the time on the weekends or after work hours

to cut a scene. This is not just to show others that you can tell a story, but also to hone your craft and add tricks to your toolbox.

Once you've reached the editing chair, it's important to remember that filmmaking is a team effort. Be someone that people want to spend time with, be open to ideas and willing to try something that you think won't work—you'd be surprised how often it does, or that a bad idea leads you to something better. Most importantly, learn how to read the room and then lead the room.

Year you began work in editorial

I worked as an assistant in 2000 with Lori Coleman on *The Shield*. After that I worked mostly on one-hour TV dramas, but occasional features.

Year you received your first editing credit

I received my first editing credit in 2004 on *The Shield*.

Did you remain in your chosen venue or did you cross over from time to time?

Lori Coleman gave me my first break as an assistant and then Shawn Ryan and Scott Brazil as editor.

I was very lucky and did not go back to assisting.

I've worked on both TV and features—drama/thriller/horror. I've worked on one comedy (pilot to *Arrested Development*) and one documentary/reality show for Country Music Television.

Influential mentors

Lori Coleman, Jim Gross, Lee Haxall.

Influential films

I'm a big believer in the use of sound and picture editing being used in tandem to tell the best story. *The Conversation* is one of my all time favorites. *Contact* is another I go to for inspiration.

Influential editors

Lori Coleman, Jim Gross, Lee Haxall—anyone with a varied and long career.

Awards

2011 ACE Eddie for *The Walking Dead* pilot—*Days Gone By.*

TYLER NELSON ACE INTERN (ASSISTANT EDITOR: *THE GIRL WITH THE GOLDEN TATTOO, THE SOCIAL NETWORK, GONE GIRL*)

Words of wisdom

I believe that one of the most important attributes of the road to becoming an editor is patience. This is probably one of the hardest pills to swallow for anyone in the creative arts, but the journey along the way contributes to the destination. However, if you are just stagnant as a production assistant or an assistant editor while you wait for the opportunity to edit to be handed to you, you will be waiting a LONG time. Never stop being the best PA or AE you can be—and learn anything and everything as you go. Make yourself invaluable so that people want to keep you around.

Year you began work in editorial

My interest in editorial began during my Freshman year of high school in 1998 when I took a sort of independent study class and learned Adobe Premiere. My first union job was in 2006 on *The Curious Case of Benjamin Button.*

Which venue?

Feature—though I got my union days working in commercials in 2005.

Year you received your first editing credit

I received my first editing credit in 2013 on a music video. I will receive my first editing credit for an HBO series called *Videosyncrasy.*

Who gave you your first break? On what show?

Kirk Baxter gave me my first break on *Videosyncrasy.*

Did you have to go back to assisting?

Between the music video and the TV series, I did. I worked as an AE on *Gone Girl*. I assisted for about 1 1/2 years.

Did you remain in your chosen venue or did you cross over from time to time?

I prefer features, but I do whatever Fincher needs me to do.

Influential mentor

Kirk Baxter.

Influential films

Requiem for a Dream and *Memento* made a big impact on me in college.

Influential editors

Kirk Baxter, Stephen Mirrione and . . . Walter Murch.

CARSTEN KURPANEK ace intern (ASSISTANT EDITOR: *BURLESQUE, THE GIRL WITH THE DRAGON TATTOO, MACHINE GUN PREACHER*)

Words of wisdom

Moving up to editor isn't easy and there are no guarantees that it will happen. However, you can increase your chances by trying to create as many opportunities for yourself as possible by editing as much as you can, both on your day job (assisting in TV or feature) and on the side (editing shorts, web series, music videos, commercials, sizzle reels etc.). The more people you work with and get a chance to impress with your yes-attitude and skills, the better. My move from assisting to editing happened not overnight, but because of years of hard work. I got my first feature (*Squatters*) because I was recommended by my friend Tyler Nelson who I worked with on *The Girl With The Dragon Tattoo* and who couldn't take the job himself. *Fort Bliss* happened because I edited some scenes for my editor Matt Chessé when I still assisted him. He liked my work and called me up a year later to

co-edit the movie with me. And *Earth To Echo* happened because I have cut short projects for director Dave Green on the side and for free since 2008. All these opportunities opened up because I laid the seed to them sometimes years before. So in the words of Lori Jane Coleman ACE: "Cut! Cut! Cut!" Also, be prepared to take a financial hit during the time of transition. You need to be able to afford not to take assistant editing jobs anymore, so you can wait, and be available for editing gigs. You will work less in the beginning, make less money, but if you're able to ride out the lows, you'll be fine. Good luck!

Year you began work in editorial

2008.

Which venue?

Reality (*Take Home Nanny*, TLC/Discovery) at Alpha Dogs.

Year you received your first editing credit

I received my first solo feature editing credit on the movie *Squatters* in 2013.

Who gave you your first break? On what show?

I have so many people to thank. My entire career has been full of 'breaks.' Without the following people I wouldn't be editing period: Terry Curren, Sandy Solowitz, Richard Halsey ACE, Lori Jane Coleman ACE, Matt Chessé ACE, Tyler Nelson, Dave Green, Martin Weisz.

I think my biggest break ever was getting to be the ACE intern in 2008. That opportunity opened many doors for me and I'll be forever grateful. So thank you from the bottom of my heart, ACE and the internship committee, especially Lori Jane Coleman ACE and Diana Friedberg ACE.

Did you have to go back to assisting?

Yes.

How many times?

My first few movies were non-union and I was about to run out of health insurance hours when I took an temp AE gig on *White House Down* before I started on *Earth To Echo*, my first union feature as editor. And I also took a VFX Editor position on *Money Monster*, reuniting with Matt Chessé, who I previously assisted on *Machine Gun Preacher* and *World War Z*.

Did you remain in your chosen venue or did you cross over from time to time?

I've only edited features so far.

Influential mentors

Lori Jane Coleman ACE, Richard Halsey ACE and Matt Chessé ACE are the editors who taught me everything I know. I hope my career will live up to their talents. Thank you for your love and support throughout the years.

Influential films

When I turned twelve in 1989, I was allowed to go to the movies without my parents for the first time. That year I saw *Indiana Jones and the Last Crusade, Ghostbuster II* and *Back to the Future 2*. Despite being sequels to classic films, they still hold a very special place in my heart and are very much part of the reason why I became obsessed with film. Other movies I saw in theaters and that had a huge impact on me before deciding to pursue a career in film: *Terminator 2, Jurassic Park, Independence Day, Titanic, Pulp Fiction, Fight Club, The Celebration, Winter Sleepers, Magnolia, Gigantics, The Insider, The Thin Red Line, Eyes Wide Shut, Memento* (not to mention hundreds of movies I saw on VHS).

Influential editors

My mentors aside: Thelma Schoonmaker, Pietro Scalia, Sally Menke, Ray Lovejoy, Michael Kahn, Billy Weber, Christopher Rouse, Arthur Schmidt, Lee Smith, Angus Wall, Kirk Baxter, Richard Francis-Bruce, James Haygood, Chris Dickens, Eddie Hamilton.

SHOSHANAH TANZER ace intern (ASSISTANT EDITOR: *UGLY BETTY, BODY OF PROOF, BECAUSE I SAID SO*)

Words of wisdom

In order to give my best advice on how to advance to editor in my chosen venue of scripted television, I have to quote my mentor, Lori Jane Coleman: "Cut, cut, cut!" Whether it's scenes, acts, gag reels, recaps, music, montages, etc., these are all opportunities to graciously show off your talents, practice your skills and get face time in with producers and showrunners. And once you have this valuable opportunity, you must ensure that producers/ showrunners view you as not just a superb assistant, but also as a valuable creative force. For this reason, my best advice to assistants looking to bump up is to have confidence. In addition to the technical and creative skills that will be discussed at length in this book, you must also exude the confidence that will convince the people in a position to hire you that you will be able to navigate their episode, their movie, their "creative baby" so to speak, through the editorial process and protect their interests, all the while, still elevating the story using all the tools that editing has to offer.

Year you began work in editorial

2005.

Which venue?

Started as a post pa/logger in reality, then moved into scripted television shortly after completing the ACE Internship in 2006.

Year you received your first editing credit

2012—co-editing credit on *In Plain Sight*.

Who gave you your first break?

Jennifer Barbot (editor) and Debra Lovatelli (associate producer) gave me my first break when I co-edited an episode of *In Plain Sight* with Jennifer.

Did you have to go back to assisting?

Yes I went back to assisting for three more years. In 2015 I was again bumped up to co-editor with Jennifer on a pilot for NBC. And subsequently, I've just booked my first editing job on a new TV show for ABC.

Did you remain in your chosen venue or did you cross over from time to time?

So far, I've stayed in scripted television.

Influential mentors

Lori Jane Coleman ACE, Diana Friedberg ACE, Jennifer Barbot, Ron Rosen, David Greenspan, Debra Lovatelli.

Influential Films

Chinatown, *Double Indemnity*.

Influential editors

Lori Jane Coleman ACE, Jennifer Barbot, Ron Rosen, Sally Menke, Thelma Schoonmaker, Steven Mirrione, Pam Martin.

Afterword

We hope you have enjoyed this book and are eager to begin applying our guidelines. Remember that rules are made to be broken. We have written them down to help jump•start your approach to editing a scene. Many thanks go to so many of our mentors and the inspiring filmmakers with whom we have had the pleasure of working.

In *Jump•Cut*, as in our first book, *Make the Cut*, we refer to people in the masculine. Please know that our reference includes both genders.

We would like to thank our publisher for their continuing support.

We have a special place in our hearts for all the intern applicants and incoming assistant editors who have participated in our internship program, and for all the editors and assistant editors who have helped to guide them in their careers. It took an entire village to make this program work. We cannot thank you enough for all that you have given in time and wisdom. A special shout out to Jenni McCormick and the entire ACE office for their continuing support necessary to keep this program alive. You have been amazing.

A great big thank you to all our editing colleagues in Hollywood who gave of their time and so kindly participated in panel discussions and shared their experiences. Their many words of wisdom are highly valued. To assistant editors Derek Fawaz, Stephanie Coats and David Kozlowski, we appreciate your time and efforts in creating transcripts. Thank you Fred Beahm for coordinating this team.

We must thank you, faithful readers, for taking the time to listen to us and for having faith in what we have shared with you.

Now go cut.

LJC and DF

Glossary

A

A.D.: Assistant Director—the person who helps the director in the making of a movie or television show.

ADR: Automatic Dialog Replacement (looping).

alts: Alternate takes.

audio layback: After the movie is mixed on the dub stage, the tracks are 'applied' to the film in an optical track (in film) or digitally married to the video master (CTM).

B

back nine: The last nine episodes of a TV show ordered for pick up by the network.

back twelve: The last twelve episodes of a TV show ordered for pick up by the network.

backplate: A still photograph used as the background for live action.

BGs: Stands for backgrounds which means either the ambient sound or the extras on a film set.

broadcast standards: See *standards and practices*.

B-roll: The modern day use of B-roll is with broadcast TV as supplemental footage inserted as a cutaway to help tell the story.

bumpers: A short piece of video shown on television shows during commercial breaks identifying the show and telling the audience that the show will return shortly.

burn-in: The process of adding live or still visuals to a blank screen (i.e. TV set, computer) after completion of the film.

C

calibrate: To determine, check or rectify the graduation of different equipment ensuring they are all lined up and giving the same readings.

call sheet: The daily call sheet is a filmmaking term for a sheet of paper issued to the cast and crew of a film production, created by an assistant director, informing them where and when they should report for a

particular day of shooting. Call sheets also include other useful information such as contact information (i.e. phone numbers of crew members and other contacts), the schedule for the day, which scenes and script pages are being shot and the address of the shoot location. Additionally, call sheets may contain information about cast transportation arrangements, parking instructions and safety notes.

chase cassette: An output (copy) of the completed show that will be used by the online editor as a viewing reference.

cheat sheet: A list of necessary information.

checking blacks: Before digitizing footage, the levels of brightness are checked. One looks at the color bars, a standardized set of graduated vertical colors that are recorded to a precise standard onto a videotape.

cinema verité: The art or technique of filming a motion picture so as to convey candid realism.

cleaned the tracks: This is the process preparing tracks for onlining and mixing by removing jump cuts, add edits, extraneous sounds, etc.

clone: A copy of a digital tape, such as D1 or D2, to another digital tape. There is no loss of picture quality because the process is completely digital and the copy is identical to the original.

continuity: A list of all the scenes in a version of the film, with scene numbers and short scene descriptions.

cover sheets: A cover page with relevant information that explains what a document is about or explains briefly about the accompanying film material.

D

DAT: Digital Audio Tape. A very small cassette tape onto which two tracks of audio can be recorded. Because of the digital nature of the recording, tapes can be copied countless times without loss of quality.

default settings: These are settings inherently in the system to which the computer will return to as a standard setting.

Digital Intermediate (D.I.): After the negative is conformed and cut to match the picture edits, a digital copy called the D.I. is made. This allows the process of color correction, titling and VFX to be done in the digital world before the final print is struck.

drop frame time code: A time code in which certain numbers are periodically skipped (two frame numbers at every minute except the tenth) in order to make the numbers exactly match reel (clock) time. The actual picture frames are not dropped, only numbers are skipped.

duplicate: To make a copy of a shot or a sequence.

E

editor's preferences: Settings that can be programmed into the computer and reflect the personal choices of the editor as to the way he would like to edit with regard to making shortcuts or other commands that ease his process of working.

event: In video or digital editing, it is a visual or sound change.

EDL: An edit decision list (EDL) is used in the post production process of film editing and video editing. The list contains an ordered list of reel and time code data representing where each video clip can be obtained in order to conform the final cut.

F

Flexfile: A computer file that contains all the relevant data concerning the dailies that is needed to import material into the computer.

format: To prepare a disc or hard drive for use, it needs to have certain directory information place on it. The process of doing this is called formatting or initializing format sheets.

FX: An abbreviation for effects, e.g. sound effects.

G

group clips: This form of syncing dailies is used when a scene is shot with several cameras following the same action. All the coverage is synced up and laid in on the timeline on different tracks at matching time codes. In this way, all the different camera shots can be played together in sync and this makes viewing of all action from all angles simultaneously possible.

J

jump cut: A cut where the out and in footage are both from the same take but there are frames missing from in between.

L

layback: See *audio layback*.

license: To attain the rights of use for any given materials, e.g. music, product placement, lyrics, etc.

lift: A scene or a series of cut picture and/or sound tracks that have been removed from an edited show. They are kept intact as lifts.

lined script: The shooting script of the film onto which the script supervisor has noted all of the setups shot and what lines of dialog each of the setups covered. The term is also used to denote the combination of the lined script and the script supervisor's notes pages, usually facing the pertinent lined script pages and contain numbers, length of the action, selected takes, a description of each setup and notes given on set for each take.

locked: At the point in the editing of the film when the picture editing is completed, the cut is then 'locked.' As it is common that last minute changes are almost called for, the term 'latched' is often used implying that it is likely to be opened again for changes.

M

master: The original footage that is shot either on film, tape or digital. It can also be the original edited master from which all copies are made.

matchback: A process for visual and audio replacement whereby higher resolution and better sound quality replaces the media with which the editor works.

mixdown: Several audio tracks can be combined and 'mixed down' to one track retaining the original settings on each track.

music and sound effects spotting: When the film is cut, the composer or music editor will come and view the show with the editor and/or the producer and decide where music should be added. Similarly the sound FX editor or supervisor will view the show and decide where FX should be added.

music codes: A time code (in digital) or code number (on film) that is applied to the dailies in addition to the already existing time code and key code. This music code enables the editor to find sync easily during a music sequence.

music tone: A musical tone is a steady periodic sound. It is characterized by its duration, pitch, intensity (or loudness) and timbre (or quality).

MX: Abbreviated form for music.

N

needle drop: A tune or piece of music that is already available on a CD and can be used as background music for a film.

non-drop frame time code: Time code in which each frame is given a continuous and successive time code number. As a result, the code does not exactly represent real time. The mismatch amounts to an 18 frame overrun every 10 minutes.

O

online: The process of editing the original master tapes into the final viewing tape at a high enough resolution to be broadcast quality. The final tape is called the final edited master.

output: The process of transferring a cut shot, scene, or an entire film from a non-linear editing machine to a videotape or DVD for viewing.

P

paper cut: Selected reality footage and bites written into script form which will be used to create a stringout.

pick-up shot: After a shot has been made on the set, the director wishes to re-do part of the take. This re-do is called a pick-up shot since the director 'picks-up' the filming part way into the previous setup. It is often designated with a 'PU' after the take number. A pick-up could also be shot done at a later date than at the time of principal photography. These are often done by second unit.

pilot and 12: The network green light order for the pilot plus 12 more episodes.

playback: A musical recording played back to the actors on the set to maintain the same musical performance or dancing sync from take to take.

playback days: The day on which the production will be shooting scenes that contain visual or audio playback, e.g. playing an edited stock footage montage on a TV set, or playing a pre-recorded song to which the actor lip syncs.

popping the tracks: The process of marking up the slates on a roll of dailies track. When this is done, you can sync them up with an already marked set of picture takes. Also called *marking the tracks*.

post-lap: In an 'L-shaped' cut (when the incoming audio is before or after the visual edit), this is when the audio continues after the picture edit.

pre-lap: This is when the incoming audio precedes the picture edit.

public domain: Being 'free and clear' or in the 'public domain' which means it is owned by the public and not by the original artist and there is no cost for using it.

Q

QuickTime: A program written by Apple Computer company giving Macs and PC computers the ability to compress, edit and play back movies

(with picture and sound). Some of the non-linear editing systems are designed to use or create QuickTime movies.

R

record side: The interface on the editing system that allows you to record and save your cuts.

resolution: The amount of detail in a digital picture image. When there is more compression, there is less resolution.

run-outs: The 30 or more seconds of excess leader or fill put onto the ends of a show.

S

scratch track: A sound recording used as a temporary placeholder during the recording and editing process.

shooting schedules: Prepared by the production office, this schedule tells what scenes are going to be shot on which days, which actors will be required, the location and any other relevant information that needs to be shared concerning that day's shoot.

slide the music: The ability on the timeline to move your music forwards or backwards to find exactly where you would like to place it.

soft-scripted: This means that certain events or conversations take place at the request of the producers who wish to increase the drama or provide clarity with the storyline of the show.

source side: The interface on the editing system that allows you to view your dailies and mark your selected clips for editing.

spot: A term used to view the final cut of a show and to determine where music or sound effects need to be added.

stand-alone show: A show that is part of a series that has no story points that relate to a past or a future episode. It is a self-contained episode.

standards and practices: The name given to the department at a television network which is responsible for the moral, ethical and legal implications of the program that airs. Also referred to as Broadcast Standards and Practices (or BD&P). This department is also responsible for the professional technical quality good enough for broadcast.

stock shots: Also called stock footage. Often a production is not able to shoot certain shots and so they obtain them from other sources like stock libraries that sell hard to obtain shots like a volcano erupting. They could be a collection of establishing shots that have been sourced from a

production and used repeatedly on a show over a period of seasons. These are stock shots of their locations and are usually shot to establish a location and for multiple use.

strike: Vernacular for making a print of the film, i.e. 'strike a print.'

stripe: Vernacular for applying sound to tape or film, i.e. 'stripe it.'

stringout: Selected reality clips and interview bites which have been notated with all the relevant time codes and edited together on a timeline to be used as a guideline for the edit.

subclip: A portion of a selected shot that can be removed as a separate clip and stored and edited.

subtitle: Writing that appears at the bottom of the screen. This is often used to translate inaudible dialog or often on television, is used as an identification of a person.

T

tech support: A service usually provided by your equipment suppliers who will be available to help with any technical problems you are experiencing with their hardware.

techs: The people who are available to answer questions and help with technical problems.

telecine: A device that takes film image and converts it into a video or digital image. It normally uses the 3:2 pulldown process. It is sometimes referred to as a film scanner

Teletron: Large playback monitors often seen at sporting events for instant replays.

temp score: Music used during the editing process that is temporary and will be replaced by a composer's score and licensed needle drops.

time code: Electronic code numbers, also called SMPTE Code, used on video tape and digital editing workstations for identification. It is also used to sync tapes to each other or to another machine. It comes in two forms, Drop Frame and Non-Drop Frame.

timeline: The display of the edited film and sound on an electronic editing machine.

timings: A measurement of a sequence or sequences in a cut show.

titles: Words that are shown on a screen with or without picture behind them. Titles could be credits, an identification line of type (Sunday morning. 9:30 a.m.), or translated lines of dialog such as subtitles.

trades: A term referring to any paper or journal dealing with film business news e.g. *The Hollywood Reporter* and *Variety*.

trim mode: A setting on the editing system that allows you to fix edits and adjust your shots trimming the head or tail by adding or subtracting frames.

TRT: Total running time.

U

user settings: These are personal preferences that can be saved on your machine.

V

VAM: The video assembled master which is the product of the video online to which sound is striped.

VFX or Vizfx: Abbreviation for visual effects.

voice-over: A recording of a voice only that is laid over a picture or a line of dialog used by an actor that does not appear on screen.

W

wild line: Sound recorded on set without accompanying picture. (A line of dialog that is recorded without picture and could replace a line that was shot with picture where the sound might not have been useable. It could also be an extra line that is recorded without picture that could be used as extra information in a scene.)

Index

Page numbers in *italics* refer to figures.

A

A&E 116
act outs 121, 132
action scenes 104–7; cause and effect 105–6;
 crossing the line 110; ear candy 106–7;
 eye candy 106; follow the ball 104–5;
 geography 106; slow motion 105
actor grooming 57
AD *see* assistant director (AD)
additional editor 13, 31
ADR *see* automatic dialog replacement
 (ADR)
After Effects 15, 26, 147
air 66, 70, 101
Alpert, Craig 117
Altman, Robert 77
alts 12, 74, 227
Amend, Kate 160; developing cut 163;
 making first cut 161, 162; viewing
 material 157, 160
Andrew, Mark: career path 215–17; cutting
 approaches 188–9; finding story 179, 180;
 music 169; narration 168; working as team
 183
Anido, Vince 183
assistant director (AD) 227
assistant editor: becoming editor 4; as career
 4; co-editor credit 30–1; as first
 commitment 21; recognizing safe
 environment 30–3; venue crossover 5;
 workload of 25; *see also* editor
Aubrey, David 116
audio layback 227
automatic dialog replacement (ADR) 78, 188,
 227
Avakian, Aram 115
Avid software 15

B

back nine 227
back twelve 227
background (BG) 25, 78; as Band-aid® 75,
 77; defined 227; removing 150; telephone
 conversations 110
backplate 227
Baker, Nancy 117
Bank, Mira 117
Barnes, Paul 117
Bartholomew, Ann 117
Benson, Lillian 117, 162
BG *see* background (BG)
blocking 52
Blush, Douglas 117
Bonnefoy, Mathilde 117
broadcast standards 227, 232
B-roll 123, 124, 125, 146, 227
budgeting 16–17
Buff, Conrad 4
bumpers 121, 227
burn-in 151, 227
Burns, Ken 117, 131

C

cable television 6, 116, 147, 171
cadence: dialog 73, 76, 83; frame rules and
 65, 66; as melody 64; meter and 72–3;
 music and 83; opening credits 99
Cahn, Dann 40
calibrate 227
call sheets 227–8
Calomay, A. J. 30
Capra, Frank 116
career assessment 3–19; current status 9–10;
 editing tools 15–16; editor choice 14–15;
 emotions assessment 13–14; finances 8,
 16–17; focusing on goals 13; limiting
 internet use 11; pace preference 8;
 personality 10; planning career path 9–10;
 project choice 10; reevaluating regularly
 18–19; venue choice 5–9; volunteering 9,
 12; work ethic 10
Cassidy, Jay 117

Taylor & Francis eBooks

Helping you to choose the right eBooks for your Library

Add Routledge titles to your library's digital collection today. Taylor and Francis ebooks contains over 50,000 titles in the Humanities, Social Sciences, Behavioural Sciences, Built Environment and Law.

Choose from a range of subject packages or create your own!

Benefits for you

» Free MARC records
» COUNTER-compliant usage statistics
» Flexible purchase and pricing options
» All titles DRM-free.

REQUEST YOUR **FREE** INSTITUTIONAL TRIAL TODAY

Free Trials Available
We offer free trials to qualifying academic, corporate and government customers.

Benefits for your user

» Off-site, anytime access via Athens or referring URL
» Print or copy pages or chapters
» Full content search
» Bookmark, highlight and annotate text
» Access to thousands of pages of quality research at the click of a button.

eCollections – Choose from over 30 subject eCollections, including:

Archaeology	Language Learning
Architecture	Law
Asian Studies	Literature
Business & Management	Media & Communication
Classical Studies	Middle East Studies
Construction	Music
Creative & Media Arts	Philosophy
Criminology & Criminal Justice	Planning
Economics	Politics
Education	Psychology & Mental Health
Energy	Religion
Engineering	Security
English Language & Linguistics	Social Work
Environment & Sustainability	Sociology
Geography	Sport
Health Studies	Theatre & Performance
History	Tourism, Hospitality & Events

For more information, pricing enquiries or to order a free trial, please contact your local sales team:
www.tandfebooks.com/page/sales

Routledge
Taylor & Francis Group

The home of
Routledge books

www.tandfebooks.com

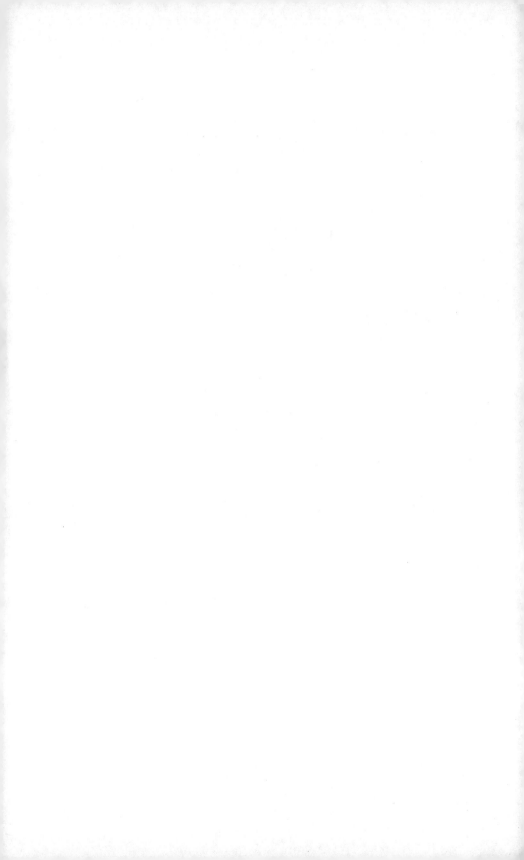